W9-DDR-913

THE COMPLETE BOOK OF

Nature Photography

THE COMPLETE BOOK OF

Nature Photography

Russ Kinne

with an introduction by Roger Tory Peterson

AMPHOTO
American Photographic Book Publishing Co., Inc.
GARDEN CITY, NEW YORK

SUE WILLIAMS

TO MILDRED, HAROLD, JANE, PAUL, AND CASEY;
for their enthusiasm, interest, and patience.

Copyright © 1962, 1971 by American Photographic
Book Publishing Co., Inc.
Library of Congress Catalog Card No. 79-134590.

Fourth Printing, March 1975

ISBN 0-8174-0387-6

Published in Garden City, N.Y., by Amphoto. All rights re-
served. No part of this book may be reproduced in any form
without the consent of the publisher.

Manufactured in the United States of America.

Preface

In woods, swamps, mountains; and at zoos, meetings, and lectures I have met and talked with hundreds of photographers, both amateur and professional. Invariably, at least two questions have been asked of me. The first was a perfectly valid, though often elementary, query about my equipment or techniques. The second was always, "What books can I study to learn more about wildlife photography?" This volume is my answer to both questions.

I felt there was a need for one book to cover the whole field of wildlife photography; a volume where eager beginners and seasoned workers could find the "tricks of the trade." I must assume the reader knows something about photography; this is not a primer for novices.

I believe readers will be divided into two general classes: non-photographers who have admired outstanding nature photographs and wish to know how they were taken, and photographers who want to learn the specialized techniques required in some fields of natural history. Most readers will pick up the book because they are interested only in one or two of the areas discussed. Fine! I believe, however, that nature students and photographers have active, searching, and inquiring minds; they soon may be trying other fields of work and expanding their photographic horizons.

In previous years, "nature photography" was almost synonymous with "bird photography." Some work was being done in other fields, but birds attracted by far the most attention. Today things are different. Photographers still pursue birds, but they also take cameras underwater, tramp the hills and valleys in search of mammals, flowers, insects, reptiles, and amphibians, and go into the hills and mountains to photograph cave formations, bats, salamanders, and insects. They bring back pieces of the mountains and photograph them in a studio or laboratory, alongside other workers recording microscopic plants and

animals or aquaria of fishes and invertebrates. Wild creatures are found nearly everywhere; and so are today's photographers.

This is not intended to be a book of pretty pictures. It is meant as an instructional guide, and the illustrations either show some piece of equipment and how it is used, or are an example of what can be done with a particular setup. I have used, tested, or devised the techniques and equipment discussed here. They should be equally useful in Houston or Hong Kong, Portland or Point Barrow, Capetown or Copenhagen.

Many generous people have aided in the preparation of this book. It would have been quite impossible without the invaluable help given me in a number of different fields by technicians, scientists, and photographers, both amateur and professional. I am also indebted to my personal friends, who have shown unbelievable patience as I turned their homes and gardens into work areas cluttered with cameras, reflectors, ladders, lights, and wires. They have been most helpful in notifying me when birds are nesting and flowers are coming into prime condition. Many readers of my articles in *Popular Photography* and other magazines have sent in excellent suggestions and techniques they have found useful. I would also like to express my especial thanks to Roger Tory Peterson, whose writings have inspired me as well as millions of others, and who kindly consented to write the introduction to this book. Robert Porter Allen's contagious enthusiasm and incredible fund of knowledge have made a number of field trips vastly more productive and enjoyable than they could have been otherwise. I am also grateful to the following persons for their unselfish assistance: Bob Adlington of the American Museum of Natural History; Dr. William Beebe, Jocelyn Crane, William Conway, Ross Nigrelli, Carleton Ray, and other staff members of the New York Zoological Park and Aquarium; Larry and Peg Braymer of the Questar Corporation; Dr. Francis H. Fay; Marty Forscher of Professional Camera Repair Service; Arky Gonzales; Russell Gurnee; Hermann Kessler; Herman Kitchen; Kurt Luhn; Stuart Mutch; Dur Morton, Director of the National Audubon Society's Greenwich Center; Charles Ott; Peter Schults and Clifford Dolfinger of Photo Researchers, Inc.; John Spence; Dade Thornton; Fred Wilson; Merwin Dembling and Louis Zara. My wife, Jane Kinne, has been indispensable during many hours of typing, conferences, the checking and rechecking of information and data.

Finally, I am indebted to the host of photographic pioneers who through the years have developed and shared with us the basic techniques of wildlife photography.

To all of you, I say a most sincere "Thank you."

RUSS KINNE

Contents

Introduction

AT LAST, HERE IS A BOOK on nature photography that will become an essential part of my field pack. This is a book which I will take with me to the ends of the earth on future expeditions.

Although I have probably read every book and pamphlet dealing with wild-life photography starting with the works of A. Radclyffe Dugmore and L. W. Brownell, excellent in their day (more than 50 years ago), I find that the majority of treatises tell me little I did not know. In fact, most of them seem obsessed with the box brownie enthusiast or the chap who can't afford to spend much on the tools of his trade. To me (once called "a destroyer of equipment"), a feature that makes this book a gift from heaven is the very thorough discussion of the ideal equipment and its care. Indeed, every chapter is a goldmine of "know-how." Wildlife photography by its very nature requires techniques that are not easy, equipment that is expensive and above all, the almost fanatic drive of the perfectionist.

The younger photographers tend to have a great advantage not only because of their youth and energy but also because they often start off with the most recent cameras and accessories on the market. More than one experienced old-timer, aware that he is being by-passed in the struggle for excellence, has wondered why. The answer may be in his reluctance to invest in new equipment and to accept new procedures. This cannot be said of such a pioneer as Arthur Allen who almost invariably has been the first to investigate new techniques.

Nature photography has two major approaches. The first is pictorial, concerned with composition, attractive pattern and values of light and shade, originality of concept and, when it can be achieved, emotional quality. Some critics question whether we can regard photography as a true art form in the modern sense inasmuch as "art" these days seems more concerned with subconscious

comment and abstraction than it is with representation. I shall not labor the point, for my own art training was in the "academic" tradition.

The second approach, the documentary, is less esthetic and more functional. The field biologist of today is seldom without a camera. Dr. Arthur Allen, who for many years was professor of ornithology at Cornell (the first of the 37 U.S. universities to offer advanced work in this discipline), placed great emphasis on photography as a tool in the study of birds. This tradition is kept alive and flourishing at the Laboratory of Ornithology at Ithaca. The animal behaviorist would be lost without photography (especially motion pictures), for pictures make it possible to analyze and reinterpret actions long after the incident. They leave nothing to faulty memory or inexperienced on-the-spot observation. The ecologist, publishing a paper, often can tell his readers more about a habitat or environment through the medium of one photograph than he can with many wordy paragraphs of description.

To the botanist, may I suggest a very special use for flower transparencies. Botanists press their plants, and there are actually professional systematists who, though able to key down dried specimens, are confounded when forced to identify the living flower. Certainly most herbarium specimens bear little resemblance to the growing plant. True, a composite holds its shape fairly well and so do flowers of certain other families, but an orchid or a mint with its complicated structure is scarcely recognizable when time and pressure have browned the color and distorted the subtle contours. Would it not be useful to include a little envelope in the upper left-hand corner of each herbarium sheet in which is inserted a transparency of the living plant before it was plucked? Perhaps some botanists have already thought of this gimmick. An herbarium collection could be made 100 per cent more effective by employing this innovation.

Twenty-five years ago I was rash enough to suggest that nature photography probably couldn't look forward to more than a 10 or 15 per cent improvement in results. I believed that this art, craft or sport—call it what you will—had attained near stability. How incredibly naive! Since that time color film has had its rise; film speeds have been stepped up and high speed strobes have been developed commercially. Lenses of great focal length and extraordinary definition and speed line the dealer's shelves. The cameras themselves are now so sophisticated that they almost think. Ingenious systems of synchronization and remote control, fluid tripod heads, gyroscopic stabilizers and 1,000 other accessories tempt the photographer to mortgage his home. From this point on I shall make no further predictions knowing that not a year will pass without seeing advances in cameras, films and accessories. Present techniques will be superseded. The only serious limitation will be one's checkbook.

I have taken wildlife pictures since the age of 13 when I purchased a 4 x 5 Primo No. 9 plate camera with my earnings from a morning newspaper route. I recall that my first bird subject was a screech owl that I fished out of a hole in an old apple tree. I tethered the sleepy-eyed bundle of feathers to a limb, con-

cealing the restraining cord behind some twigs—an out-and-out case of nature faking. Since then I have taken tens of thousands of bird pictures but never again have I tied my subject down. In fact, I feel rather strongly about filming wild birds under studio conditions except at feeding stations or watering places where they are free to come and go. Zoo shots are something else again, for these are usually self-evident and the photographer seldom tries to palm these off as wild birds. There is no objection, I feel, to photographing insects or reptiles or amphibians under restraint. But inasmuch as birds are the very essence of mobility and freedom it does not seem cricket to confine them for their portraits. I know of one well-known photographer who has no compunction about photographing a chickadee or a warbler in a studio set where there is only one branch on which the frantic captive can perch. This procedure is unfair to purists like Allan Cruickshank, Eric Hosking and Sewall Pettingill who do it the hard way. I doubt that the photographer himself can really take much satisfaction from indoor shots, pin-point sharp though they may be.

I shoot an appalling amount of film and sell comparatively little of it for actual reproduction, but I find photography one of the most important tools in my profession. I do considerable lecturing with 16mm film and 35mm transparencies and could completely occupy my year in this manner if I chose, but the main function of my photography is as a kind of note-taking primarily for paintings and illustrations. In my studio, 35mm transparencies are projected on a Trans-Lux screen and then there is no question as to just how a duck holds its foot or how a leaf catches the light. 16mm film is used in the same manner— projected through a special wide-angle cold quartzite lens. I can advance the film by hand, one frame at a time, until I find the precise action that I want and then hold it there for as much as an hour without burning too much color out of the film. This technique is particularly useful for studying the wing action of birds.

Although I use photographic reference material constantly I seldom make a literal copy. That would be pointless; it would usurp the role of photography. The illustrator (I prefer this term to "artist") should use photographs mainly as a point of reference. Although his work may be "representational" it should avoid being slavishly photographic.

This brings up the inevitable query: "Which is preferable for natural history illustration—a good photograph or a good painting? Don't they do essentially the same job?" By no means. A photograph arrests a moment in time. It is an exact record of what happened in a particular split second. A painting, on the other hand, even a representational one, is a composite of the artist's past experience.

A photograph cannot show two or three plumages of the same species in the same picture. Nor do birds and other animals fully cooperate in assuming the ideal pose or fit into the ideal composition when a lens is aimed their way. For straight portraiture, color film can seldom equal the brush of a truly skilled

man. On the other hand, I believe action and behavior are more accurately interpreted by the lens. When the lens captures an image there is no mistake that it portrays exactly what the animal did at that particular moment. Unlike painting, it is not subject to the vagaries of memory.

Valuable as photography is as research material in painting I find an equally important use in connection with my writing. I wonder how many other writers use transparencies as a memory jog? A picture taken on the Maine Coast recalls the exact appearance of the kelp at low tide, the color of the rocks along the shore, the cloud formations above. It may also conjure up a succession of half-forgotten thoughts. "It was on that point where we had the lobster roast . . . Joe Cadbury was there . . . And what was that story he told us about the Indian chief who once lived on the island?"

This is no argument against notebooks. Such items as time, place, exact species observed, and numbers of individuals must be jotted down. Transparencies, on the other hand, trigger a whole string of associations and recall minor points that one seldom includes in his notes.

Although I may justify my photography as essential to my work, my wife questions the need of each new lens. She hints that I am a gadgeteer, but I don't think so. I use all my equipment. The simple truth is that I enjoy taking pictures; it gives me more pleasure than anything else I do. It is at once a sport and a relaxation, at times a mania and a vice.

Some psychologists would insist that nature photography—particularly bird and mammal photography—is a remote survival from primitive times, when every man had to hunt to keep alive. Millions still shoot for sport; others with a distaste for the unnecessary taking of life, subconsciously enjoy the thrills of the chase by bagging their quarry with a camera. This takes greater skill than handling firearms, but there are not so many prohibitions and limitations. There are no closed seasons, no protected species, no bag limits. The same creature can be "shot" again and again, yet live to give pleasure to others beside the photographer. The picture is the trophy, as tangible as a moose head on the wall and not as dust-catching.

ROGER TORY PETERSON

Dr. Roger Tory Peterson, famed ornithologist, artist, lecturer, and author, at work in his studio. Mr. Peterson frequently uses photographs as a reference in his paintings, to assure accuracy of posture and form in portraying wildlife.

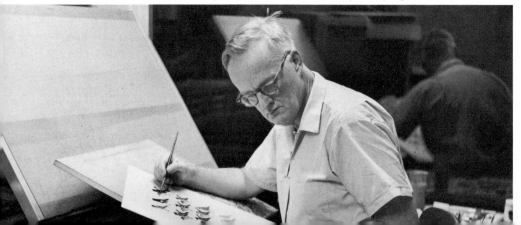

1
Cameras and Lenses

THE TREMENDOUS array of photo equipment on dealer's shelves nowadays is enough to make strong men weep—for joy. There is so much excellent equipment available today at reasonable prices that I often feel I should bow my head in humble thanks to the manufacturers. Cameras are being improved continually. Lenses are getting sharper, faster, and better in every way. Films are superb—and getting still better. Flashguns and bulbs are becoming smaller and more efficient. Electronic flash units are marvels of miniaturization, with more output, better color balance, more shots-per-charge, and faster recycling than they offered just a few years ago. Exposure meters will give usable readings even when it's too dark to see the meter needle.

In the midst of all this activity sits the happy photographer, whose work is becoming easier and results more consistent. Many of the technical gymnastics and mental calisthenics are eliminated or reduced, and he can devote more time to exercising his compositional eye and experimenting for special effects than ever before. This all means better quality and more satisfying results for everyone concerned—a very happy situation—and due largely to what's on those enticing, glittering shelves in the photo store.

It would be impossible for any one man to test all the equipment available, and still have time to do any serious photography. I have mentioned certain cameras, lenses, and other equipment in this book because they have performed well for me. I have recommended what I believe to be the best in that particular field, considering all factors.

Cameras for field use are of three main types, excluding view and press models. The rangefinder camera is the most common. Rangefinder cameras are fast to use, the best type for very dim light, and are favorites with many photo-

journalists and news photographers. However, with a rangefinder camera, you are obliged to "shoot blind." The view-and-rangefinder indicates that the subject is framed and focused properly, but there is no way to examine the actual image thrown by the lens. It is entirely possible (as most of us know) to take photographs with the lens cap on, a finger or glove in front of the lens, or a collapsible-mount lens in the collapsed position. In each case the viewfinder shows a bright, beautiful picture that never gets onto the film.

The twin-lens reflex has enjoyed a good deal of popularity for more than 30 years. The viewfinder shows a fine, full-size image (generally 2¼ inches square), big enough to examine carefully and comfortably. Many of the potential pitfalls of rangefinder cameras have been diminished. Lens caps generally cover both lenses and can hardly be left on accidentally. Focusing is perhaps more reliable, framing more exact. Here we have two identical lenses throwing, for all practical purposes, two identical images; we examine one image and the other goes onto the film. Furthermore, our "examination image" is produced by a lens at its widest aperture and consequently its shallowest depth of field. If the groundglass image is sharp and the taking lens is stopped down to any degree, we can be pretty sure our subject is in focus and our negative will be sharp.

The single-lens reflex uses a similar system, but there is only one lens throwing one image. A hinged mirror reflects this image onto a groundglass for viewing and focusing. When the shutter is pressed this mirror obligingly flips out of the way and *the same image* goes onto the film. Whatever image you see on the groundglass is what you get on film—if a negative is out of focus, the image was out of focus when you pushed the shutter, and you have only yourself to blame. You cannot leave a lenscap on—there would be no image at all on the focusing screen. A finger, glove, or object in front of the lens will cut off the image immediately. Furthermore, you can see the effects of filters by placing them over the lens. You can study the depth of field at leisure and decide if you want the background sharper or further out of focus. In short, you can examine and create exactly the image you want to capture on film. Also, this holds true *regardless of what optics produce the image*—and this is important.

For "normal-lens" work at normal ranges; that is, using a lens that covers about a 45-degree angle of view, at distances of three feet to infinity; any of the three types can be used with success, and about the only real choice is personal preference.

This sort of a situation seldom occurs in nature photography. More often the subject is shy and unapproachable and we must use telephoto lenses; at other times we may work with small animals or objects, and must use extension tubes, bellows attachments, or even microscopes. With one exception, twin-lens reflexes do not have interchangeable lenses or any provision for extreme close-up work. Though many rangefinder cameras do offer the interchangeable lens feature, the longest lens that can be coupled to the rangefinder is usually 135mm.

Most wildlife subjects call for longer lenses and these cannot be coupled to the rangefinder.

Reflex attachments will convert some rangefinder cameras into single-lens reflexes, but in many cases the cost of such an attachment is equal to the cost of an entire SLR camera. Furthermore, this is one more piece of equipment to carry and care for, and there is a greater chance of letting dust and dirt into the camera body and of fogging the film when putting on or taking off the reflex housing. These attachments also slow down the "lock time" between finger-push and actual exposure.

In my opinion there is no question that the single-lens reflex is by far the best type of camera for use in photographing wildlife and natural history subjects. I own and use all three types but frankly prefer the SLR for nearly all jobs.

This is not to say that other types of cameras can't be used, or that everyone should sell his present equipment and get reflex equipment; but it *is* to say that if you are considering buying new cameras, by all means look long and hard at the SLR's before making a choice. The SLR has had ample time to prove its worth in modern photography, and has come through with flying colors. I would recommend it to anyone for at least 95 per cent of all nontechnical photographic work.

More and more refinements are being continually added to the single-lens reflex. At first the image would disappear when the shutter was tripped, not to reappear until the film was wound. Then came the automatic-return mirror that blacked out the viewfinder for just a fraction of a second. The advantage was psychological—it was too late to change any settings when the image disappeared; and, image or no image, the shutter must still be wound for the next exposure. But photographers tend to work better and feel easier if the image is visible nearly all the time, and the instant-return mirror is worth its salt for this reason alone. But other features are more important.

Automatic lenses are a valuable convenience. The image is focused at the widest aperture of the lens, and the lens stops itself down a split-second before the shutter goes off. In dim light, focusing and shooting is much easier, but there is a more important advantage to automatic diaphragms in wildlife work. Any moving subject, large or small, may well move out of focus if you have to stop a lens down manually before shooting. If you focus with the lens already stopped down, sharp focus is a gamble. Following an insect, for example, and focusing with an automatic lens wide open, then shooting at $f/16$ or $f/22$, practically guarantees he will be in the middle of the zone of sharp focus.

More and more automatic lenses are becoming available. The widely used Nikon F Camera, for example, has automatic lenses with focal lengths of 20mm, 24mm, 28mm, 35mm, 50mm, 55mm, 58mm, 85mm, 105mm, 135mm, 200mm, and 300mm—not to mention zoom lenses.

Most SLR cameras have focal-plane shutters. This is the most accurate and efficient type, and offers the highest speeds. The only drawback comes when

using strobe in daylight. The fastest strobe-synchronized speed is usually 1/50 or 1/60 sec., and this is slow enough to let the sunlight form a blurred "ghost image" on the film, with the sharp strobe-image superimposed upon it. The results are far from satisfactory.

Some single-lens reflexes use a blade-type shutter between or behind the lens. Either the front lens element, or the entire lens itself, is interchangeable, and strobe can be used at any speed under any light conditions. This is a good way to do things, but there are some limitations, due to the construction and design problems that arise. Extreme close-ups, greater than life-size on the film, are seldom possible. Moderate close-up pictures can be made by adding one of a set of supplementary lenses. Moderate telephoto work is not only possible but highly convenient and pleasant. Extreme telephoto lenses are not available. This type of camera is excellent for everyday photography at normal ranges and is a happy compromise for the amateur who wants to dabble in wildlife work from time to time without sacrificing any of the little conveniences built into the camera for average use.

One more type of camera deserves mention, and it is one not often considered in nature work. This is the picture-in-ten-seconds Polaroid Land Camera. It is not a reflex. It will not take telephoto lenses or close-up pictures. Why, then, do I mention it? Because the Polaroid Land Camera is the best public-relations agent you could ever find. Giving people Polaroid pictures of themselves, their homes, children and pets will open more doors than you can imagine. It is much simpler than mailing them prints later. Aside from its worth in making friends and gaining special favors, a Polaroid camera can be used to check contrast and exposure when doing precise color work. A test exposure will point up any major discrepancies on the spot.

As to film size, 35mm is excellent for at least 95 per cent of the wildlife work done. Several national magazines prefer 35mm color transparencies to the larger film sizes, and often enlarge them to double-page spreads. There is a greater choice of film types in the 35mm size and film costs are of course quite low. Perhaps the main reason is that Kodachrome film is made ONLY in small sizes at present.

The next larger size to consider is the 2¼″ x 2¼″ or 120 rollfilm size. Many workers prefer this size in black-and-white work due to the better quality that usually results from using a larger negative. Film costs are slightly higher than 35mm but still quite reasonable. Color transparencies are big enough to view without a projector, and are of ample size for most commercial uses, barring only the large posters and billboards. Until recently the only quality single-lens reflex in the 2¼″ square size was the Swedish Hasselblad. The Japanese Bronica and Pentax, and the German Rollei have some very interesting features, but it still remains to be seen how well they will stand up under hard usage. Eye-level prisms for 120 reflex cameras are appearing on the market. Though they are bulky, they do make wing-shooting possible and even convenient.

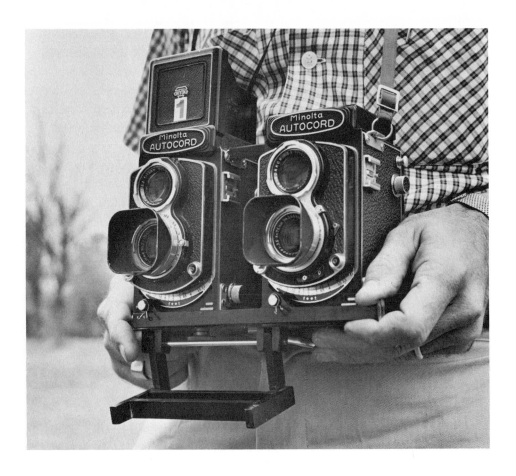

Two twin-lens Minolta cameras linked for simultaneous shooting with two different film types, or at two different shutter speeds, for special effects. The focusing levers are connected so adjusting one camera assures sharp focus for both; the bracket on the bottom swings up to set off both shutters nearly simultaneously.

Press and view cameras use cut film, usually 4″ x 5″. The swings and tilts available are quite valuable in some types of work, but weight and bulk make these cameras quite inconvenient for most field work. They are not well-suited for fast operation or inconspicuous work. Film costs are much higher than with rollfilm, both in raw stock and processing. In color, a 4″ x 5″ cut-film transparency costs five to six times as much as a 2¼″ x 2¼″ rollfilm transparency. Large cameras are more conducive to careful, planned work and are excellent for certain purposes, but for versatility and ease of operation, I would still recommend a smaller single-lens reflex.

People often ask, "Which are better, German or Japanese cameras?" Excellent and mediocre equipment is made in both countries and it's unfair to put a blanket commendation or condemnation on either. Other countries are in the field, too: Sweden with the Hasselblad, England with certain lenses, and France with the incomparable Balcar strobe unit. On the whole, Japanese cameras are

quieter and have some very clever features. The most versatile cameras now available for wildlife photography are the top-line Japanese and German SLR's: the Nikons, Minoltas, and Leicaflexes. They have many different lenses and accessories, and even electric motors for rapid-sequence and remote-control work.

Figure out what features a camera should have for the type of work you have in mind, and look over the makes and models that offer the most. It's smart to think of the future, too; even if you intend to do nothing but floral work now, getting a camera that will take a long telephoto lens is wise; if you get into bird or mammal work you won't have to buy another camera.

When contemplating a second camera, give some thought to getting one identical to the one you now have. Two such cameras are most valuable on long trips; if one breaks down, all accessories and lenses can be used on the other. Both can be carried around your neck, one loaded with color film and one with black-and-white. You may need regular and high-speed films in one case, or daylight and tungsten-type color film in another. At other times when you want to have the same film in both cameras, put a telephoto lens on one and the normal lens on the other; or a normal lens and a wide-angle. Some twin cameras lend themselves very well to being mounted together, with a double cable release setting them both off at once. Occasionally, the focusing can be linked together too, simplifying things greatly. Cameras such as the Minolta Autocord, where focusing is done with a lever, are quite easy to couple this way.

A photographer's "glassware" occupies a special niche in his affections, and well it should. Lenses must get the loving care reserved for worthy wives, good working dogs, aircraft, and sailboats if they are to perform at their absolute best. Also, these lenses often represent the major part of a photographer's cash investment. There are places in the field of photography where a little economy is possible or even advantageous, but this is not one of them. The only safe way to be satisfied is to get the best lenses possible and take *good* care of them.

In selecting a second lens for your camera, I would recommend getting a really long one rather than gradually working your way up the scale. The long lens will be more useful than a medium-long one; generally, if you need a telephoto lens, you need a long one. I think the 200mm or 300mm lens is the best telephoto for a 35mm camera. The 300mm lens is half again as long, but usually slower by a full stop. It is also heavier and bulkier. Surprisingly, both lenses cost about the same, and all you must decide is whether you need more length or more speed. A good tele lens will focus to ten feet or so, without accessories. Some are faster than the "usual" but cost and weigh more. The Novoflex lenses have a follow-focus grip that is invaluable in flight work. I commonly handhold the Novoflex 400mm and occasionally the 640mm! They are well balanced and lightweight, as well as being excellent lenses. With a special bellows, the 400mm will focus to eight feet without any "extras." With a motorized camera, the 400mm lens is the greatest wingshooting rig ever. I'd be lost without it.

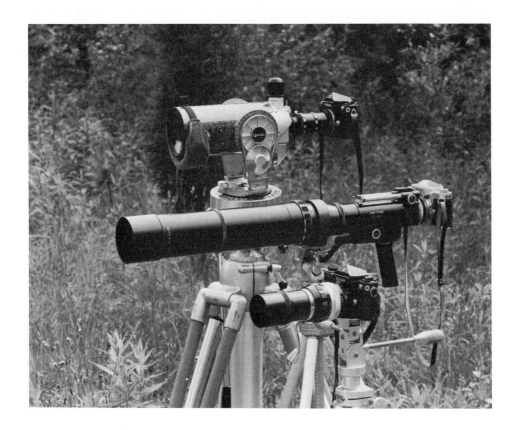

Conventional lenses get bigger and longer as their focal lengths increase. Shown here are 200mm and 640mm lenses. For comparison, the Questar telescope is 1600mm in effective focal length. Its small size is due to its catadioptric design.

Later on, a serious photographer will want an in-between lens of 100mm or 150mm focal length. I believe that any new lens a photographer gets should be about twice, or half, the focal length of the lens he already has. Doubling the focal length each time, or nearly so, would produce the following battery of lenses: 24mm, 50mm, 100mm, 200mm, and 400mm. For a 120 reflex you might have 38mm, 80mm, 150mm, 300mm, and 600mm.

The gaps aren't as serious as you might think. If the major subject is too small with one lens, switch to the next longer; it will be twice as big and should be nicely framed. Finally, a point is reached where long lenses are just too heavy, bulky, and clumsy to be used efficiently. A 600mm lens is about the longest that can be operated with any degree of speed and convenience, and at that may weigh ten pounds or more. In these longer ranges it's better to use a spotting telescope or catadioptric (mixed lens-mirror) optical system. Both of these use what can be called "optical folding," so that long tubes are unnecessary. The Questar telescope, for instance, gives effective focal lengths of from 3½ to 50 feet; all out of an eight-inch barrel! The Questar is a catadioptric system, and is sharper than is theoretically possible.

Some prism telescopes, such as the Bushnell Spacemaster, have been designed specifically for photographic use and a camera can easily be attached. The effective apertures are quite small when shooting through telescopes, generally $f/11$ or $f/16$, and considerably smaller with higher magnifications. With high-speed films, however, this need not be a serious handicap. There are several monoculars on the market that produce effective focal length of around 300mm–500mm. They are built along the lines of a prism-telescope and some screw directly into camera lens mounts. With any monocular or spotting scope, sharpness is seldom anywhere near that of a good telephoto lens of the same focal length, and there may be a "hot spot" to the image or vignetting in the corners. Whether the loss in sharpness is offset by the gain in magnification depends on what use will be made of the pictures; for some purposes they will be quite satisfactory.

Practically all reputable dealers sell equipment on a ten-day trial, money-back basis. Make sure this is a *money-back* guarantee. Some stores offer to take back equipment only if you'll accept other equipment from them in trade; you must accept whatever they want to give you at their prices and terms. A reputable store will refund your money without question when equipment is returned in good condition within the free-trial period. Ten days is plenty of time to do a little testing and see just how good an unknown camera or lens is.

When choosing lenses, beware of bargains! Usually, you get what you pay for, though there are exceptions. The very cheap lenses often prove unsatisfactory. Buy at least medium-priced equipment, forget any wild advertising claims, and do some personal testing. Look at the results with a critical eye, and then decide whether or not to keep the lens.

2

Additional Equipment

ARTIFICIAL LIGHT is a necessity once in a while in all types of photography, and all the time in some fields. Floodlights are seldom used in wildlife still photography; flashbulbs and strobe units are the best and most popular light sources. Flashbulbs can only be used once and cost 10–20 cents apiece. Their duration is too long to do much action-stopping, and they must be accurately synchronized to a fast shutter. The considerable light and heat produced at close ranges will alarm wild birds and mammals. However, flashbulbs and flashguns are nearly foolproof, and can even be used underwater with a few changes. A flashgun can be set and left for weeks or months, ready to go off at any time with virtually no drain on the battery or maintenance of the equipment. Any sort of a crude electric circuit will fire a bulb perfectly; one can be improvised from a flashlight, car battery, or house-current line.

Flashguns have become so small they are being built into amateur cameras! These ingenious little affairs fire miniature bulbs, the all-glass type, or flashcubes. The flashgun and a few dozen bulbs are small enough to tuck into a pocket for emergency use anytime and anywhere.

Electronic flash units use an electric circuit to load a storage capacitor with electrical energy, and produce a very fast, very brilliant light when this charge is released through a glass tube containing xenon gas. The most striking quality of a strobe is that of stopping action far too fast for the human eye to see. The light is very close in color quality to that of sunlight, and gives excellent results with daylight film. Earlier models may give a slight bluish tinge, easily corrected by a warming filter. The ultra-fast flicker of strobe light disturbs wildlife much less than the blast of a flashbulb. Birds may even continue to feed while a strobe goes off. Cost of operation of electronic flash units is very low and practically nil on 110-volt house current. Most models are equipped with a battery for portable use as well.

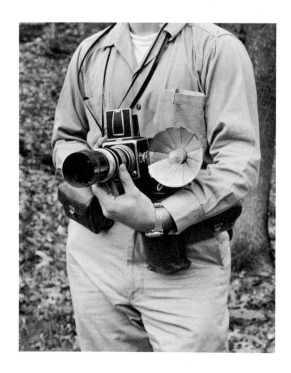

A small fan-flashgun, here mounted on a Hasselblad, neatly solves the problem of fill-in lighting with focal-plane shutters, where strobe is impracticable at high shutter speeds. The reflector may be folded if too much light is produced at close ranges.

A bewildering number of units are on the market now, and a newcomer may well ask, "Where in the world do I begin?"

There are three main classes of portable electronic flash units: low-voltage battery, high-voltage battery, and A.C. Many units incorporate two systems, and can be used on either A.C. or low-voltage batteries.

Low-voltage units use transistors (or a vibrator) to boost voltages to usable levels. These will whine or hum, and may alarm some shy subjects. Also, current drain may limit their "on-time" to five or ten hours, or less. Low-voltage dry cells, such as flashlight batteries, wear out and must be discarded. Low-voltage nickel-cadmium cells can be recharged many times and are most economical. High-voltage dry cells give faster recycling, but are expensive and will give out in a year or so whether or not they are used. They do not hum, and can be left on for hours with little drain on the battery.

In cold weather dry batteries lose much of their power and may not operate a flash unit at all. Sometimes the power-pack can be kept inside a coat and will be warm enough to work well. The ideal range is between 70° and 100° F. Wet cells work fine at low temperatures as long as they are kept charged. Discharged cells will freeze solid and may be ruined. Nickel-cadmium cells are best for cold weather.

The "strength" of an electronic flash unit is measured in watt-seconds (joules) or effective- or beam-candle-power-seconds (ECPS or BCPS). It is a bit confusing, but at least better than the previous guide numbers recommended by the manufacturers. These were usually wildly overoptimistic! Among reputable brands, you can now almost believe what is claimed; with cheaper units

you may be a stop underexposed if you follow the claimed guide numbers. There are a great many small units now available, most of which are excellent. Many, however, have sealed-in NC batteries, meaning that when the unit is shot out, the entire flash unit is out of commission for hours while being recharged. With *replaceable* batteries, you can pop in a new one and keep shooting. The smaller units are usually 40 watt-seconds or less and weigh a pound or less; price is anywhere from $15 to $50. Many good ones are in the $30 class. Such a flash gives ample light for color shooting up to ten feet or so. Larger units let you shoot at greater distances and/or stop down further for more depth of field. The larger ones are of course heavier and more expensive. There is a lot to be said for getting two or even three identical small units. They can be "stacked" for more light output, or used separately for multiple-light setups. Small "slave-trippers" synchronize them all to fire at once.

Most units have provision for battery and 110-volt A.C. power. On A.C., they can be left on indefinitely and make no noise. On low-voltage battery power, they will whine or "beep." This may alarm wildlife. High-voltage batteries are noiseless and avoid this problem, but they are expensive—from $5 to $15 a set—and wear out in a year or so regardless of use. Just about any unit can be wired to take high-voltage dry cells; at the same time check the "idling drain" with a milliammeter. This will tell you how long the unit can be left on before the battery goes dead. This may be several hundred hours.

For nature photography you certainly want a portable electronic flash unit, but these range from 20 to 1,000 watt-seconds. Among modern units, weight is fairly constant within a given power-range, but older units may be heavier (though cheaper!). The speed of the flash varies little from make to make, despite claims by manufacturers. If a unit has removable flash-heads, and you can put two flash-heads on a single power-pack, you will shorten the flash duration by about a third, but for real action-stopping you must go to a high-voltage unit with oil-filled capacitors. This is specialized gear that gives a flash of 1/10,000 sec. or less. Some of the new automatic-exposure electronic flash units will give a short flash too, but only within a few feet of the subject, and you never know just how short the flash was. There will be a noticeable color shift above 1/10,000 or 1/15,000 sec. The automatic units are best for photographing people, weddings, and the like. I don't care for them for serious wildlife work; but the automatic feature can usually be shut off when you don't want to be tied to its one *f*/stop. Recycling times seldom run over ten seconds with small units and are getting shorter. Faster times are convenient but seldom really necessary. Most units now have—and should have—monitor circuits to assure uniform flash-strength and to conserve battery power. For small units, I use two Spiratone Monopaks, and two Braun F800's as big units. The Kodachrome II guide numbers are 28 for the Monopaks, and 50 on low and 100 on high for the Braun units. These give me 400 shots per charge on low power! I also have a Lightning-Light unit (A.C. only) for action-stopping, with a flash duration of

1/15,000 sec. These are of course just personal choices; other brands may be equally as good.

Electric cords for photo use never seem to have the same fittings, but at least most sync cords have a polarized household-type plug on one end. Power and common extension cords also use this fitting. To simplify things, I have converted all cords for flash units, flashguns, remote-control gear, power, and camera-trap switches so they all have the same connectors. Now standard extension cords can be used anywhere. I have four 10-foot cords, two 20-foot cords, and two 40-foot cords. They are made of green wire so that they blend into the grass and also to identify them as *mine!* To convert a sync cord with unique fittings, simply cut it and put in a male and a female household plug on the ends. With an ohmmeter, or test prods, determine if it is hooked up the way it was originally, and mark one side of each household plug with red nail polish. The ends of extension cords should be similarly marked—otherwise, you may reverse polarity and things won't work right! Flashbulbs may go off in your fingers, strobes may self-fire, or not fire at all, and you may even get slight shocks. If you don't have meters or test prods, hook things up right by trial and error, then mark the plugs and sockets.

The human eye continuously and automatically adjusts itself to changes in light intensity, but cameras don't. The photographers who "never use a meter" operate by guesswork, and their results aren't as good as they could be.

Exposure meters are simply small electrical meters that measure relative light intensity. The older and less expensive ones use selenium cells, the newer and more complex ones use a cadmium sulfide (CdS) cell, powered by a small battery. They are much more sensitive to dim light than the selenium-type cell, but in good light both types should be equally accurate. The two may behave differently in cold weather, but this is largely academic; in your pocket they will not get that cold. Exposure meters are two main types, reflected-light and incident-light. Incident-light meters measure the intensity of the light that *falls on* the subject, and reflected-light meters measure the light that is *reflected from* the subject into the meter. Both types are good and each is "better" under certain circumstances.

The light that affects the film is light that has been reflected from the subject; therefore we might assume that the reflected-light meters are more accurate, and theoretically this is true. However, if we photograph a person standing in full sunlight, we should use one "correct" exposure. If he is standing in front of a white house, the reflected-light meter will measure the light reflected from this dazzling bright surface, and we would underexpose the skin tones. If he were standing in front of dark green foliage and black shadows, the reflected-light meter would measure these, and he would be overexposed by one or two stops. An incident-light meter would give the same readings in both cases.

Taking close-up readings with a reflected-light meter is the most accurate method of determining exposure, but using a meter properly is an art that takes

months, if not years, to perfect. Remember that no exposure meter will tell you infallibly how to set your camera; it will only give you information on which to base an educated guess. There are less calculations and fewer chances for error with an incident-light meter, and for this reason I prefer it. Each type has provision for being converted into the other type, so the choice of one or the other is not seriously limiting. Incident meters are more sensitive and accurate than conventional reflected-light meters at low light levels, and take less practice to use effectively.

Many cameras now have built-in light meters, generally of the reflected-light type. This is very convenient, but leads to the habit of taking overall readings from the camera position—and this is far from the most accurate method. To use a built-in meter properly, the whole camera should be moved around to measure light reflected from the subject in all directions, and this can be very clumsy. Also, the working parts will be small and consequently either delicate or coarse in response. Also, if the meter breaks, the whole camera is out of commission while repairs are made. It is interesting to note that when a secondhand camera is sold, even though it is nearly new, the meter is rarely guaranteed. So keep the built-in meter, if you have one, for its convenience in casual snapshooting, but carry a separate meter in your pocket for serious work.

Carrying two meters is about four times as good as carrying one. Not only do you have a spare, but at intervals you can check one against the other. If one isn't functioning properly you'll find it out before ruining a lot of picture opportunities. If your camera does have a built-in reflected-light meter, get an incident meter to go with it. I often carry both types. In an unusual lighting situation I can check it both ways and make a better estimate of proper exposure.

Tripods should be selected with steadiness as the first consideration. For nature photography choose the lightest one *that will do a proper job of holding your camera steady*. Elevator-type tripods are very convenient for getting just the right height-of-camera with a single adjustment. The small table-top tripods are practically worthless; you may well do better using no tripod at all. If many floral pictures are planned, find a sturdy tripod that will bring the camera fairly close to the ground. A home-made "lowpod" discussed in Chapter 4 is good.

"Clampods" are handy, especially on long hikes where a tripod is simply too much to carry. These are a "C" clamp frame with a ball-and-socket tripod head built into one end. They can be clamped to a branch, fence, chairback, table, or automobile. Some have a corkscrew attachment that can be driven into any wooden support, and the clampod locked to this. Going a step further, there is the Rowi Combination Camera-Stand, which is a set of legs, connectors, tripod head, and clampod. Different bipods, tripods, and other camera supports can be made up, much like putting together a child's Erector Set. It makes the lowest ready-made camera-holder I know of and is sturdy enough to hold a Hasselblad with ease. The center of the lens will be just five inches from the

ground. Unipods and shoulder-pods are good for special purposes, and easier to carry than tripods.

A remote-control air release is a most valuable piece of equipment. It consists of a rubber bulb, vinyl tubing, and a small brass cylinder and piston that drives a standard cable release. Squeezing the bulb will set the camera off from 30 to 40 feet away; with a small bicycle-pump 100 feet or more of tubing can be used. Use vinyl instead of rubber tubing! The "stretch" of rubber tubing will cause an appreciable time-lag and many pictures will be missed. The Rowi Kagra is a compact, well-made, and dependable air release.

For close-up work, we must use extension tubes or a bellows with the single-lens reflex, and supplementary lenses with twin-lens reflexes and rangefinder cameras. These inexpensive lenses are available for nearly every camera on the market and permit photography up to life-size on the film. With supplementary lenses, sharpness usually suffers to some degree, unless they are made by the manufacturer for that particular camera. A single-lens reflex with extensions is best for close-up work. Extension tubes are rugged and inexpensive, but may be unwieldy to use. Bellows are easier to use, and a well-made one will have no "blind spots." That is, the normal lens will focus down to 18 inches; with the bellows you can focus continuously from here down to two or three inches.

Supplementary lenses are the only way to shoot close-ups with rangefinder cameras, but can be used with SLR's as well. In fact, they are the most convenient of all close-up devices, in that no exposure increase calculations are needed, and automatic lenses remain automatic. However, there will be a loss in sharpness. With a plus-2 or plus-3 supplementary lens, this is slight *if* you stop down at least three stops. A plus-1 lens has a focal length of one meter, or 39 inches. So, *with the lens set at infinity,* you will be in focus at 39 inches and can then focus closer. A plus-2 lens has a focal length of 19½ inches, a plus-3 13 inches, and so forth. Usually, with these three supplementary lenses, you can focus continuously from infinity to about ten inches with a 50mm lens. These supplementary lenses, often called "plus-lenses," are made in standard filter-series sizes and in the common screw-in sizes, too.

Filters are among a photographer's best friends, but are often neglected or mistreated. Color film simply does not "see" every scene the way the human eye does, and filters will let us correct the film's "seeing" to what we consider correct. It is false economy to buy cheap filters. They become part of the optical system when used, and a superbly sharp lens can't do anywhere near its best work when the image passes through an inferior filter. The price difference between poor and excellent filters is seldom as much as one dollar, and ruining a few color shots with a poor filter more than consumes whatever "saving" was made in the purchase. Good filters should be dyed-in-the-mass optical glass, carefully and meticulously ground and coated on both surfaces. The mounting should seat them accurately and parallel to the lens mount. Good filters should be kept in individual cases and carefully cleaned before being attached.

For good color work, the skylight filter is the most commonly used. A haze filter eliminates stray ultra-violet light, as does the skylight filter, but it does not warm up the scene as much. A polarizing filter will let the photographer darken the sky without changing any other color in a scene. It also is useful in eliminating reflections from glass cages at the zoo, or from water in scenic pictures. Conversion filters let us use daylight film indoors, and indoor film outdoors; they are invaluable when you don't shoot an entire roll in one situation before switching to the other.

Gelatine color-compensating, or "CC" filters, are very valuable for making slight adjustments in color balance. They are made two and three inches square, and are quite inexpensive. Standard conversion filters are also available in gelatine squares; convenient if you use a telephoto lens and don't have the large filters its objective would require. Gelatine filters can be mounted behind the lens.

In black-and-white work, the yellow filter is the old standby and corrects most panchromatic films so the scene appears nearly the way our eyes see it. An orange filter adds a bit more contrast and darkens skies more than the yellow. A red filter makes skies quite dark and allows the use of infrared film. Green filters are good for balancing tungsten illumination and for portraits outdoors.

For special effects there are fog filters, diffusing filters, and neutral-density filters. Judicious use of them will improve picture quality.

There are other specialized tools that, so far at least, are not commercially manufactured. One is a light-beam tripper that will take a creature's picture when it moves through the light beam. It is used with flying birds, leaping fish or frogs, and even large insects in flight. Plans for one were published in the November/December, 1956, issue of *Audubon* magazine; this was only an A.C. model. With today's electronic goodies, a competent tinkerer can work up a battery-powered model without too much difficulty, but so far as I know plans have not yet been published. Sound-activated trippers fall in the same category, but are being marketed. Keep an eye on the photographic and electronic magazines, or write in a query to see what the latest available information might be. This is an area where there is much interesting work to be done, with little money invested.

Miscellaneous gear for wildlife photography should include caps for the front *and back* of every lens you have, a changing bag for freeing jammed cameras in the field without sacrificing film, and some spare parts for the cameras. In the spare-parts department, carry anything that may be lost, dropped overboard, or broken. A spare groundglass will let you keep on shooting if the regular one is broken; otherwise there's no way to focus and frame a reflex camera accurately. Many viewing screens can be easily replaced with a jeweler's screwdriver.

On a long trip, I always like to process a roll of black-and-white film from time to time, to make sure all equipment is functioning properly. This entails carrying a developing tank and solutions, and a changing bag, unless one of the

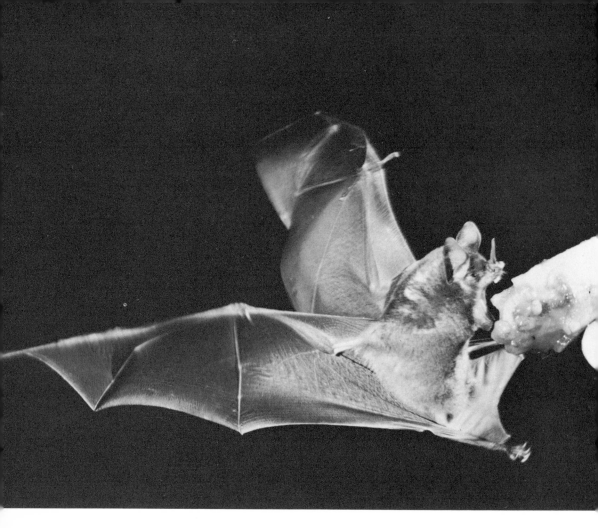

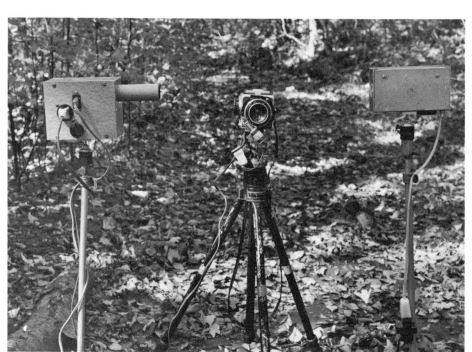

small stabilization processors is used. These one-solution gems develop a roll in a very small tank, with a minimum of fuss. All you need is some wash water! Burleigh-Brooks, Hackensack, N. J., sells the "Pixmat," which is even a daylight-loading rig.

Though film is not strictly "equipment," it's one of the most important things to consider when outfitting for wildlife photography. Personal tastes vary widely, but some films are excellent for one particular job, and may be unsuitable for others. In color, there is nothing to equal Kodachrome II for sharpness, color saturation and contrast, and fineness of "grain"—it's virtually grainless. When processed by Kodak, it is the most stable of all color emulsions and the most consistent from one batch to the next. Kodachrome II is rated at ASA 25,

Opposite, above. Picture of a bat in flight, taken with homemade electric-eye unit discussed in the text. The bat was baited in by an over-ripe banana that was held by the photographer at the right of the picture. Three strobe units were used, in near-total darkness. Hasselblad camera, 135mm lens in between-the-lens shutter. Opposite, below. The author's homemade light-beam tripper for photographing fast-moving birds and animals. The light source is on the right, projecting a narrow beam of light into the cardboard tube protruding from the main unit at the left. A knob adjusts the sensitivity to whatever conditions prevail, and the between-the-lens shutter on the Hasselblad is tripped by a 110-volt solenoid mounted just below the lens. As soon as the light beam is broken, the unit fires the shutter; the time lag is negligible. In use, strobe units illuminate the subject and stop motion, while the camera shutter simply keeps out excessive daylight. Below. A changing bag lets you take a darkroom with you wherever you go, for use in emergencies or to process film in the field. It is used here as part of the "Unikit," for one-solution processing of film almost anywhere.

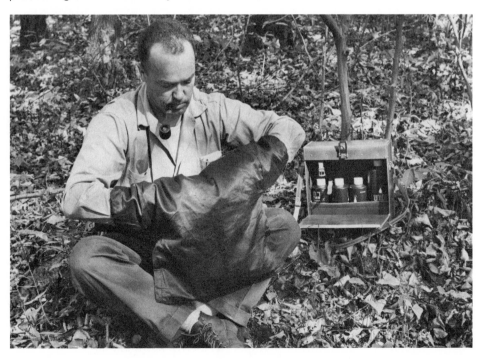

and Kodachrome-X at ASA 64. The latter is a shade more contrasty, but doesn't render blues as well as Kodachrome II. Ektachrome-X is very different compared with Kodachrome-X, even though they have the same ASA number. Ektachrome-X gives you real zingy colors and is fun to use, but it isn't quite as sharp as the Kodachromes. Ektachrome-X can be processed at home or by independent labs, but only Kodak can properly process Kodachrome. With Ektachrome-X you can double or quadruple the film speed and have the processing compensate for it. Also, Kodak offers a speed-boost service for Ektachrome-X. If you need more speed, there is High-Speed Ektachrome, rated at ASA 160. This is available in daylight and indoor types, as is Kodachrome. High-Speed Ektachrome can also be boosted to ASA 320, 400, or even higher. And the price you must pay for all this speed? High-Speed Ektachrome is softer, less sharp, and less contrasty than the others. When you "push" it to higher speeds, the contrast rises some; it becomes even less sharp and blacks may go greenish. So by now, if you are well confused seeing four different color films from the same maker, here is the way I see it. If there is plenty of light, use Kodachrome II. If you need a bit more speed, use Kodachrome-X. If you would rather have brighter colors than the ultimate in sharpness, use Ektachrome-X in preference to either Kodachrome. If you need still more speed, push Ektachrome-X to ASA 125. To get still more speed, use High-Speed Ektachrome at ASA 160, 320, or higher. Just remember: *the slower the film, the better the quality.* This is basic.

Some photographers swear by Agfachrome, Anscochrome, and several other lesser known brands. Others swear *at* them. Trying these films yourself, shooting at the same time with your "standard" color film and carefully evaluating the results, is the only way to tell if they are good for your particular type of shooting.

Occasionally photographers find themselves working under daylight and artificial light conditions in quick succession. Either daylight or tungsten film can be converted to the other type with conversion filters, but tungsten-type films are much better for this mixed shooting than daylight-type films. Some aerial photographers prefer using tungsten-type films outdoors with a filter, and a few fashion photographers as well. As a general rule, though, try to match film type and light source.

Color negative films are used where color prints on paper are wanted. The negative will also produce black-and-white prints and positive transparencies, but the quality is not as good as if color-positive or black-and-white film were used to start with. Color negative films are probably the films of the future, when technical problems have been further resolved.

There are far too many black-and-white films for the average person to test personally, and most photographers settle down with three or four that will handle almost any job that comes up. The great, universal, inescapable rule for choosing films is this: *the slower the film,* the finer the grain structure and the

sharper the image, and generally, *the better the quality*. It's tempting to sally forth with the newest and "hottest" film available—but you'll bring back better pictures if you use the slowest film that will do the job well.

A wealth of information, often ignored, lies in the technical-data sections of the excellent annual issues put out by leading photographic magazines. Details of film, developer, exposure, and filters are listed there for every picture included, and you can see at a glance what professionals and prizewinning amateurs use.

It's best to determine the ASA ratings by personal tests; your development procedures may be quite different from those of the commercial laboratory. Select the thinnest negative that will yield a quality print. Overexposure coarsens grain structure, lessens sharpness, and lowers the action-stopping abilities of strobe units. *Overexposure and fine print quality simply don't go together.*

There are some other special-effects films that are fun to use. One is infrared film, available in both black-and-white and color emulsions. The black-and-white film is used with a deep red filter for very contrasty, dramatic results or fake moonlight scenes. These films photograph by invisible infrared light; you cannot see exactly what you will get. Ektachrome Infrared Areo was designed for military aerial reconnaissance. Shoot it through a yellow or orange filter and you will get wild, wild results—like red-purple foliage. One word of warning though—watch the processing. Infrared light will pass right through many black materials, such as hard-rubber developing tanks, black darkroom curtains, and black cardboard. Use metal tanks if possible and process at night if your darkroom is not absolutely safe. You can shoot infrared film at night too, with a dark red gelatine filter over your flash unit.

I am occasionally asked what I would recommend for a person who is starting nature photography and has no equipment. Having no equipment is a good way to start! We're not trying to adapt any presently-owned cameras for wildlife work, or trying to utilize equipment that isn't quite suitable. I would recommend a 35mm single-lens reflex. (This will surprise no one who's read this far.) It should have a focal-plane shutter, an eye-level prism finder, and provision for interchangeable lenses. It should also be synchronized for strobe at least, and most cameras have a built-in self-timer. The leather case should have a detachable flap. Most pros don't use a case at all. Such cameras are available for $75 or less. All modern cameras, even less expensive ones, have thumb-lever film wind and are synchronized for both flashbulbs and electronic flash. A waist-level or angle finder is helpful when photographing flowers, but seldom used otherwise. Having interchangeable viewfinder screens is a big help with telephoto lenses—many microprisms don't work too well, and that abominable split-image rangefinder is worthless. But if you can change viewfinder screens all's well!

The very next thing on the agenda, *with no exceptions,* is an "all risk" camera insurance policy. This will cost five to ten dollars a year and is worth

five times as much. Items can be added to it as you increase your kit, without additional charge until you reach the total maximum liability of the policy. For peace-of-mind alone, it's worth it.

A good exposure meter is a must for careful and accurate work. Some models have a sliding sphere and will measure either reflected or incident light. The professional's standard is the beautifully made, but a bit expensive, Gossen Luna-Pro. However, there are many other good meters available. The next items are filters, a polarizing filter, supplementary lenses, extension tubes or bellows, a Kagra air-release, and a gadget bag big enough to hold everything with a little room to spare. Next, I would get a 200mm or 300mm telephoto lens. With just this much equipment I have turned out over 5,000 color slides of reproduction quality, many of which are still being used as book and magazine illustrations. It would take years to exhaust the photographic possibilities that this basic kit supplies.

A small strobe unit permits indoor work and action-stopping with any fast-moving creature. It should be a 50- to a 100-watt-second model with provision for A.C. and battery operation. A folding-reflector flashgun provides light when using high shutter speeds in daylight, and is good for any camera-trap work.

Now we're pretty well set. If your budget permits, get a second camera or at least camera body without lens. Then, buy a shorter telephoto, perhaps 100mm if you first bought a 200mm, or a 135mm if you first bought a 300mm. Also, you should consider a second exposure meter, one or two more electronic flash units, and any minor accessories you do not yet have. From here on the type of work planned will dictate what other equipment you will need. You may well want a longer telephoto like the Novoflex 400mm, and if much wingshooting is on the schedule get a shoulder-pod too. For insect work you will want a good bellows unit and perhaps a specialized close-up or "macro" lens, an ultra-sharp design in a close-focusing mount.

"Last, but not least" applies to this section. One piece of gear that should be carried and used each and every time you photograph is a pocket notebook. Into it should go all important details about each series of pictures you make. I cannot over-emphasize the value of keeping accurate notes—as you'll realize when you reach the last page of this book and find I've mentioned it a dozen times! There is no other way to avoid repeating mistakes, profit from testing, work out successful procedures, or repeat photographic techniques that have proven themselves in the past. Note-keeping need not be complicated; a set of abbreviations will do fine and are easily worked out. For instance, an entry in my shooting notebooks reads, "Trillium, 150w/20, inc. dir, 1-A, 1/50 f/5.6 (7), f/4.5 (8)." Translated, this means the trillium pictures were made with the 150mm lens with a 20mm extension tube. An incident meter reading was used directly, with no changes; a 1-A skylight filter was on the lens. Exposure number seven was taken at 1/50 sec. at f/5.6; number eight at 1/50 sec. at f/4.5. Another entry is, "Chuck/set #22, 6½ feet, 1/500, f/16, VPan." A camera trap

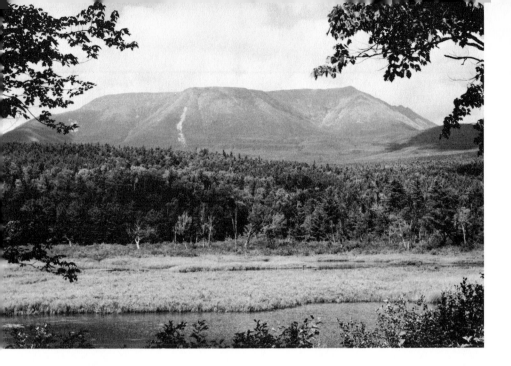

Above. Mount Katahdin, Maine, as "seen" by standard black-and-white film exposed through an orange filter. Foliage registers quite dark, clouds are indistinct and haze obscures detail of the mountain itself, about five miles distance. Below. The same scene taken a few minutes later on Gevaert Infra-Red film. The foliage is now light, water and sky are dark, and all traces of haze have disappeared. Details of the mountain itself are as clear as a close-up would be.

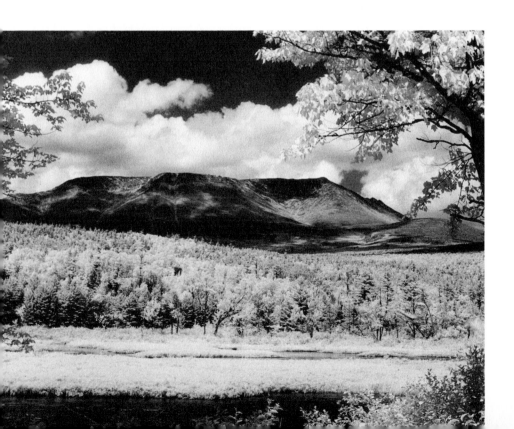

was set at a woodchuck hole. The camera was set at 1/500 sec. at $f/16$. A flash-gun was set $6\frac{1}{2}$ feet from the hole, with a #22 flashbulb, and Verichrome Pan film used.

The abbreviations used can be anything you wish; as long as you can decipher them, that's all that counts. When finished transparencies or negatives are examined, decide which exposure or filter gave the best result and transfer the information to another book for a permanent record. For this I use a pocket-sized loose-leaf notebook, with alphabet tabs. Periodically, I take the pages out and photograph them for protection in case the original book is lost. There's too much work and time between those covers to gamble on losing it all.

3
Care of Equipment

IT IS SURPRISING how many people invest in a good camera and expect it to take care of itself for years. Though they have their automobiles checked and lubricated regularly, their TV sets adjusted periodically, and their wristwatches cleaned, the poor old camera must survive months and months of neglect and is still expected to turn out prize-winning pictures. It may roast in a glove compartment, bounce around in a bureau drawer, swing on a neck strap and bang against doors and tables, get rained on and put away wet, or be exposed to blowing dust or sand without protection. No piece of precision machinery can take much of this without faltering sooner or later. The surprising thing is that modern photo equipment can stand as much abuse as it does.

A camera's best friend is its case. Even an eighth-inch of leather affords a fair amount of protection against hard knocks and will shed drops of water. However, cases leave a lot to be desired design-wise, and photographers who work rapidly seldom can use them. One of our top pros calls them "never-ready" cases; he has a point! If you use one, make sure the front flap is removable. The neck strap generally is attached to the case, so the camera has no "safety line" when it is removed. A simple improvement is to use a neck strap on the camera, if the case can be closed over it—sometimes possible, sometimes not.

The most common cause of serious damage to a camera is dropping it. Inspect the strap from time to time, especially the rings or snaps holding it to the camera. Split rings are ten times stronger than any snap made and can't accidentally come open. Get them at a hardware or fishing-tackle store.

Transportation has its dangers for equipment but they can be minimized. If a camera is the last thing into a suitcase, it is the first thing bashed when something hits the suitcase—better to wrap it in clothing or a towel and stow it in the middle somewhere.

If you have two identical cameras, cut a "1" and "2" from an old calendar and glue them to the cameras to avoid mixups. It is often possible to have a small notch filed in the film gate of one, that will print through onto the film. You can tell which camera produced any given negative or transparency, and if camera troubles occur, you can tell which camera is at fault. If you try this yourself, use a small Swedish file and be *sure* no filings fall into the camera mechanisms. Paint the notch with flat black lacquer afterwards.

Lenses are the heart of any optical or photographic system and demand a little attention from time to time. What care they need is important and consists mainly of cleaning *gently*. A modern lens is an amazing piece of workmanship. Ground to unbelievably fine tolerances, it will stand accidental hard knocks that would make us all shudder to see. Some photographers industriously scrub a lens with tissue, paper towels, or—heaven forbid!—their handkerchief or necktie, every time they open their cameras. This may be good for marble floors, but not lenses.

Clean them *when they need it* and no oftener. The most common maltreatment of lenses is to wipe them without first removing dust particles. The wiping tissue picks the dust particles up and becomes a pad of sandpaper in the process. Get that dust off first! Blow it gently, or use a camel's hair brush, but remove it *or let the cleaning go until you can.* Lenses can be safely wiped with lens tissue or a soft facial-tissue, after the dust is removed. Any non-scratchy paper tissue will do in a pinch, but may leave lint. NEVER, NEVER, NEVER go near a coated lens with any silicone-treated tissue meant for eyeglasses! The silicone combines with the fluoride coating on modern lenses to form a film that simply cannot be removed—and there goes the fine, sharp edge of definition the lensmaker worked so hard to produce.

A filter will protect the front surface of a lens nicely. Keep one on whenever working in fog, rain, or dusty places. It will also keep salt spray off optical surfaces, and is much cheaper to replace than the lens. If spots or fingerprints won't come off, use a solvent: commercial lens-cleaning fluid is the best; *pure* alcohol is a good second, and *the list of safe cleaners stops right there.*

If salt water gets on a lens or camera remove it as soon as you possibly can. When it dries on, it will have to be dissolved off with a cotton pad soaked in fresh water. Most lens mountings are fairly well sealed, but the cement may still be alcohol-soluble. Go easy with *any* liquid around a lens.

Salt air will affect the finish of aluminum lens mounts and other parts, and sometimes chrome-plated brass as well. Some photographers apply a coat of clear brushing lacquer to new equipment if they work near salt water. This is a good idea on the face of it, but the dangers involved are serious ones. If the lacquer runs into diaphragm leaves and shutter parts your camera may have clicked its last click. The lacquer coating chips off too, and the metal corrodes in the chipped spots, giving a dalmatian appearance to the whole rig. Some combat photographers used layers of cellulose tape to cover their gear. It looked

terrible at the time, but the camera was well protected and could easily be cleaned up later. Bare aluminum parts are the only ones seriously affected by occasional exposure to salt air, and it's usually easier to polish them bright again afterward. There is an ion layer deposited on all parts of a camera, inside and out, when near salt water. There's nothing to do about this except make sure all equipment is aired out and dried after each shooting session. This should be standard procedure anyhow.

The most careful worker may sooner or later dunk a camera or lens in the water. The first thought that comes to mind is: "I'm glad I have insurance," or "Oh, *why* didn't I get insurance?" The next thought should be: "Let's get that gear drained and dried *fast.*" Wind the film out immediately. It may or may not be ruined, but you don't want gelatine emulsions running into the gears in either case. If dunked in salt water, rinse the camera in fresh water. IF you can get it to a repairman within a few days, leave the camera in a bucket of water, completely submerged, and take the whole works to the repair shop. If air can't get at it, it shouldn't rust. If you are far from repair facilities, dry it out yourself. Take off everything that will come off, and dry the camera with dry air and gentle heat—a hair-dryer or just bright sunlight should do fine. While it is drying, exercise all parts continually—shutter, film wind, self-timer, slow speeds, lens diaphragms and focusing mounts, and all knobs, dials, and levers that will move. Take things apart if you must to get at entrapped water or leave that particular part soaking in fresh water. These are emergency procedures, but if you follow them immediately after a dunking, you have a good chance at least of saving your camera. If possible, take or mail the camera to a good shop promptly. Best of all is to check with the manufacturer on emergency procedures before the emergency occurs. The Minox, for example, is so rugged they recommend dipping it in hot water for a few seconds if it gets soaked in salt water. A tribute to Minox's rugged workmanship; I'd hate to try it with any other camera.

It may be safe to use alcohol as a drier-outer but only the manufacturer knows for sure. Cements, plastic parts and wire insulations can be softened or dissolved by alcohol. If it is safe for your camera, carefully swab out the inside cavities using a pipe cleaner or cotton wad on a small stick. The alcohol will mix with the water, and both will evaporate. Carrying a small bottle of alcohol can save some major repair bills. I once tumbled into a river in the Darien district of Panama carrying a Hasselblad, spare magazine, and extra lens. Two months and many miles away was the nearest qualified repairman. The dismantled outfit was given alcohol first-aid on the spot and there wasn't a single malfunction for the rest of the trip. Lucky? You bet it was. But it wasn't just luck that there was a bottle of alcohol in the tool kit.

There is always the possibility of fungus growing inside a camera or on a lens that has been submerged. Keep a sharp eye out for it, even months later. Fungus will even grow on glass, and will eat into fluoride lens coatings.

37

When mailing a camera in for repairs, there should be three inches or more of excelsior or wadded newspaper on all sides of the camera. It is more weight but well worth the additional postage. If you're going abroad, get several declaration forms from the customs office before you leave the country so you can mail a camera back and not have it sit—and rust—for days while it's being cleared through customs. Enclose a declaration form when you mail it and it should zip right through.

Meters are invaluable in determining exposure, but a few hard knocks will ruin one. Some of their parts are as finely suspended as watch staffs. Shocks are the things to avoid; dropping, of course, and hitting against things when in use. Meters come with either long or short neck-cords. The long ones will let the meter be carried in a trousers pocket; the short ones apparently designed for shirt pockets. People differ in which they prefer, and which is safest for them. I seem to have trouble carrying a meter in a pants pocket—there's always a stump, car door, canoe paddle, or doorknob to bang it against. The shirtpocket carry is fine until you bend over; then the meter can drop out and fetch up against its own cord (or a big rock!). A button-down flap on the pocket helps a lot. Some field men prefer to rivet an S-shaped steel clip to the meter case, and clip it onto a belt. The neck cord is left attached as well. It's ready for instant use but still exposed to knocks and jars.

Aside from shocks, meters are most often damaged by heat or water. The glove compartment of a closed car may well reach 140° F. on a hot day, and it is *no* place for a meter, camera, lens, or film. The rear window shelf is even worse. Most heat damage to meters comes from this cause, or well-intentioned attempts to drive moisture out of one by putting it near a radiator or stove. Storing meters in plastic bags will preserve them in case of a canoe's overturning or other unexpected dunking. Drops of water will get on a meter from time to time and usually have no ill effects. Dry it off as well as you can and look closely to see if the moisture reached the inside. Once water gets inside a meter there's no alternative to sending it in for repairs. The manufacturer is the only one who really knows how to repair a meter, and will often replace the entire "innards" at his cost. If you've been considering a new meter anyway, ask him for an estimate of repair costs first.

The zero-setting will occasionally get a bit off, and there is usually a screw to adjust it. Be sure no light reaches the cell, and hold the meter normally while you make the adjustment. Checking readings against another meter *of the same make and model* will show up any major ills it may have. Don't hold them close together; they work magnetically and may interfere with each other. Incidentally, when out with yachting friends, stay away from the binnacle! A meter set down five feet from the compass may land you in Greenland.

If a photographer were taken into an Indian tribe, his given name might well be "he-who-bulges-everywhere," or "man-who-carries-too-much." Unfortunately, few of the myriad gadgets can be left home, especially if a man works

Carrying things while still having hands free can become a problem. These accessories help. Left. Dade Thornton's quick-draw holster for a Minolta SLR with a 300mm Novoflex lens. The camera can be drawn and fired within two seconds of sighting a bird or animal. Shoemakers and hobby shops can make up leather goods like this from a rough sketch. Right. The "fanny-pouch" is a standard skiing item, but the imitation leather belt-pouch must be homemade. It folds flat for easy storage.

far from home base or automobile. He often looks like a walking camera store.

Carrying everything can be quite a problem. Like Boy-Scout equipment, everything seems to have a belt loop. This isn't a good place to hang very much. Gadget bags aren't much better, as the weight is off-center and will shift when you bend over. At best, they'll produce a very uncomfortable mailman's list to port or starboard. If the shoulder strap is long enough they can be carried comfortably, Caribbean-schoolboy style. Put the bag on like a jacket, with the strap passing in front of both shoulders and behind your neck. Then both hands are free and your balance is good. A back-pack is good for a lot of gear, and can be partitioned to hold various pieces of equipment snugly and safely. It should be fairly waterproof and have a quick-release buckle on one strap so you can shed it if you fall into rapid or dangerous water.

The handiest pouch I've ever found for miscellaneous gear is a skier's "fanny pouch" that straps around the waist and rides in back. Mine will hold 36 rolls of 120 film or its equivalent in filters, extension tubes, bellows, self-timers, and notebooks. The film supply stays cool since the pouch can be rotated from side to side to stay in the body's shadow whenever you walk or face in one direction for any length of time. The weight is supported by the long leg bones

and you hardly know it's there. The pouch also makes a handy shelf when changing film or lenses.

Belt pouches are fine if they're big enough. I found two leather pouches designed for holding big-game rifle ammunition some years ago, and I'd get a couple more if I could find them. Each pouch will hold a Hasselblad magazine, light meter, color temperature meter, or a lens of 135mm size or smaller. The pouches are heavy leather, protect the contents, and keep two items always ready for use.

The camera will ride along nicely on its neck strap, but will bounce, sway, and drop into the water if you bend down to drink. Try passing a length of elastic webbing behind your back, tying the ends together over the straps or clipping them to the straps or camera. You can take pictures without removing it.

If the camera gets uncomfortable on a hike, shift it to one side or the other, putting one arm and shoulder through the strap. Some photographers have made holster-type belt pouches so that a 35mm camera with a long telephoto lens can be slipped in and will be ready for immediate use.

When you are using lenses, filters, and accessories in quick succession, it is convenient to have several right at hand. A belt-pouch with several pockets helps a lot; sew it at home from imitation leather, sizing it to fit your own lenses. It will fold flat and easily tuck into your gadget bag. Sew a belt of the same material and use a clip-together type buckle.

For traveling, fibre cases are quite good. Each should be marked **"FRAGILE,"** and I like to add a distinguishing mark of some kind. I paint a wide yellow stripe around all suitcases, camera bags, and equipment cases. You can tell a porter to bring you all the yellow-striped pieces, and baggage handlers will often group them without being told. An energetic porter once tried to bring along a small blonde in a yellow belt too! If a case is lost or stolen, you can alert people to watch for luggage with a yellow stripe around it, and you should stand a better chance of getting it back.

Carrying cases and gadget bags may lead you to assume that everything inside is well protected. Not so! A camera may lie only a sixteenth of an inch from the hazards outside. Sears Roebuck and Co. sells foam-plastic lining by the yard that can be used to cushion equipment in the carrying case. It's good heat insulation too. You may find a fishing-tackle box to fit your gear; it is fairly waterproof, and will often float even when full. Also, consider the semi-rigid plastic boxes made for food, such as Tupperware. These have tight-fitting, press-on lids and come in lots of sizes and shapes. I have used them to hold gear when I have had to swim ashore on some bird islands. Insulated plastic picnic bags are quite good for carrying film stock, if you reinforce the handles. I have also used a war surplus aluminum box lined with half-inch foam plastic. The aluminum reflects the sun's rays nicely, and the whole box can be popped into an icebox. On long drives in hot weather, I confess I have been guilty of sneaking it into the ice-cream storage case of markets and drugstores for a few

minutes' cooling-off. With $100 worth of film inside, it's worth a little time and effort to keep the case from getting cooked. The ready-supply of film, and the exposed rolls, I keep in a flexible insulated picnic bag. This goes with me as hand baggage *everywhere*. If a week's or month's work is in a single small package, I will not let it out of my sight. The stock in the ready-supply bag is divided as to size and type. One transparent plastic bag holds 120 color, another 120 black-and-white. The same for 35mm and any cut film being used. I also keep a thermometer in the bag as a check on the storage conditions. There is room for a small changing bag, tied in a roll and protected by a plastic bag—just in case a camera jams and must be unloaded.

In buying color film stock, the safest method is to buy 20, 40, or more rolls at a time, all of the same emulsion number to eliminate possible variables in manufacture. Most large stores will set aside the order while you take one roll from that emulsion batch and test it. If it is satisfactory, pick up the rest of the order and you're assured of a dependable film supply for several weeks or months.

The main stockpile should be kept in a refrigerator, where it should be good for at least a year, or in a deepfreeze where it will keep almost indefinitely. Film takes about an hour to warm up from icebox storage when the rolls are separated and left at room temperature. *Opening the vapor-proof packaging any sooner is inviting trouble.* Moisture in the air will condense on the cold surfaces and humidity will do the rest. Film from deepfreeze storage should be allowed to warm up overnight—lay out what you think you'll need the night before the shooting. After exposure, get the film to a processor as soon as you can. Leaving a half-finished roll of color film in the camera for a number of weeks is false economy. Better to waste the last half of the roll and have the first half come out well than wait and have the whole roll only half-good. Many people let exposed color film pile up while traveling, and have it all processed when they return home. It's a risky business, and results won't be as good as if the film were processed promptly. This explains why people often find that the early shots on a vacation trip aren't as good as the later ones.

Mailing small lots of film from time to time seems to be the safest procedure. Labeling it "Film—Keep Cool" in *nice, big, un-ignorable letters* is a good idea. I prefer to send film first-class certified mail. This travels in locked mail bags and gets preferential treatment. Registered or insured mail is all right, but these cost more and I strongly doubt that you'd ever collect more than the price of raw film to replace any unprocessed rolls lost.

Generally, packages from foreign countries will pass customs easily if marked, "Exposed photographic film—no commercial value." You can have your processor or a friend scan the rolls as they are finished to spot any camera defects, consistent over-or-underexposure, or peculiar results. If your shutter is sticking or your meter is off by a stop, you'll want to know it as soon as you can and before the whole trip is over. Take a little care in packing exposed film.

A plastic "Kimac" protector keeps 35mm slides safe from finger-prints, dust, and scratches, even when carelessly handled. They are slipped over the mount after numbering and captioning.

It represents a cash outlay and a lot of time and labor; it's a shame to lose every-thing through simple neglect.

When traveling by car, it's hard to decide on the safest place for the film supply. When the car is moving, the rear seat is usually the best, if direct sun-light doesn't pour in. In a parked car, the floor in back may be the coolest spot, again assuming direct sunlight doesn't hit the film bag. Trunk, rear-window shelf, and glove compartment are among the hottest locations and film should never be left there. If you are carrying camping gear, it may be wise to wrap the film supply in a sleeping bag in the early morning before the air warms up. Placing a small thermometer in various parts of your car will show you which place is the coolest. Anytime film gets above 70° to 75° F. you'd better take steps to see it doesn't get any hotter. Eastman Kodak Company publishes a free booklet (#E-30) on the storage and care of color films; reading it may give you some good ideas.

Film is probably the most perishable material in everyday use and should be so treated. It is most susceptible to heat and humidity, especially after expo-sure and before processing. After processing, color-film dyes are fairly stable and with a minimum of care transparencies will last for years. Projecting them without a blower-cooled system is not a very good idea, nor is leaving them on a light box for hours at a stretch. I never project any films intended for repro-duction use; for lecturing, copies do fine and the originals are safe from harm.

Protecting processed film from physical damage is well worth the trouble it takes. For 35mm slides, there is a delightful little acetate cover made, called a "Kimac." It fits snugly over a mounted transparency and protects it nicely from dust and heavy-handed editors and projectionists. These sleeves can be ordered from the Kimac Company in Greenwich, Conn.

I mount 2¼" x 2¼" transparencies in heavy white paper mounts that slip

into 4" x 5" acetate Kodapak sleeves. The paper mounts can be put into a type-writer for adding numbers and caption information, and make a neat, professional-looking presentation. If you prefer black mounts or acetate sleeves without the paper mount, then the name, caption, and number can be typed onto a "Kum-Kleen" label and attached to a corner without danger of damage.

Deliver me from glass mounts! They have advantages, I admit, but if one is cracked or broken it's good-by to that picture. I'd simply rather not take the chance.

There are solutions on the market that slides can be dipped into, cardboard mount and all, that will coat the whole thing like a layer of varnish. These are very good for filling in minute scratches and may save an old favorite of yours for many more showings. They also stiffen the mounts and make projector feed mechanisms work more smoothly. This coating cannot be removed, and extreme care should be taken to keep dust, hairs, and foreign matter off the wet surface and out of the solution itself. Unless your slides are strictly for "home consumption" I wouldn't make this coating a general thing. Use it to reclaim scratched slides, but concentrate on preventative medicine in the scratching department.

Slides should be kept in dustproof files, and negatives in individual envelopes. The glassine envelopes that open along one side will accommodate either 35mm or 120 strips. Much less static electricity is produced in removing a strip from the side, compared to drawing it out of the end of an envelope.

Strobe units are like any other electrical gear in that water does them no good *at all*. Modern models are sealed, or have the component parts sealed, against normal amounts of moisture in the air and raindrops in moderation. Practically no maintenance is required except for keeping the batteries charged and not letting a youngster drive nails with it. Every month or so any strobe unit should be warmed up and allowed to stay charged for a few hours. The electrolytic capacitors gradually develop minute short-circuits within themselves when unused for long periods. This is normal and does no lasting damage, but the capacitors should be "re-formed" at least once a month. Most units have provision for operation from 110- or 220-volt main current—use this for the forming process to save the batteries. Most units can be left plugged in over-night without any damage. Vibrator circuits shouldn't be left on this long un-necessarily; if your unit uses battery power only, settle for about an hour of warm-up time. If a strobe unit should be submerged or seriously damaged, send it back to the manufacturer. The electronic parts are designed for photographic use and are not the same as those the radio repairman on the corner has in stock. Any attempts at do-it-yourself repairs are idiotic.

High-voltage dry cells should be kept in the icebox when not in use. This is worth doing; they are expensive items and their useful life can be prolonged several hundred percent. They can be used after a few hours warm-up. These cells should always be kept out of the reach of children and discarded where youngsters and animals can't get at them.

A few small camera parts and simple tools are handy to have along, especially on extended trips. Breaking the groundglass of a reflex camera means you cannot focus or compose accurately until you put in a new one. Carrying a spare puts the camera back in commission 15 minutes later, instead of after the trip is over.

Many small items, like the tripod-thread adapter, to let European cameras be used on American tripods, are easy to lose. Some cameras need an adapter to take a standard cable release. If you lose the dark slide of a Hasselblad you can't change magazines. I carry one spare in the emergency kit and another in my wallet. Lens caps disappear every so often and your lens will suffer without one. Cable releases break or rust occasionally, and strobe synchronizer cords don't last forever.

I carry an emergency kit that will take care of minor repairs and some, at least, small disasters. In it is a set of jeweler's screwdrivers, two pair of needle-nosed pliers, a bottle of denatured alcohol, some envelopes for small parts, plastic bags for rain protection, a tube of household cement, a tube of colloidal graphite, a bottle of lens cleaner, lens tissue, a spare cable release, pipe cleaners, safety pins, lens caps, rubber bands, a spare synchonizer cord, tweezers, an assortment of needles and pins, and a spool of thread. Where space permits, I add a small soldering iron, and there's always a changing bag in my film supply bag. A flat tin cigarette box safely holds spare groundglasses for single- and twin-lens reflexes, and a spare Hasselblad dark slide.

Handling cameras for a long time develops a certain touch that seldom causes any damage. There's no need to force anything on a camera. If it "won't go" there's a reason for it—you're at the end of a roll of film, or something equally simple. Reading the manufacturer's instruction booklet will save many a repair bill. Most cameras will jam if the shutter release is held down and the shutter wound. Normally, this is a hard thing to do unconsciously, but with camera-traps and remote control work, it can be done very easily.

The photographic equipment we buy today is produced by skillful technicians with years of manufacturing and designing experience. These tools will serve us well and faithfully—and we hope profitably—for years, if given a little care.

4

Plants and Flowers

OVER 40 PER CENT of the entries in a recent photography contest were of flowers! Many of these were, of course, of the cultivated varieties found in gardens or against the side of a house. They are well-known and frequently seen by almost everyone, yet they still make breathtaking and prize-winning picture subjects, both in color and black-and-white. The wildflowers are much less familiar to the public and are generally more delicate and appealing in color and form. They are easily found in season and the season is a long one; yet until recently wildflowers have been sadly neglected by most photographers.

They say fishing "gets a man out where he belongs" and that is also true of wildflower photography. The best hunting is in open woods, along little-used country roads. Of course, you may also have to climb a mountain for arctic poppies or do some swamp-sloshing, but there is seldom a lack of excellent subject material. At practically any season of the year you'll find plenty to do.

When you see certain plants in bloom, don't procrastinate. Many blossoms are in their prime only a few days and you must act quickly to photograph them. If you're after a certain species and don't have time to catch it in bloom, drive 50 miles north or to a higher elevation and chances are it will still be in prime condition. Even in winter, lichens are readily available and trees show their branching patterns better than at any other time of year. As soon as the snow starts to melt it's time to go after mosses and the early wildflowers and ferns. Spring and summer are excellent for flowers in general, and the fall ideal for the flamboyant display of deciduous trees.

Almost any camera can be used, for some flowers at least, with good results. The twin-lens reflex with supplementary lenses, or a rangefinder 35mm model with a medium telephoto lens will handle the majority of flower subjects. Even a box camera turns out good pictures when fitted with a "portrait" lens and a

If a flower does not grow in a suitable location for good photography, take it indoors! This passion-flower was kept fresh in water until it could be photographed some hours later. Hasselblad, normal lens with extension tubes, strobe exposure at *f*/16 on Panatomic-X film.

wire frame to indicate the plane of sharp focus. The single-lens reflex is near ideal; its flexibility will let you shoot the biggest sunflowers, or the small wintergreen blossoms, the latter several times life size on the film. View and press cameras are good, but slower to operate and more unwieldy. Depth of field may also be a problem, so the swings and tilts of a view camera are often very useful.

Possibly the most common phrase in the speech of an avid flower photographer is, "Blank the blankety-blank wind anyhow." It generally is a problem, and not an easy one to lick. Patience is a necessity, but not always the whole solution. Shooting early or late in the day may help—when air is quieter but the light then is poorest. Windscreens can sometimes be set up out of camera range, or a background screen be angled to do double duty. Some energetic photographers have built cellophane tents which allow them to work under practically any conditions. If you are trying to photograph a desert flower where the wind may blow every day that the flower is in bloom, there is not much else to do, short of transporting the entire plant indoors.

Indoor photography of flowers is not a bad idea, though it has some disadvantages. Results are often better than can be produced in the wild, but it should be a specialized technique used on certain occasions rather than the normal pro-

cedure. Pictures of plants taken in a studio invariably lack a certain something; calling it "mood" probably comes as close as any other description.

Close-ups of single small blossoms are best handled by placing the flower on a plain background on a table and shooting straight down on it. An enlarger baseboard and upright make an ideal camera and subject support. Many enlarger heads are attached with a standard tripod screw and the camera can be simply screwed on. It can be raised and lowered for different degrees of magnification, and locked into position. The flower is resting flat and will not wilt and droop out of focus or position. To eliminate shadows the flower can be put on a sheet of clear glass a few inches above the background paper. For scientific purposes and to show botanical structure the studio pictures are by far the best; to show a flower's habitat, the studio shot is worthless. Both techniques have their place.

Flowers selected for indoor work should be typical specimens and should be picked only when they can be transported and photographed promptly. It is also wise to check the laws of your state, as many of the rarer wildflowers are protected and cannot legally be removed. The specimen should be carefully trimmed and any bent or crushed portion of the stem cut away with a razor blade. Often digging up the whole plant, if this is permitted, is the best idea. It will keep fresh longer, you have a certain amount of its natural surroundings, and you can replant it without damage after you are through.

Standing a cut flower in a container of water will prolong its life. It is wise to support the stem with a wire brace of some sort as far up the stem as you can go without getting into camera range. Some flowers may photograph best if they are suspended upside-down, but this may produce unnatural effects and should be restricted to vine flowers or others that droop normally. Lighting should be kept low until you are ready to shoot. Focusing lamps will wilt a fine specimen in a few minutes, and photofloods in almost no time at all. Strobe is the best bet, and small flashlights can be used as modeling lamps to see what effect each strobe light will have.

Many flowers will look their best if you duplicate the effect of sunlight by using one light placed above the flower with a weak fill-in light or a white cardboard reflector to increase shadow detail. For color pictures, make sure this reflector is white! A slight tint to the reflecting surface may not be noticeable to the eye but can cause some disconcerting color changes in the transparency. By the time you discover this it may be too late in the season to reshoot.

Plants and flowers that normally grow in the shade will look most peculiar if your lighting resembles bright sunlight. Balance the lighting carefully to produce even, uniform illumination, especially in color. Shooting inside a translucent paper tent, or using bounce-lighting gives the best results.

Backgrounds can be blue paper or cloth to simulate sky, or mottled greens and browns to resemble a natural, out-of-focus setting. Be sure the main lights don't throw shadows on the background; even photographs that were obviously

made in a studio take on a jarring note if a shadow appears on the backdrop. For black-and-white work try a medium grey background. A fairly strong background light will eliminate shadows and still not produce a chalk-white background area.

The most valuable tool for flower photography is a good *low* tripod—and it may be the hardest thing to find. You will often want to work less than a foot from the ground, and precious few camera supports will sit that low. The Rowi Combination Camera Stand is a set of legs and connectors of different sizes that can be used to build a variety of tripods, bipods, and clampods. It is sturdy and well-made, and at its lowest position the center of the lens is just five inches above the ground.

Another simple device I find useful is a home-made "lowpod." It is nothing more than a ball-and-socket tripod head screwed to a piece of half-inch plywood about six inches by twelve, with some strips of thin rubber glued to the bottom to prevent slipping. Sections of wooden dowels could easily be fitted into holes drilled into the plywood to give various degrees of elevation. For any low-level work, use a waist-level viewfinder. The eye-level prism finders require a photographer to lie prone or "stand on his ear."

Using a self-timer, either built-in or accessory, will avoid vibrations that may crop up if your camera is resting on a makeshift prop. For an exposure of a second or more, hold a piece of black cardboard or a dark hat or coat in front of the lens, but not touching it. Open the shutter on the Time or Bulb setting and wait a few seconds for the camera to become absolutely still. Then whisk the

For plant photography a low tripod is essential. This can be the Rowi camera stand, shown here, or a homemade "lowpod." For maximum sharpness, place a black object in front of the lens and lock the shutter open. Vibrations will die out within a few seconds. Then, when you are ready to expose the film remove the black object from in front of the lens.

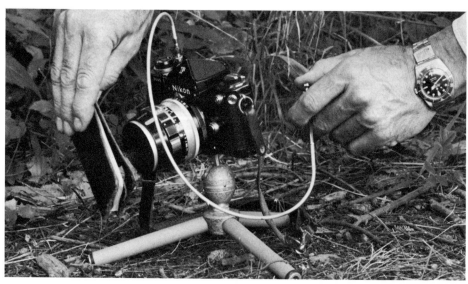

dark object, count off the exposure time, and close the shutter; this will give you a steady camera and should make for needle-sharp images—unless the perverse breeze springs up in the middle of the exposure!

A long cable release or remote-control air-release can be helpful, especially when you need to hold an intrusive branch out of the way, or manipulate a sun-shade, diffuser, or background cloth. You can also set off the camera at the instant of no wind, which must be guesswork if you use a self-timer. Make the exposure by stepping on the bulb of the air-release, leaving both hands free.

Backgrounds for small flowers can be sheets of colored paper or cardboard from an artist's supply store. Stay away from gaudy colors! Blues, browns, and greens are best for color work and various shades of grey for black-and-white. Colored cloths can also be used but may show wrinkles and will show light or shadows falling on the back. Cloths have one advantage in that they can be moved gently during a long exposure to produce a uniform, diffuse background. They can be of any closely-woven material. Black velvet is good but will pick up lint. Some of the no-iron, no-wrinkle cottons are excellent. Three or four feet square should be big enough; if your work is all in the 35mm format make it 3' x 4', or 4' x 6'. Keep background cloths wrapped around cardboard mailing tubes to avoid wrinkling. Background papers can be rolled and stored inside the tube.

Artificial backgrounds can be improved by adding blotches of darker color with a spray-paint can. If these are kept out of focus they look much like the dappled light falling on leaves or other natural objects behind the flower.

Flash or strobe can be used to good advantage and may be a necessity for proper emphasis. The lighting ratio between subject and background illumination can be controlled by the flash distance. If the subject is two feet away and the background four, the subject gets four times as much light. If the distances are eight feet and ten feet respectively, though, there is very little difference in illumination.

When shooting down on a single flower, especially a small one on a fairly long stem, try cutting a small slit in a background cloth and working the flower stem up through it. This will eliminate any distracting rocks, twigs, leaves, and other objects under the flower. If the cloth is kept out of focus it will produce a fine diffuse background against which the single blossom will stand out sharply.

Cleaning up around a wildflower is often necessary, but go easy! Pick out twigs, blades of grass, and leaves if they are distracting, but be careful not to overdo it. A spic-and-span forest floor just doesn't exist in nature and such a setting will look artificial. A small pair of sharp scissors can be useful in elim-inating small intrusive objects. You may create a plainer background by bring-ing in a flat rock or other article from nearby, if it is still in the natural habitat of the plant. Use this as a last resort; making it look right can be a tricky business.

Selective focus is a valuable technique in many types of photography, and this is no exception. In a field of daisies, for instance, you can single out one fairly isolated flower and move around it until the background and lighting seem best, then set up the camera and decide how sharp you want the flowers in the background. With a single-lens reflex this is easy. Studying the image in the finder, stop down and open up the diaphragm until you have the effect you want. With other cameras it is largely a matter of guesswork. Consulting the depth-of-field scale on the lens and using a tape measure will give you some idea of what you're getting.

Ideally, the primary subject should be the only needle-sharp thing in the picture, and the other objects sharp enough to be recognizable but not fighting for attention. It is possible to show the habitat of a flower, and how groups grow, in the background of a portrait of a single bloom. If the background competes for attention even though out of focus, try throwing a shadow on it by holding up a coat or large piece of cardboard. If the area is not too large this can be very effective, literally "putting the spotlight" on the most important object. A flashgun, strobe unit, or reflector can achieve somewhat the same result though the effect is less marked. The fill-in light must be close enough to the main subject to add light to it without increasing the light intensity of the background.

Neither black-and-white nor color film "sees" a scene the way our eyes do. Films respond to ultraviolet light we can't see, and to colors in a different way. Experimenting with filters and *keeping accurate notes* is the only way to get the effects you want.

A skylight filter is needed for many color shots of plants growing in shady areas, and may even be too "weak." An 81A or 81B filter will add still more warmth where needed. Ultraviolet filters are also useful in preventing bluish casts. Interesting effects can be produced by using color-compensating gelatine filters, with a density of 10 or 20. You can add any color to a picture for special effects.

A polarizing filter is useful when skylight is reflected from green leaves, particularly glossy ones. The blue cast may have a very nice effect and be just what you want, but you can eliminate it easily if you care to.

With black-and-white films a yellow filter is "standard," but CC filters are useful, too, since the normal filters may prove too strong. Remember the basic rule of contrast filters in black-and-white work: *a filter lightens objects of its own color*. A green filter will make foliage come out lighter in the final print. A CCR (red filter) will make a red rose register lighter than normal, and the regular "A" filter may make it chalky-white. Experience will tell you what filters will give too much contrast correction; a little effect tends to go a long way. Properly used filters will add plane separation and quality to your prints. In the studio, adding filters to the light source may give the best results.

In your gadget bag should be a small atomizer or spray gun. Spraying a fine

(A) Without any filter, yellow forsythia blossoms have a fairly natural tone, but the blue sky is washed out and registers too light. This is not the way color film or our eye would see them. (B) A yellow filter (K2) renders the sky a natural, pleasing tone, correcting most scenes to look the way the human eye interprets them. A yellow filter, however, will lighten yellow objects. Notice that the blossoms are too light and much detail is lost. (C) The effect of an orange filter is half way between a red and a yellow filter.

(D) The green filter (X1) darkens the sky, but keeps the yellow blossoms a natural tone. If there were green leaves in this photo, they would be washed out. A green filter is most often used to keep skin tones from becoming "chalky" in outdoor portraits. (E) The red filter darkens skies almost to black, which makes lighter objects stand out dramatically. (F) The polarizing filter can be used for black-and-white shooting. It offers some control of sky tones, however, it may change the tones of other subjects in the photograph as well, whether or not you want them changed.

mist of water on a flower adds tremendously to the mood of a picture and I don't consider it nature-faking one bit. You are just adding dew at an unusual time! You would see the same effect at dawn when petals are sprinkled with dew, but the light would not be as favorable. Adding dew during hours of good light is only sensible, and your results will be better, which is the end goal after all.

The atomizer is very widely used by insect photographers to make spider-webs show up in a pleasing and natural way. You may well bump into some good webs on your flower hunts—another good reason for toting an atomizer.

A piece of rubberized cloth or an old poncho is a handy item to include in the kit. In swampy areas there may be no dry place to set gear down, and a dry spot to kneel on is always welcome. Furthermore, if you are caught in a sudden shower your gear can be protected.

Color contrast runs rather high with many flowers, and in sunlight may pro-duce a screaming-color picture that is downright unpleasant. Shooting on an overcast day will help greatly; it seems to give the best results with white flow-ers, and in fact, with most white objects.

If you want to shoot a highly-saturated color in bright sunlight, try using a diffuser to soften the light falling on the subject. Cheesecloth is an old standby and can be sewn or pinned to a simple hoop as big as needed. Translucent plas-tic makes a good second choice. Unless you are after a special effect, be careful that the background is not too bright in relation to the main subject. Your dif-fuser will cut down the light somewhat.

Reflectors are another good way to lower contrast ratios in both black-and-white and color. White cardboard is good, or, for more light, try crumpled aluminum foil that has been smoothed out and glued to a flat surface. If you want to add a little warmth to the reflected light, get some gold-colored foil from a florist and glue a piece in the center of the aluminum reflector. This can be very good for portraits outdoors as well—the added warmth is very pleasing in the shadow area. In a pinch, white paper, a white coat or shirt, or even news-paper will do as a reflector. The palm of your hand will add a touch of warm light to the underside of a small flower, and a mirror will let you throw a spot of sunlight on a flower growing in a dark spot.

Whenever the subject is closer than eight times the lens' focal length, we should add to the exposure to compensate for the increased lens-film distance. Another way to put it is that the effective f/number of the lens is less than the marked f/number. In any case, we must increase our exposure, and the rules for this sometimes seem complicated. Many photographers take a healthy guess and let it go at that. There's not that much to it! The increase needed is in propor-tion to the square of the lens-film distance (before this discourages you—we'll come to an even simpler method in a minute). Using a two-inch lens four inches from the film requires four times the exposure. Lens-film distance (4″) *squared,* divided by focal length (2″) *squared,* gives us 16 divided by 4, or 4; we must

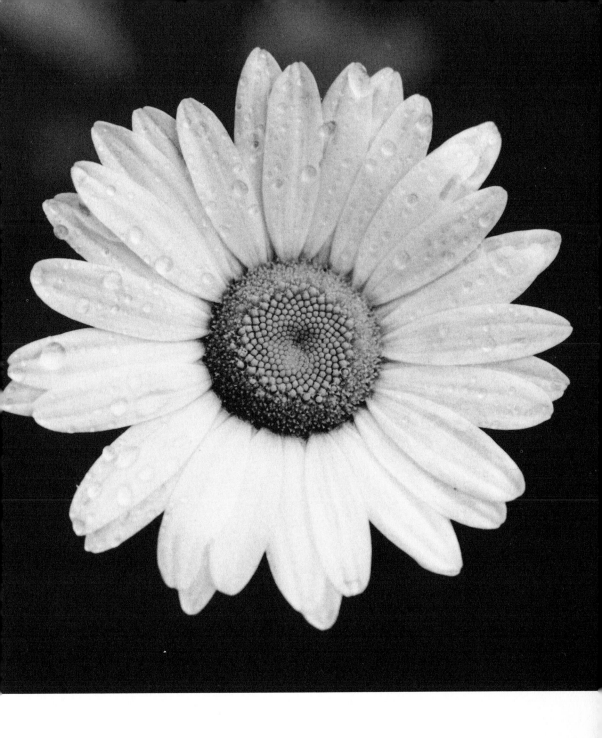

The soft light of a calm, drizzly day shows the texture of this daisy's petals much better than harsh, strong sunlight or strobe possibly could. The dewdrops here are natural; they could easily have been added with an atomizer if necessary. Hasselblad, normal lens with extension tubes, Panatomic-X film, ½ sec. at *f*/11.

Left. Shaded dark shrubbery provides a contrasty background for this head of bear grass. With a light background, this photo would have been flat and dull. Right. Overhead light, provided by an overcast sky, yields good modelling with anything as round as these horsechestnuts. It also rimlights the spikes. A 200mm telephoto lens gave a good image from a position on the ground below.

increase exposure four times. Six inches from the film, the increase is 6 *squared* divided by 2 *squared;* 36 divided by 4, or nine times.

The English system of measurement is a pretty sad affair at best, but it is most unwieldy in a case like this. Using the metric system, with all measurements in millimeters, is by far the easiest method.

Now let's look at an easier way to figure the more common cases.

Suppose we are using a 50mm lens. When it is focused at its closest distance of 20 inches (film-to-subject), we measure and find the lens has been brought forward 10mm. The 20 inches distance is more than 16 inches (8 times the focal length), so no additional exposure is necessary. We have moved the lens forward 10mm, or 1/5 of the focal length. Setting the lens on infinity and adding a 15mm extension tube, we have added 15mm to the infinity distance of the lens. With the same 15mm tube and the lens set at 20 inches on the focusing scale, we have added 15mm (tube) plus 10mm (in the lens mount), or a total of 25mm. The amount of lens-extension *added* to the normal lens-film distance; in this case half a focal length, can be used to compute the exposure increase with a minimum of work.

Additional lens extension:	Exposure increase:
¼ focal length	½ stop
⅓ focal length	¾ stop
½ focal length	1⅓ stops
⅔ focal length	1½ stops
¾ focal length	1⅔ stops
1 focal length	2 stops

Interpolation will be accurate enough for all practical purposes, and measuring is a simple matter with a small steel metric rule. The bellows can be marked

Plant and flower shooting need not be confined to the warmer months. In midwinter many more details of bark and branches are visible, including some interesting patterns. An excellent time to take pictures is just after a snow fall.

at intervals or the table engraved on an extension tube by using a machinist's pocket scriber. Incidentally, when you add one focal length the image will be life-size, the lens-film distance is two focal lengths and the lens-subject distance is also two focal lengths. This table will hold true for any focal length lens in the normal or long-focus class. Many of the "macro" lenses specially designed for close-ups will automatically compensate for this exposure increase, or at least indicate how much it should be.

Exposures for flower photography are determined in the normal manner when the subject is big enough to get an accurate reading. Incident-light meters will be misled much less by surrounding objects than the reflected-light meter, but in the case of a dark flower may lead to underexposure. Anything resembling green foliage will require about one stop more exposure than the incident-light meter shows. I feel the incident meter is the more accurate type in the greatest number of cases. Working with very small flowers, it may be the only one that will give any kind of true reading. A reflected-light type can be used if it is aimed at a white card in the subject's position, and five times the recommended exposure given. This will, in effect, measure the incident light but is prone to errors of stray light and reading the meter's shadow on the card. The incident meter is very useful with a backlighted subject and will indicate exposure without any correction. If the subject is opaque, such as a many-petalled rose blossom, you may want to shield the meter from direct back-light and expose only for the shaded side of the flower. Reasonably "open" flowers like daffodils, trilliums, or daylillies take very well to backlighting, and some beautiful effects can be achieved. Use the meter in the usual manner, pointing it toward the camera, and use the reading directly. If in doubt, give one or two stops more exposure than the front-lighted setting, depending on how much natural reflected light there is.

There is another factor that must be taken into account when working with lengthy exposures, particularly in color. This is reciprocity law failure. In short, you would expect that one unit of light exposing a film for 100 seconds would be the same as 100 units of light exposing the same film for one second; but it just doesn't work that way. With exposures over about 1/5 sec. the reciprocity law failure effect starts, but it is slight and seldom noticed. If your meter recommends an exposure of five or ten seconds you will have to increase that by a good margin or suffer underexposure. Eastman Kodak Company has studied this effect in great detail, and has prepared the table on the next page for use in computing long exposures.

If your meter recommends an exposure of 20 sec., you should use 80 sec.— a substantial increase! Hopeless underexposure would result if you didn't allow for the reciprocity law failure effect. With long exposures there will be some color shift involved, generally toward the blue or magenta. This will vary from film to film and can only be determined by tests. Try using an 85, 85-B or 85-C conversion filter. Though not designed for this use, they often prove excellent. Reciprocity law failure also occurs at the high end of the speed scale, starting to

If the calculated exposure time is between:	Multiply the exposure by:
1/5-2 sec.	1.4
2-6 sec.	2.0
6-15 sec.	2.8
15-35 sec.	4.0
35-70 sec.	5.6

become noticeable at 1/1000 sec. and up. These speeds are seldom available except when using electronic flash, and since these exposures are based on tests, you can forget about the reciprocity effect. It has affected the test shots you made the same way it will affect your "working" shots, both in sensitivity and in color shift.

Where considerable time and work have gone into composing a picture, don't be chary with the film supply. There are many things that can go awry, and for that matter, you may like a slightly over or underexposed rendition of a subject better than the "correctly" exposed shot. Bracketing exposures a half-stop or full stop in color and a full stop in black-and-white is sensible insurance that you will come back with what you went after. Bracketing should not be regarded as a technique to overcome sloppy light measurement; it is a method by which you can turn out quality work that won't have to be corrected by a darkroom man or engraver. Color transparencies for projection should be a shade darker than those for reproduction, and vice-versa, and shooting two frames a half-stop apart will satisfy both needs; also you won't have to jeopardize slides intended for reproduction by projecting them. Two cameras will let you load two types of film and choose the one most suitable for each situation, or shoot the same flower in both black-and-white and color. For shady locations I use Kodachrome. There is nothing like it where the subject or lighting is of low contrast. For reds Ektachrome seems best, and to reduce high contrast, try Anscochrome.

Shooting from several distances and angles is worthwhile, too. For some purposes you will want to show considerable background and a fairly small image of the flower; for others you will want one blossom or bud to fill the frame. Any subject worth one piece of film is worth two or three at least, and the more you shoot the better you will become—it (almost) can't fail. Keeping notes carefully is important, too! For scientific work, unless you have made an absolutely infallible identification, you may want to collect the specimen you have photographed. This, of course, can only be undertaken in remote areas and where it is legal.

Tree photographs are not hard to make and certainly deserve a place in your photographic efforts. The main problem is finding a good specimen. Farm coun-

Variation in exposure and printing can make a lot of difference in the finished picture. Underexposure (A) creates a silhouette effect, while a normal setting (B) shows details of bark and leaves. The overcast sky registers the same in both cases. A low angle was chosen to show the typical round crown of this Californian palm.

try is good hunting ground; there are often isolated specimens out in the middle of a field with nothing else around—except possibly a bull! Camera angle is the important thing in composing your picture. If you feel you are looking up too much, use a telephoto lens and back farther away. Moving just a few feet to one side or the other may hide a distracting object behind the trunk. A silhouette is good treatment for many tree subjects, and time of day is important. To do a good job you should be free to come back at whatever hour the lighting conditions will be suitable for what you are trying to accomplish.

Weather can be used to fine advantage in creating a mood—fog adds a great deal artistically and may obligingly blot out a hot-dog stand, power sub-station, or other unwanted object in the background. Snow on evergreen branches may resemble the fine and delicate brush strokes of a Japanese painting. The first buds of a willow in spring call to mind sunny days or warm showers—either can be included in a photograph to build the desired effect.

Bark patterns vary widely among different species and register best when there are no leaves on the tree and the sun is at a low angle, as in winter. Snow on the ground will give some welcome reflected light for filling in shadows, or reflectors can be used. Strobe and flash can be very useful, but may create an unnatural appearance unless carefully placed to simulate sunlight. Cross-lighting will bring out texture beautifully.

Each photographic situation should be approached with the attitude, "How can I make this picture more than just a record shot?" A creative eye, thought, and planning will result in pictures to be proud of; not an endless series of uninspired identification photographs.

5
Bird Photography

BIRDS! WITH A wingspan of ten feet, or a wingspan of five inches. Black, white, brown, and grey birds. Red, orange, yellow, green, blue, violet birds. Twenty-pounders. One-ouncers. Birds that walk on river bottoms, migrate 22,000 miles a year, navigate by sonar, dig burrows in the ground. Birds that beat their wings 200 times a second, and others once in a half-hour. No wonder people have been interested in birds since time began, and that photographers are so strongly attracted to them.

With such variations in the subjects, techniques and equipment must be as widely varied, and photographers go from below sea level to the slopes of the highest mountains. All communities have avifauna of some sort—barren deserts, ocean vastnesses, the thickest forests, and most densely populated cities. Photographing birds is one of the most challenging, rewarding, and varied types of work an outdoorsman is likely to find. There is a year-round season for the sport and no bag limit.

Most everyone has taken a picture of a bird at one time or another. The most usual response, when the picture is viewed, is, "Where did he go?" If you can find the bird at all, it is a small speck on the film. The solution is: produce a larger image. This can be done in one of two ways: by telephoto lenses, or by moving the camera closer. These are the basic techniques used in bird photography. They both have good and bad points, and they can also be used in combination.

There is nothing to match a good telephoto lens.

I give that sentence a full paragraph because it deserves it. Tele lenses have made possible more revealing, appealing, accurate, and interesting nature pictures than perhaps any other single type of equipment. Nothing can take their place. Being able to shoot wildlife from a distance, without its knowledge, or at least concern, is a tremendous advantage in any nature photography.

Telephoto lenses come in a bewildering array of focal lengths, ranging from "moderate" to "extreme." The magnification produced is in direct relationship to the focal length. If we consider a 50mm lens "normal" for a 35mm camera, a 300mm lens is six "power" and the image will be six times as large from the same distance. On a Hasselblad, where the normal lens is 80mm, the same 300mm lens has a magnification of three and three-quarter times. For bird work, assuming you have no tele equipment to start with, I would suggest a 300mm or 400mm lens; anything shorter is really inadequate. I like the Novoflex 400mm, which anyone can handhold with a little practise. It is an excellent lens, moderately priced, and with the special bellows it will focus from infinity to eight feet. It's long enough to do some real good with birds, and will focus close enough to use with small mammals, flowers, and even large insects, such as butterflies.

When wildlife photographers get together, the lament "I wish I had a longer lens" is nearly universal; very seldom do you feel yours is *too* long. However, the very long lenses are not without problems. They are heavy and awkward, and tend to wobble about considerably. But a 300mm or 400mm lens will be at least $f/5.6$, and you can shoot Kodachrome II at 1/250 sec. in good sunlight. If you have a 400mm Novoflex, you can unscrew the lens itself and screw a 640mm lens head onto the same focusing mount. This excellent feature saves buying another whole lens mount and camera adapter. Using two lens heads on one focusing mount lets you buy both long lenses for little more than the cost of just one. The 640mm is a sharp lens; it is slow, $f/9$, but you can still handhold it and shoot Kodachrome-X at 1/250 sec. in good light. Brace it against a car or tree and you can shoot at 1/125 sec. or even 1/60 sec. on cloudy days or when your subject is in the shade.

Conventional lenses longer than 600mm or so are so fraught with problems that few photographers use them. Instead, they switch to *catadioptric* ("mirror") lenses or small telescopes. Many "spotting scopes" have camera adapters and will throw a fairly good image, but they are slow—$f/16$ or less. There are a number of 500mm mirror lenses priced from $100 up that are surprisingly good. They are *mathematically* $f/8$ lenses, but in practise they are usually $f/11$ to $f/16$. Test before you buy! The catadioptric system reaches its peak with the superb Questar telescope. This gem is sharper than is theoretically possible! With a camera attached, it will give you effective focal lengths from 1077mm to 50 *feet!*

Vibration is the major problem when you use any extremely long focal length optic. The image may be there, but getting it onto the film properly takes work. It can be a problem with the Questar too—but not like using a 50-foot lens barrel!

Most bird photography is either telephoto work, remote-control, or both. Even working in a blind ten feet from a nest you will need a telephoto lens to get a fair-sized image of small birds. You will have to be closer than ten feet to get a frame-filling warbler, even with a 300mm lens! The tele lens is a necessity for any photography attempted without a blind or remotely-controlled camera.

These flying geese were shot with a motorized Praktina. This is the last shot in a series; the wingbeats came to this perfect synchronization only after the birds had flown about 200 feet, during which time the camera followed them and took a number of pictures. Plus-X film, 300mm Kilfitt lens, 1/500 sec. at f/11.

A slow, cautious approach paid off handsomely in stalking this mourning dove. He was finally photographed at a distance of 15 feet; it is obvious from his posture that he has not yet become alarmed. Praktina camera, 300mm Kilfitt lens, Panatomic-X film, 1/200 sec. at f/8 in early morning light.

Above. The alert posture, erect tail, and beady-eyed stare of a roadrunner make a typical pose—but he doesn't hold it long! You must be ready to catch it and quick on the shutter. Below. A long lens outfit for serious wingshooting. The 640mm Novoflex lens is attached to a Nikon F with an electronic motor for rapid-sequence shooting and a shoulder pod for holding the camera steady. By pressing a micro switch, four shots a second are possible.

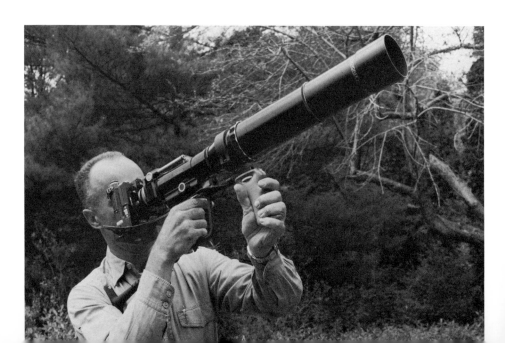

There are times and situations where you can walk slowly along and expect to get some pictures of birds, but they are unfortunately few in number. Birds near an active nest may stick close enough as you approach to make things interesting, and in sanctuaries and parks wild birds may be tame enough to let you shoot away at will. Some exceptional areas, like Anhinga Trail in the Everglades National Park, allow photography of ten or more species of birds with either the normal lens or one of about twice this focal length. You may even have to back up to include the whole bird!

Prowling around slowly and quietly is worth a try in any area. If you hit the right time of day and can arouse more curiosity than fear, you may get some excellent results under completely natural conditions. I once approached a mourning dove during the hunting season in an area where they were regularly shot at, and after ten minutes was only 15 feet away. The 300mm lens gave me a fine full-frame image. When trying this, take several shots as you approach. This guarantees having something to show for your labors. If a bit of fill-in light is desired to eliminate harsh shadows, mount a small strobe or fan-flash type of flashgun on your camera. If the light is too strong use smaller bulbs or leave the reflector folded. The "catch-light" in the eye alone will add a lot of snap to many pictures.

An automobile can be used as a rolling blind if you keep reasonably still inside it. Many birds perched on fenceposts or wires will hold until you get stopped and have time for at least one shot. Gulls, hawks, eagles, and vultures frequent roads and bridges, and may ride air currents rising from a road or wind deflected upwards by a bridge. Flight shots can be made from a convertible with ease (assuming someone else is driving). On a decent road surface the camera will be steady enough to shoot at 1/125 sec. or even 1/100 sec. if your hand is extra steady. Don't let any part of your upper body touch any part of the car's framework or vibrations will be transmitted to the camera.

"Wingshooting" of a bird in flight is an art, and practise will improve the results. Following through is important; a steady swing, *continued after the shutter is released,* makes for sharp images. Keep the shutter speed as high as you can, light conditions permitting, and don't worry too much about depth of field. An image sharply in focus will still be worthless if it is badly blurred by subject motion. Medium speed black-and-white film allows shutter speeds of 1/250 sec. to 1/1000 sec. under most daytime conditions. A yellow filter makes the sky tone register pleasingly unless there is a solid cloud cover and no blue evident.

With Kodachrome II in bright sunlight you can shoot at 1/250 sec. at $f/5.6$. If you have a 200mm $f/4$ tele lens, you can shoot at 1/500 sec. at $f/4$. With the 640mm $f/9$ Novoflex it would have to be 1/125 sec., and this is a mite slow. It is better to switch to Kodachrome-X, with twice the speed, and shoot at 1/250 sec. To my eye, Kodachrome-X renders blue sky as a grayish-blue, and other things being equal I prefer to use Kodachrome II. Ektachrome-X gives beautiful

Left, above. Petrel in flight was photographed from bridge wing of a Navy icebreaker in the Antarctic. This is one of the few occasions where an individual flying bird can be shot with a normal lens; he was riding the updraft along the ship's side and came quite close. View from underneath shows pattern detail in wings nicely. Canonflex, 50mm lens, 1/250 sec. at f/4 on Adox KB-17 film. Left, below. Just standing in the water, this wood stork would have looked ordinary. But if you are fast with your camera and always alert, you can take action-filled pictures. Above. Birds flying overhead to look you over make very good photographs. I was near the nest of this grey-backed tern and it flew in very close. Food tossed into the air will also attract gulls and terns.

blues, but is not as sharp a film as the Kodachromes. However, its speed can be doubled in processing, which is quite an advantage. Super-speed color films are seldom needed unless the weather is terrible. Some sort of shoulder-pod is a great help in wingshooting. Most lens manufacturers also supply shoulder-pods, and some fold up to pocket size. A homemade one, sawed out of a one inch plank, will work fine. Shape it like a gunstock.

Any camera without an eye-level prism finder may prove troublesome in wingshooting with a telephoto lens. The image on a waist-level finder's ground-glass moves in the *opposite* direction to the subject's motion. If the bird moves to the left in the finder, you must swing the camera to the *right* to keep up with him. This is against all of our "visual instincts," and if you can track a bird this way, focus as you swing, and shoot successfully, you're a better man than I am.

A hunter-turned-photographer has an advantage in having trained himself to follow through on a moving bird, but he will find himself unconsciously leading the bird as he would with a gun. The result is a nice picture of sky, with the bird's head just coming into one side of the frame!

With practice, focus can be changed as you track a slow-flying bird, but the best rule is to preset the focus where you think he will be, pick him up in the finder and follow him as he comes closer. Just as he gets sharp, or a split-second before, press the shutter release. The timing will depend on your reaction time and that of the camera. This preset distance will vary, but waterfowl will usually be nicely framed at 60–80 feet—if they ever do come that close. Remember diving ducks will always take off into the wind; they will come right toward you if you're in the right place.

If you notice shorebirds flying regularly a constant distance from shore, or over a certain spot, get into position, focus, and wait. Often they will skirt a pier or other projection as they trade along the shoreline, and come closer here than at other places. With gulls and terns you can have an assistant throw bits of bread or fish into the air and shoot while birds are swooping or hovering over your head. Excellent pictures can often be made with a normal lens, rangefinder camera, or twin-lens reflex with sports finder.

Presetting the focus and shooting at 1/250 sec. will give enough depth of field to produce a good ratio of sharp pictures. It may help to have someone else estimate how far above your head the birds are flying. It's hard to tell from camera position.

Motorized cameras are wonderful for working with flying birds. The noise is no disadvantage and you can shoot several members of a flock as they come into focus one after the other, or get several shots of the same bird before he moves too far away.

You can locate good spots to shoot from by watching the birds as they fly from resting to feeding areas at certain times of day, or watching where they go when they leave their regular perches. You can conceal yourself along natural flyways by wearing drab clothing and *keeping still,* without using a blind. It is amazing how far away a bird who has had his tail-feathers riddled with #6 shot can detect the slightest motion! Birds can sometimes be herded into a good location, whether you use a blind or not, by having an assistant walk slowly toward them from the far side. This maneuver works well with shorebirds, and you know that they will pass close to the water's edge in front of you. You can prefocus on the six-inch strip of sand at the very edge of the beach and be confident that's about where they will come. The procedure can be repeated any number of times until the photographer, the assistant, or the birds decide they've had enough.

If there's any dredging going on in your vicinity, plan to give it a look-see. The exhaust end of a suction dredge will spew forth all sorts of shellfish and food items and rapidly becomes a popular cafeteria for many kinds of birds.

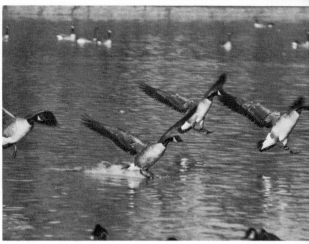

A rapid-sequence camera is extremely useful in photographing any moving bird or animal. Only one or possibly two shots could have been made with a hand-wound camera.

The Canada geese landing on a pond were shot with a Praktina and spring-motor, 300mm Kilfitt lens, on Plus-X, 1/500 sec. at f/8.

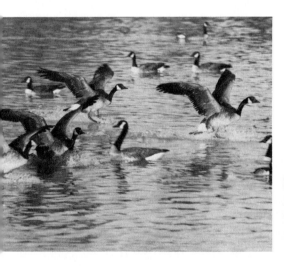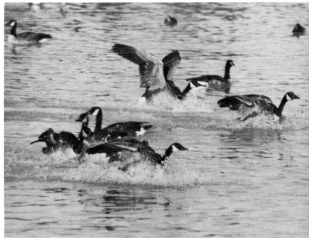

They will sometimes be quite tame. The city dump can be a good spot—for flight shots at least: the ground is seldom pictorially pleasing! Federal and state wildfowl refuges, sanctuaries, parks, and the brushy areas of zoos are all good birding spots. An unbelievable amount of useful information has been compressed between the covers of Olin Sewall Pettingill's *A Guide to Bird-Finding,* published by Oxford University Press. These two volumes (one for the eastern United States, the other, western) contain extremely detailed descriptions of productive areas and accurate directions for reaching them. The states are treated separately, and no matter where you find yourself you can pinpoint any number of worthwhile spots nearby. Long trips can be planned to include the best birding grounds, and to hit them at a good time of day.

Finding birds' nests is not the magic it may seem at first. Reference books will tell you what type of terrain a given species will choose, and how high off the ground you should look. *The Audubon Guides,* by Richard H. Pough and Don Eckleberry, published by Doubleday & Company, are excellent. Scanning suitable areas—moist and brushy grounds for one, open gravel bars for another —will reveal the spots of greatest activity. Watching through binoculars from a little distance generally reveals the adult birds making frequent trips to one spot

Nothing could be more typical of a great blue heron than this neck-stretching, bright-eyed, alert pose. The photographer approached slowly across a beach, trying to look nonchalant and harmless. A 200mm lens was used, fairly wide open, to throw the background out of focus.

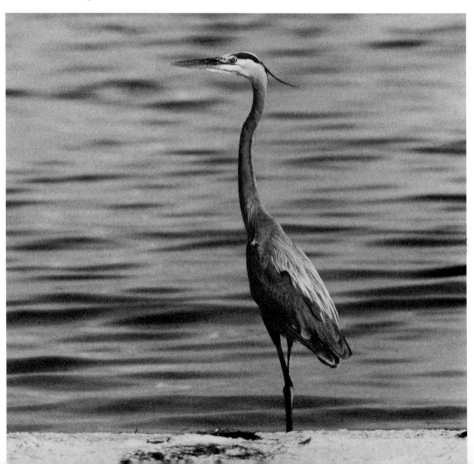

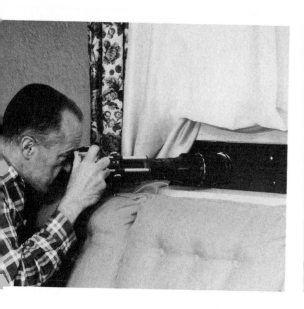 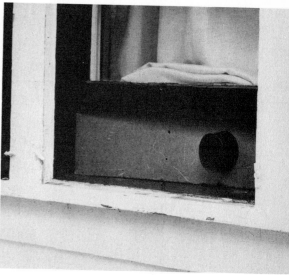

Using a house as a shooting-blind is very effective. For a temporary setup, cut a piece of plywood or heavy cardboard to fit snugly into an open window. Cut a hole for the telephoto lens and a smaller peephole for viewing. You can take picture after picture, if you are quiet, without disturbing a feeding bird.

If you own your own home, you can cut permanent camera ports through the wall in any suitable location. A hinged piece of wall seals weather out when you are not photographing.

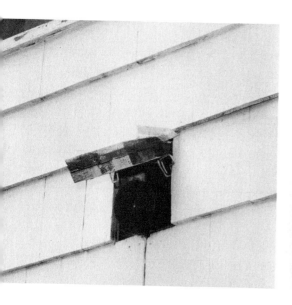 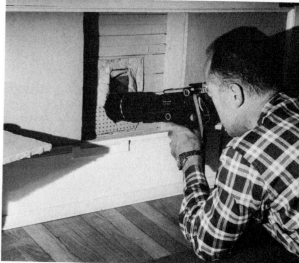

—and there you have it! Even furtive birds who walk to a concealed nest on the ground will give themselves away if you watch carefully enough or can startle them into sudden flight by a rapid approach. An automobile rear-view mirror on a broomstick will let you peer into high nests to check on the progress of eggs or nestlings. Spotting the previous year's nests in winter will reveal any particularly popular areas.

Blinds will let you work practically within arm's reach of nestling or feeding birds without alarming them unduly. Any sort of structure will do if it conceals the photographer and is not so large it scares birds away. In the past great pains have been taken to construct dummy trees, stumps, and even livestock! This is unnecessary labor; concealment, rather than imitation, is what to work toward. The old standby is burlap, sewn into a tent or strung up on poles ten feet or so from a nest. Burlap is all right but produces lint and even a double thickness will transmit enough light to show you in silhouette within. Your movements must be slow and cautious. The size will vary from case to case, but three feet square and four feet high is a good average. For higher nests, make it six or seven feet high and work from a standing position. A slit in the side will allow you to stick the lens through (before the birds are nearby) and with the camera on a tripod you can wait and watch through a peephole. By all means allow yourself some comforts! A stool and enough elbow room in a blind will avoid involuntary motions and result in more and better results. Insect repellent, a canteen of water, warm clothes or even a sleeping-bag in cold weather, should be included. If the birds seem overly suspicious, weave branches or bunches of grass into the burlap to disguise the blind further. The important thing is to change the *form* of a human being. This form is what alarms birds more than anything except maybe flapping cloth. Sometimes the birds will become so trusting that they pay no attention to the blind and don't look alert enough. A slight noise may perk them up, and if this fails try wiggling a finger at them through the peephole!

There may be little choice in placing your blind, but consider the direction of the sunlight and the background if you can. Some guy ropes are good insurance against wind damage in an exposed spot.

Some blinds must be put 50 or 75 feet above the ground to get near a nest, and this entails more time and effort than most people can devote to it. High blinds can be built in the same tree as the nest, or in an adjoining one. They can also be built from the ground up, as a framework of steel pipe or aluminum tubing with the blind on top. A large coat or sack filled with brush can be lowered after the photographer is in the blind, to make the birds think everyone has left. There is certainly a strong case here for the remotely-controlled camera that will reset itself. True, controls can't be changed to accommodate changing light conditions, but there is much less strain on the avian peace-of-mind, less equipment, and less time involved in working this way.

Above. With slow moving birds, wait for the best angle before you begin to shoot. The primary feathers of this turkey vulture are nicely separated, and even the opening in the upper mandible shows. Shooting in soft light on a cloudy day helps avoid silhouetting. Below. Close-up shots of gulls in flight are not as easy to obtain as you think. A red filter was used to darken the sky for dramatic effects; gulls were lured in by throwing pieces of bread into the air. A 105mm lens allowed the rapid focusing necessary and gave a sufficiently large image. Plan to use a lot of film for this type of shooting; out of 50 shots, at least one should be excellent.

A very efficient blind made from a "Pop-Tent" designed for use as a duck-hunting blind. Extra zippers were put in to provide peepholes and allow a variety of camera positions.

Some excellent work has been done in tern colonies with no more cover than a few yards of burlap tacked to a four-foot stick and tied across a man's shoulders. The burlap will completely cover a photographer lying prone and the birds will return to their nests a few minutes after he has gotten into position. There is a tremendous amount of variation among birds, however. Terns will even tolerate a six-foot-high tent ten feet away from the nest, but a condor won't stand for a human's presence within a half-mile of the nest site. Many birds won't return to the nest until they see a person leave the blind. Two people can walk up to it and one go inside, but if one person leaves they generally assume everything is all right and will come back. Many times it will be necessary to build a blind slowly, over a period of several days, so the birds will gradually become accustomed to it. It may also be built full size at some distance and moved a bit closer each day until it is in position. Some recent developments in tents hold promise for interesting blind work. The Draw-Tite tent, for example, can be set up in three minutes and moved around freely after it is erected. Some of the small "pop-up" tents for children should be good also, if they are available in dark colors or can be painted or dyed.

Blinds should be guyed against wind, especially so if they are to be left for some time. Blinds do, unfortunately, attract the attention of such creatures as dogs, cats, cows, and people. Cattle will investigate a blind and may try to scratch themselves on it. This does no good whatsoever to the blind, the camera,

the nesting bird, or the photographer. Stringing barbed wire around the blind *and the nest,* or picking a different location, is the only course of action. People may leave you alone if you put up a sign saying, "Photographer's blind—please stay away;" but more often you will meet the curious ones eyeball-to-eyeball through the peephole.

Using a tent as a blind can be a godsend if an unexpected shower comes along. You can't do much in a burlap blind but sit and get wet. If you suddenly appear out of the blind the sitting bird may panic and the eggs or fledglings are left at the mercy of the rain. She may even stay away as long as the blind remains there. To leave the blind when you are through, you should wait until both birds are away feeding, or make some noise until they leave; then pack up quickly and go. The best procedure is to have an assistant approach the blind on a prearranged signal and then both of you can leave. Occasionally you can slip out of the back of a blind and crawl away undetected, keeping the blind between you and the nest. It all depends on the terrain, the temperament of the bird, and if the other parent is watching. You should leave the blind before it gets too late. The light will be fading anyway and you shouldn't leave the nest unoccupied too long in cool evening air. You may have to tie back branches to get a clear view of the nest. If you do, release them when you leave—they are important to conceal and protect the nest and its occupants. If the nest is on a

A bit of action will improve almost every bird photograph. These mute swans were observed having a slight disagreement and the photographer was close enough to photograph it. The 1/1000 sec. shutter speed was needed to stop wing motion. The lighting angle could not be controlled. Fortunately, however, it produced good modelling.

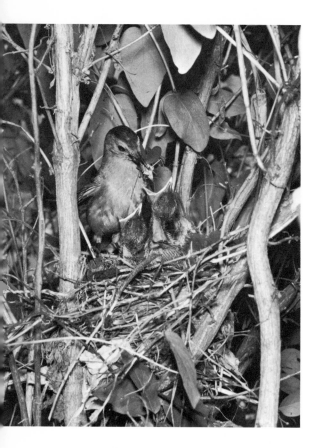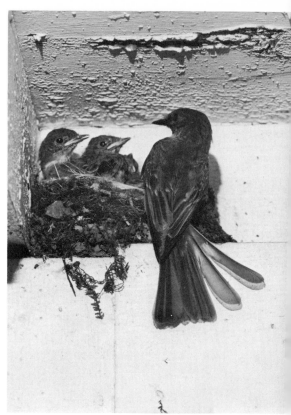

Birds usually nest in a fairly inaccessible place. This may restrict the possible camera angles and demand flash. Left. The catbird's nest was built in the middle of a thick bush. Even with branches tied back, sunlight could not penetrate. A strobe unit just above the camera supplied light and stopped motion. Hasselblad, 300mm Kilfitt lens with extension tube, Plus-X film exposed at f/11. Right. This phoebe's nest under a porch was photographable only from this angle.

limber branch you may tie the branch to solid supports on both sides—these guys need not be removed until you are through working. It's a good idea to leave a tin can or bottle sticking out of the blind as a dummy lens whenever you leave, so the birds can get used to it. As a rule, the best time to start work at a nest is just after the young have hatched. Feedings are frequent and the parents tend to stick closer than they may at other times. This does not hold true for ducks and some shorebirds who run practically as soon as they hatch! Then you must be on hand at the right moment or miss the picture.

All possible precautions should be taken to assure the safety of the young birds when working near a nest. Nature photography is a fine sport, a fascinating occupation, and a valuable method of study. It defeats its own purpose if the wildlife studied is destroyed in the process. If there is any chance the nestlings will suffer due to your activities it's better to pass up that nest or species. You'll live without the pictures: the birds may not if you get them.

Photography should be avoided during the heat of midday. A very few minutes' exposure to broiling sun is enough to ruin a clutch of eggs or kill naked fledglings. The nest site should be disturbed as little as possible. Branches should be tied back if necessary and not be broken off. Cutting or trimming should be kept to a minimum.

A bit of prudence is indicated not only for the birds' welfare but for the photographer's also. Aside from the obvious falling-out-of-tree perils, remember that some birds will not hesitate to attack an intruder and can cause serious injuries. Terns and jays will peck an unprotected head, and one world-famous photographer lost an eye while working with owls. Go slowly and give up the project if there's danger to *either* party involved.

Light conditions at a nest may not be, and often aren't, the best for photography. One or two strobe units are excellent, and flashguns can be used, but you will disturb the birds with each shot. It's best to wait a few minutes before reaching out to change bulbs—this causes less alarm. If you can keep the power pack of a strobe unit inside the blind you can turn it on and off at will. Sometimes a micro-switch can be put into the circuit and operated by a string or a relay from a distance. High-voltage dry cell strobe units can be left on for considerable periods of time without causing undue battery drain. The high-voltage strobe is good for remote-control work at a nest for this reason. You can set up the camera and strobe and retire to watch through binoculars until the time is ripe for the shot. With an ultra-long lens you can operate the camera manually from some distance, using the strobe unit close to the nest as a light source.

Remote control of a camera is easy with an air-operated release that screws into the cable-release socket. The handy Rowi "Kagra" unit is good to 100 feet or more. Each unit is supplied with 30–50 feet of tubing. For the longer distances use a small bicycle pump instead of the rubber bulb supplied. As I have mentioned before, *stay away from rubber tubing;* the stretch will cause an appreciable delay, and in long lengths the camera may not fire at all.

Electric remote releases use a solenoid to set off the shutter, a battery for power, and a push-button as a switch. A relay should be added for long distances. The action is almost instantaneous, but solenoids are hard to come by for most cameras. I use a Guardian #11 solenoid, designed for a six-volt intermittent operation, which pushes a cable release. A battery-powered solenoid has a limited amount of "push"; whereas the Kagra trips my Hasselblad easily, I've never found a solenoid that will.

Another ingenious tripping device is one that sets off camera and strobe units when a flying bird passes through a beam of light. It is impossible for human reactions to catch a bird in the right spot except occasionally through sheer luck. The electric-eye tripper does so easily and repeatedly. Such a device is fairly easy to build and quite inexpensive. Plans and descriptions of one were published long ago in *Audubon* magazine; an electronics buff could design and build a more modern one.

Press cameras and some others may be simplicity itself to set off from a distance by tying a thin black thread to the shutter-release lever. The thread should be led through a relatively friction-free fairlead under the shutter and back to your wait-and-watch spot. Wind may trip the shutter prematurely or the bird may catch the motion of a tightening thread, but on the whole it will work.

The big disadvantage of a remotely operated camera is that you must go to it to rewind it for each exposure, and some time goes by before the birds calm down and come back to the nest. A camera that will reset itself is the obvious answer for making a series of nest studies without disturbing the parent birds unduly. There are at least ten cameras now that are motor-operated. Most have small battery-driven motor attachments that fit the standard model of the camera; others offer a motorized camera body that all the regular lenses will fit.

The Robot is a rangefinder camera with a built-in spring motor that has been around for years and always seems to work; however, it has never become very popular. All electric motors are fairly "touchy" and may quit working from time to time. Sometimes this is due to dirty contacts, weak batteries, or a loose wire; other times a costly repair is needed. If you do get a motor drive, treat it *carefully!* The motor is most useful in nest and feeder work, and just great for wingshooting. Most models will fire off three shots a second. Model airplane radio controls can be adapted to operate a motorized camera from a distance without wires.

Remotely controlled cameras are put to good use at bird feeders, especially if near a dwelling where a person can keep one eye on the feeder while doing other tasks. Some good photographic opportunities will be missed, but you can get some pictures when time is limited. The tubing or wire can be led through a partly opened window, and any amount of control is possible in building the feeder and a background. You may be better off for strobe work if you put the feeder in the shade. All reflex cameras capable of taking long tele lenses have focal-plane shutters and the highest speed that can be used with strobe is 1/50 or 1/60 sec. In sunlight this will form a blurred "ghost image" around the sharp strobe image. In shaded areas the light is too dim to cause ghost-image trouble. By using slow speeds in near-darkness, the subject will be lighted only by the strobe and will be wire-sharp.

Artificial backgrounds are necessary for well-balanced lighting. If the sun controls the brightness of a natural background some of your shots will look like nighttime exposures and others may have a burned-out background. The double-image problem will crop up too. A cardboard background, blue, green, or grey will do nicely; or if you're artistically inclined, try painting an out-of-focus woodland scene or anything else suitable. Keeping the lights high or to one side you should be able to avoid shadows. Feeders can be set up behind a barn or small out-building and a hole drilled in the wall to shoot through. The whole building is thus used as a blind and can be entered quietly from the back without alarming feeding birds.

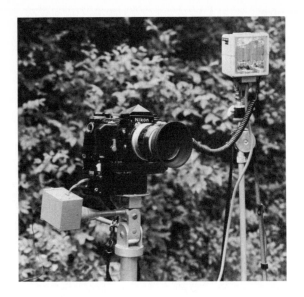

A camera with an electric drive is excellent for nest photography or any other remote-control application. It will take a picture and rewind itself within a second or less. A long wire and push-button can be used to trip it, or a model airplane radio control as shown here.

A bit of care in constructing feeders will pay off handsomely in the quality of the result. Generally you will not want the feeder to look like a feeder. A food tray can be made with a branch or slab of bark along the front edge to disguise it. Better still, the food can be put into small containers, tacked to the back of a branch, out of camera range. Typewriter-ribbon cans, cellulose tape cans, and jar lids are ideal. The bird will have his back to the camera but often will give you a fine head profile as he eyes the camera suspiciously. To get a front view, set up a stick as a convenient perch just above the feeder, and focus on that. Birds will almost always light there to survey the scene before starting to feed. These perches should be changed *frequently* to give variety to your pictures. The same goes for backgrounds behind a feeder. Another trick to use with many birds is to get a branch two or three inches in diameter, drill some half-inch holes in the sides and even the bottom, and fill these with suet, peanut butter, or other foods. Woodpeckers, nuthatches, chickadees, and titmice will perch in profile, showing details of tail-propping, feet, and plumage to best advantage, and the bait will not show. You may well get some unusual behavior, such as chickadees hovering like hummingbirds as they feed from the underside of the branch.

Camera gear shouldn't be set up until birds are using a feeder regularly. A dummy camera can be left up between shooting sessions to condition the visitors to the sight of a camera. A wooden box with a hole cut in it for the lens can be erected permanently near a feeder. The box becomes a permanent part of the landscape, and when the camera is inserted no new or suspicious objects are visible; the birds should approach confidently. Shiny parts are concealed and the gear is protected from both sun and rain. For a permanent setup, the photographer can plant certain flowers, bushes, and trees that will assure a steady flow

77

of avian gourmets—or gourmands. Tony Soper's *The Bird Table Book* published by David & Charles, Ltd., Dawlish, Devon, England, is a delightful compilation of most useful information about birds, nests, feeders, and foods. Foods will vary with the species. Chicken feed and commercial wild-bird food sold in markets will draw the seed-eaters. For insectivores try hamburger. Grapes, cherries, raisins and half-oranges entice the fruit-eaters. Peanuts and peanut butter will be welcomed by jays and grackles—and often squirrels and chipmunks! "Bee balm" flowers

Above. A cellulose-tape can tacked to the back side of a log holds bait for birds and does not show from camera position. An air release sets off the camera from 30 or 40 feet away. Below. Photographing birds on a feeder is an easy and popular technique that requires a minimum of equipment. A tufted titmouse at a suet feeder was photographed with a tripod-mounted camera, set off with a Kagra air release from 30 feet away.

and half-oranges attract hummingbirds. Small glass-bottle feeders filled with a sugar syrup and suspended near flowers are popular with these tiny birds, though they may not discover them for some time. Corn is a favorite food of crows, ducks, and pheasants. Sunflower seeds appeal to many of the garden songbirds.

Keeping squirrels off the feeder can be a real problem. They will leap and wire-walk a surprising distance and can climb all sorts of supports. Try using a piece of glass waterpipe, which plumbers stock, as a feeder support. This is one thing they can't climb!

Your feeder's offerings may be ignored when natural food is plentiful. Geese feeding on corn, ducks on wild rice, or chickadees dining on pine seeds can hardly be enticed away, though they may flock to your feeder later on in the season. Brush heaps and hedgerows provide shelter in winter and protected nest sites. They also give birds access to gravel in the winter. Food is not enough at these times, and birds must find sand or gravel to survive.

Remember, also, that a plentiful supply of food may entice birds into staying north in the fall when they would normally migrate south. *If feeding is done in the autumn it must be continued throughout the winter months.* To stop supplying food would seal the doom of the very birds you have attracted. A birdbath is another drawing-card. A small pool is better, and dripping water better yet. This proves to be a *most* popular spot, and offers all sorts of photographic opportunities. Pools can be made to look quite natural and you can include any props you desire.

Some purists would be horrified at the idea of photographing a bird that had been attracted to bait of any kind. To them, bird photography is a very pure sport and such tactics just aren't cricket. However, if your aim is to produce the best possible pictures, crisp, clear, well-lighted close-ups where all details show to the best possible advantage, any reasonable methods are not only acceptable but may be downright necessary. The end result is the important thing in this case, as long as you admit how the picture was obtained. Be careful, however, not to arrange an unnatural photograph. For instance, crossbills and pine siskins would not normally be found in a flower garden.

A bit of ingenuity and effort will lift your photographs out of the ordinary. The age of the photographic bird portrait is past; editors and viewers want action, behavior, and variety in the pictures. Six pictures of different birds on the same perch against the same background look static and hold little appeal, as does a row of pictures of sitting birds, like cups on a shelf.

There is little excuse for not turning out interesting, high-quality work with the tools and supplies now available. Photography should be a story-telling art, and creative imagination combined with technical excellence should be the goal.

6

Mammal Photography

MAMMAL photography is probably the biggest challenge to a field man. The photographer must cope with a subject that is smarter than he is in many ways, and has highly developed senses of sight, hearing, and smell.

Wild mammals must in many areas be furtive, suspicious, and cunning to stay alive, and cannot be baited in as easily as many birds. A catspaw of wind may spook an animal several hundred yards away from the photographer, and the animal will take off for parts unknown before being seen. Hunters especially will realize how very much harder it is to bag game on film than with a rifle; but the rewards are proportionally greater. To stay healthy in hunting areas, game animals must see to it that man doesn't get close enough to them to get a clear view; which is just the situation we try for in photography.

Areas where hunting is not permitted are the most rewarding for mammal photography. State parks, wildlife preserves, or really remote areas are the best to try. You still must work hard, improvise equipment in some cases, and have a good supply of patience and luck. There is a certain element of danger involved in some types of work, but common sense will almost always suffice.

The smaller mammals may be easier to photograph, but they may also be harder! Woodchucks can spot a man when only a few square inches of his clothing show through a screen of grass or brush. On the other hand, chucks who have grown up in a protected area must regard humans as peculiar though harmless creatures who occasionally leave delicious bits of food. They may feed unconcernedly 50 feet from a group of people.

Small mammals can be trapped in wire "catchalive" traps (that do them no harm) and photographed in a cage-studio setup under artificial lights. Such studio sets are a lot of trouble to make and use, and most animals don't take to them very well. If controlled conditions are necessary for some scientific speci-

Many nocturnal mammals will be attracted to bait set in front of a remote-control camera. A backlight is usually necessary to get good results, and two are better. One light lit this raccoon's head, but left his hind quarters dark.

mens, all well and good; but studio work for any other purpose seems rather unsporting and is seldom worth the effort involved.

Observing the habits of animals in the wild can be very helpful in planning your photographic activities. Some are obviously nocturnal; others may be abroad during the day, so watch closely; do they pass through one definite area each morning and afternoon? Is there a favorite area where they congregate when it rains, snows, or blows? Deer especially tend to drift toward farmed fields in the late afternoon. Watching closely one day will probably show you the regular routes they use, and they'll be pin-pointed for the next day's shooting. If the trail is narrow and well defined you can set up a camera-trap. If there is an open area, check the prevailing wind and find some natural cover to use as a blind. A regular blind set up near the trail is bound to be regarded with suspicion as something new, different, and probably dangerous. With natural cover, if the camouflage is good and your hand motions slow, you may be able to take

several pictures while the animals are trying to spot the source of the camera's sound. Here is another place where a motor-driven camera is excellent. Not only can a series of pictures be made quickly, but the only motion involved is the bending of an index finger—and that slight movement is hard for even deer and elk to spot. Use a tripod, preferably a dark, dull-finished one. Holding a camera at the ready for even a few minutes will start a case of the wobbles. Leaving the pan and tilt controls loose will let you follow a moving subject with a tripod-mounted camera, and the film images are bound to be sharper.

Below. This silky anteater was captured in Trinidad, W. I., and photographed in a simple controlled setting. Since he is a nocturnal animal, the photography was done at night with two strobe units. Hasselblad, normal lens, Panatomic-X film exposed at $f/8$. Opposite, above. Pine martin in Wyoming was photographed as he left tunnel in a snowbank. Canonflex, 200mm Canomatic lens, 1/250 sec. at $f/5.6$ on Adox KB-17 film. Opposite, below. The young of many animals are more curious than adults and can be approached more closely. The fawn was found feeding in a roadside field in the late afternoon, and was photographed at about 30 feet with a Hasselblad and 300mm Kilfitt lens. Verichrome Pan film rated at ASA 320 with extended development, exposure 1/250 sec. at $f/6.3$.

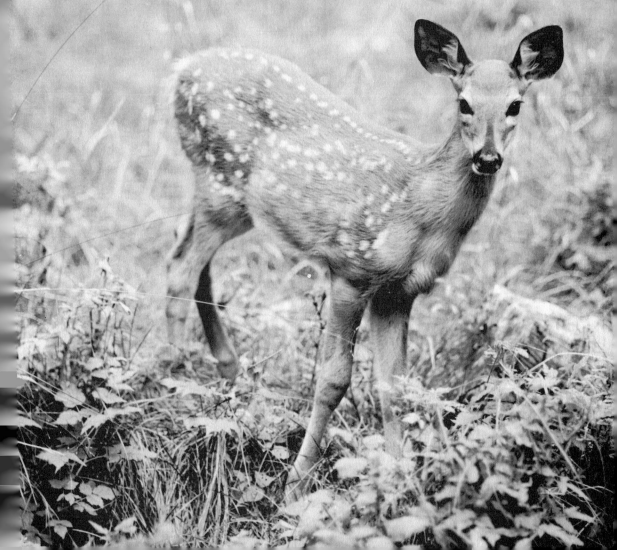

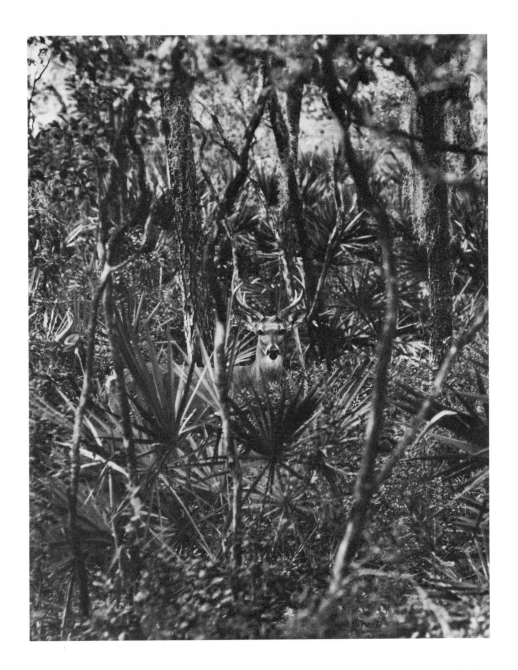

Blinds are less used in mammal photography than other types of work because mammals are highly suspicious of any new and strange object, because the blind itself takes on human scent while it is being built, and because it cannot, in most cases, be moved around to remain downwind of a water hole or trail when the wind changes direction. Natural cover is usually sufficient if drab, natural-colored clothing is worn and the camera-hunter *keeps still!* Craning one's neck to keep an animal in view and slapping mosquitoes will undo many hours of waiting in a second, but it's surprising how few people can resist wiggling while supposedly motionless.

Opposite. This Florida white-tailed deer is well camouflaged amid the palmettos as long as he doesn't move. A 200mm lens, kept at the ready, made the best of a fleeting moment to produce this picture. It would be easy to miss seeing this buck! If you see a tenth of the game that sees you, you're doing very well. Below and right. Bears are most often seen in and around dumps and can be photographed successfully if you can spot their paths and catch them as they come in to feed. Unfortunately, this is often in the late afternoon when dim light prevails. This Maine bear was photographed with a Praktina, 300mm Kilfitt lens, on Panatomic-X film. Exposures were 1/100 sec. at f/5.6 with a hand-held camera. The bear was about 70 feet away, then, still suspicious, he came into the open after 15 minutes of eyeing the photographer from the bushes along the edge of a dump. Range of second photo about 60 feet.

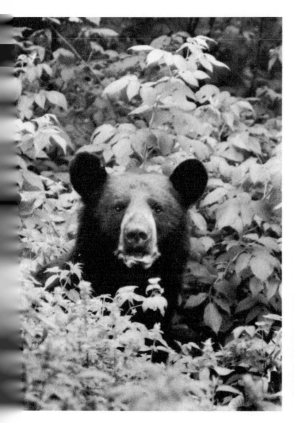

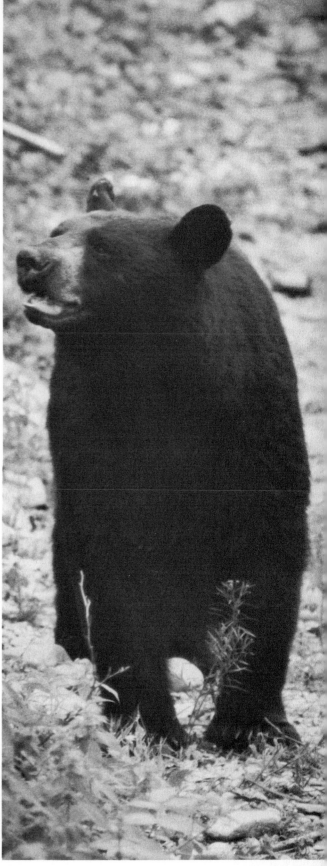

Some types of "blinds" not only permit movements, but encourage them. These are costumes designed to imitate an animal, or at least to imitate a non-human. Some of the finest motion pictures of buffalo made to date were made by a photographer draped in a buffalo hide, walking near the herd. There is a bit of danger involved here; pugnacious or amorous bulls could really do serious damage. As in stalking birds, disguising the *form* of a human being is the most important. Approaching caribou on hands and knees causes no great alarm; but the moment a person stands up and is recognized as human the alarm sounds! In the same manner photographers have approached mountain sheep by wearing a white sheet; certainly the sheep know he's not one of them, but they don't know what he is—and curiosity is stronger than fear. If a concealed approach is impossible, as it often is, try a *slow* walking approach, keeping in plain view at all times. Don't keep looking directly at the animal; glance around the country-side and watch him out of the corner of your eye. Wild creatures simply don't like being stared at. This may sound improbable or impossible, but it's nonetheless true—and easily proved if you care to take the trouble. Some stalkers feel it's better to zig-zag in the approach, rather than walk directly toward the animals. Walking along slowly, you may arouse more curiosity than fear, and if so, you can get close enough for some fine pictures.

An automobile can often be used as a blind; most animals are used to seeing vehicles of some kind. They may—or may not!—come fairly close to a parked car. A moving car doesn't cause too much alarm until it stops, and if you are quick you may get two or three fine pictures. You might try a shot while you are still moving, being careful not to let the camera touch any part of the car—vibration will ruin things. A motor-driven camera is a huge help. Try one shot as you approach and are rolling to a stop (this will be a bit of a gamble but good insurance anyhow). Take another picture as the animal sees the car has stopped. One, two, or even three shots as he turns tail and scoots, are all possible within five or six seconds using a motorized camera.

There are times when an animal may even be attracted to the concealed cameraman by curiosity. Antelope have been tolled in to 100 feet or less by gently waving a white handkerchief. Woodland caribou will sometimes come up to a crouching man to investigate. Using a horse or cow as a moving blind is an opportunity that's rarely available, but it can be very successful. This maneuver is so successful in approaching ducks and geese that there is a federal law against using it while hunting. In general, daytime stalking of animals is not too successful. Occasionally the terrain and wind direction will allow a concealed approach to be made, but more often your quarry will head for the tall timber long before you get within camera range. If you know their "escape route" you may be able to conceal yourself along it and have someone else alarm them.

Feeding moose can be approached on foot or in a canoe if the stalker will move only when the animal's head is underwater, and freeze each time he comes

up for air. If on foot, come up from downwind, *use the utmost caution,* and keep as close to a climbable tree as possible. If you are in a canoe be sure not to get into shallow water! There is possibly no more dangerous animal than an enraged moose, and no canoeist could outdistance one. Disguising the bow of the canoe with brush will help considerably; it should be kept pointed toward the animal. A broadside view will spook him every time, unless he is used to seeing fishermen in boats. Then try a nonchalant, slow approach, coming in at an angle or letting the canoe drift slowly closer. If he shows little interest or faces away when you are ready to shoot, give a whistle or make a peculiar sound.

A fine bull caribou eyes the photographer suspiciously across 80 yards of Alaska tundra. Pictures were taken at intervals as the photographer approached, starting at a distance of about 120 yards. This was the closest this particular bull would tolerate; he trotted off immediately after this exposure. Hasselblad, 500mm lens, Verichrome Pan film, 1/250 sec. at f/10.

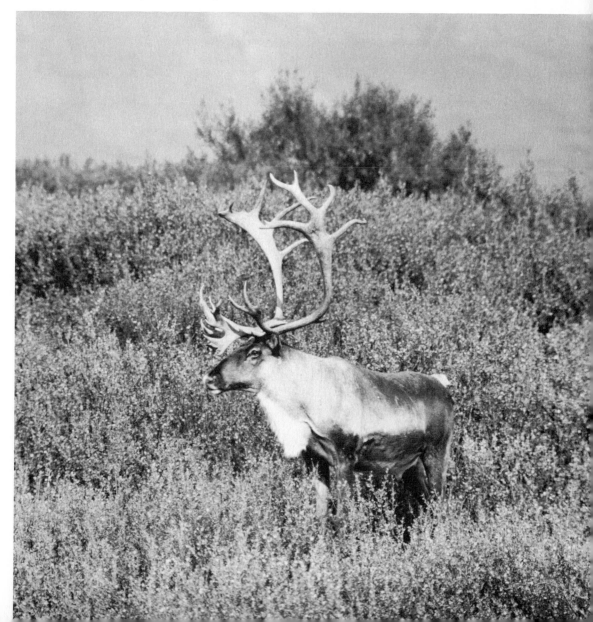

Photographing from a canoe is often the best way to go after deer and moose. They generally show little fear of a man in a boat, and camera angles can be varied at will. Above, left. This cow moose continued feeding while the canoe was brought to within 40 feet. Hasselblad camera, 150mm Kilfitt lens, Verichrome Pan film, exposed 1/100 sec. at f/5 in the late afternoon. Right. Shortly after sunset. Low light level allowed only 1/100 sec. exposure at f/3.5. Hasselblad, 150mm Kilfitt lens. Camera was panned to keep cow sharp; background is blurred. Below. Bull moose are simply too big and too unpredictable to take any chances with. They can also get very close to you, in alders, before you see them. This bull was photographed at 60 feet from the top of a small bank. Had the ground been level, the photographer probably would have been up a tree!

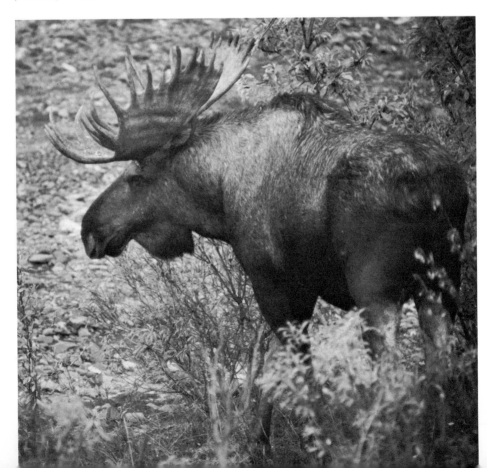

Chances are he will perk up his ears and assume a keenly alert poise. The canoe approach is excellent for nighttime photography of nocturnal mammals. Many years ago George Shiras produced superlative pictures of deer and moose, using flashpowder, slow lenses and plates, and kerosene lanterns—equipment considered primitive today. Yet his pictures are probably the best ever taken in this field. Shiras also rigged up two cameras to fire in quick succession. The second usually caught the animal in midstride as he ran from the first flash.

It is possible to approach some animals on land at night, especially if they feed in open areas, as deer do. Mount a strobe unit or flashgun on your camera, and a fairly strong flashlight as well. By all means do some testing before you start out; shoot some pictures on fast film outdoors at night, to see how far your strobe or flashbulb will carry. You will then know how close you have to get to be sure of a good exposure. Due to the lack of reflecting surfaces, flash shots outdoors at night require at least one stop more exposure than a shot at the same distance indoors. My favorite rig is a 35mm SLR with a 200mm telephoto, or even a 400mm, and a good strong strobe unit. This is either the Braun F800 or the Multiblitz Press with a booster attached. With black-and-white film I can shoot at 100 feet or more, even with the 400mm; with color it is worth a try at 50 feet. Admittedly, this is pushing things a bit and the success ratio will drop a little, but it is still well worth a bit of film. This is interesting activity, both photographically and experience-wise, and a lot of fun.

Often, along a stream, you can move much more quietly than through the woods. Running water will mask small sounds and also attracts small animals. This bull elk was feeding and did not detect the photographer until he was less than 100 feet away. Dim light required an exposure of 1/50 sec. at f/8 with a 300mm lens.

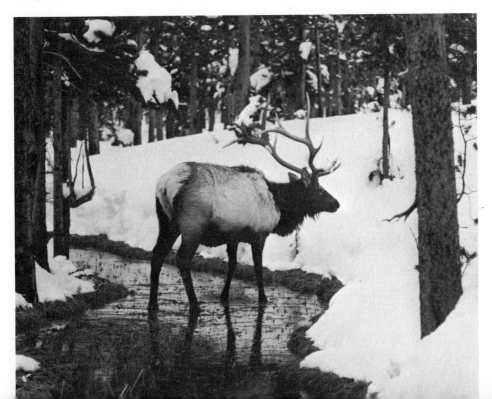

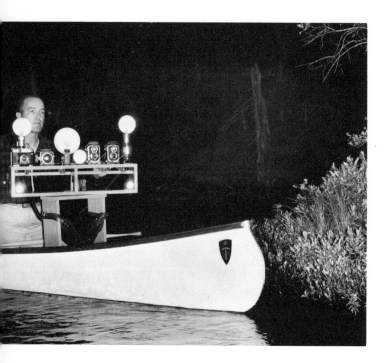

Above, left. The author's nighttime outfit for sequence pictures of deer, moose, and other mammals. Four cameras and three lighting units are mounted on a turntable, one flashlight is used for spotting and two others form a rangefinder with their beams. The Thompson canoe is made of rubber compound that makes an extra silent approach possible. Right. A nighttime hunting outfit includes a 35mm SLR with telephoto lens, the most powerful electronic flash unit you have, and a small, powerful flashlight for finding subjects and for focusing. The entire rig only weighs 10 or 15 pounds. Below. Otters are wonderful, playful creatures and excellent models for wildlife photographers. Their curiosity will keep them nearby for a half-hour or more if the photographer doesn't alarm them by sudden motions. This trio was photographed in a Maine river with a Praktina, 300mm Kilfitt lens, on Plus-X film; exposed 1/500 sec. at f/8.

This raccoon would not hold still for a picture on the ground, but felt secure enough aloft to drape himself over an oak branch and watch the proceedings. He was photographed with the nighttime-camera outfit described, at a distance of about 50 feet.

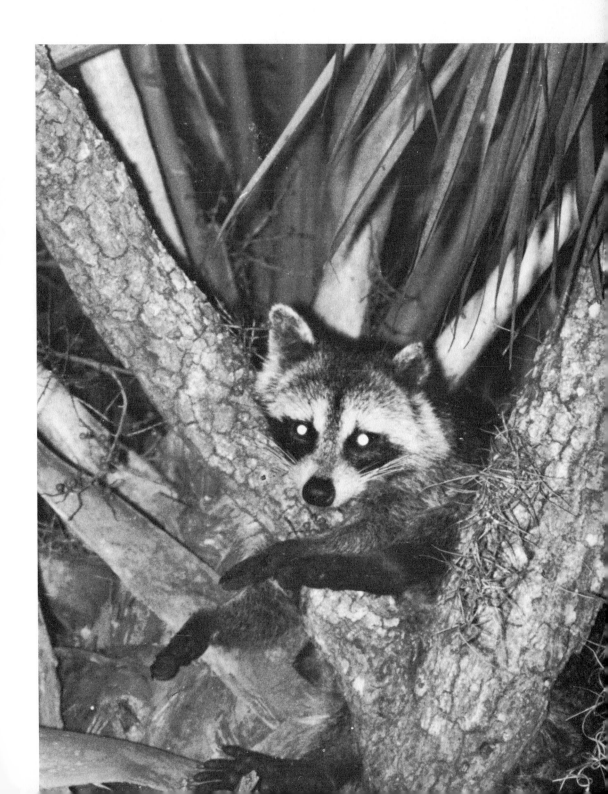

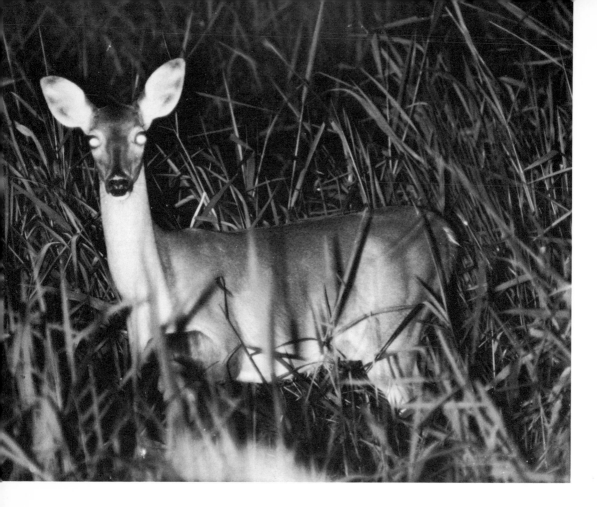

A whitetail deer, hock-deep in swamp water, eyes the approaching photographer suspiciously. A flashlight was used for focusing and to make the animal look at the camera. This deer is about 80 feet from the camera. A slow approach (about 20 minutes) from downwind did not alarm the deer, in spite of the noise produced by wading through water and mud.

The flashlight is used for searching and for focusing. The eyes of animals, shining like twin lanterns, make a fine focusing target. If for any reason you cannot focus by eye-shine, you must get the focusing light several feet to one side of the camera. Otherwise there are no shadows and it is next to impossible to focus sharply. An assistant is a godsend here, but you can do it alone in open country by fastening a lightweight light to a bamboo pole four or five feet long, and attaching this to the camera. A sportsman's "headlight" is good for this use. The battery is in a belt pouch and the light itself weighs but a few ounces. Moving quietly is the rule, but on occasion some animals don't seem to care how much noise you make. I almost bumped into a deer once while sloshing through a swamp at night. He may have thought I was another deer; he certainly wasn't the least concerned with the approaching "schlurk-schlurk" of sneakers in the mud!

Night-prowling is a great sport, and you never know quite what you'll find. Dangers are mostly imaginary, except in snake country. It is conceivable that an animal, blinded by the flash, would run over a photographer or jump into his canoe, but this is a rare instance. Much more dangerous are some of the antics of otherwise intelligent people when they meet bears and other wildlife in places like Yellowstone or the Great Smokies. A bear may look cute mooching food from someone's car but he is a wild animal *and should be treated as such.* Why lamebrained tourists think it's *de rigueur* to try and hand-feed them, or—heaven help us!—encourage their children to do so, is beyond me. Much better to pass up picture-taking when there's this much risk of losing life, limb, or certainly happiness. Common sense will take care of most situations but even a cautious person may underrate some dangers. City park squirrels, for instance, should *never* be allowed to take food from a person's fingers—many have been found to be rabid. Many people don't care to prowl the woods at night, and luckily there is another approach to nocturnal photography.

The camera-trap is a useful device in many cases, but really comes into its own here. Setting up a camera on a trail or bait and letting your subjects take their own pictures may sound like laziness; if it is I'm all for it. This is the only practical way to shoot certain species, and the results in all cases can be controlled to some extent. Lighting and composition can be arranged beforehand, but the subject's pose remains a gamble. Clamp the camera to a tree if possible, or use a non-shiny tripod. Mount the flashgun in a tree or on a light stand. A little trimming may be needed to give the camera a clear shot. Stretch a trip-"wire" (nylon thread is better) across the trail, or tie it to the bait. Plastic bags protect the gear, and you go back to a warm bed while the wild creatures obligingly take their own pictures. The thrill of anticipation is at its highest peak.

Finding the trap set off, with the latent image keeping its secrets, raises all sorts of hopes. The temptation is to shoot up the rest of the roll in a hurry and hightail it to the darkroom; and I for one always yield to this sort of temptation! The resulting photograph may be the animal you expected; it may also be a roaming dog, songbird in flight, or a rare and unusual visitor, perhaps even an albino. You may have a falling branch or the local Boy Scout troop; but it's all in the game.

Camera-traps fall into two general categories: mechanical and electrical. Both have their good and bad points. Mechanical traps are cheap and easy to build, and dampness doesn't bother them much. They are light in weight and don't take up much space in a pack. There is, however, the chance that an animal will trip the thread between the camera and the trail, and be way out of focus. Often you can place large branches along one or both sides of the thread, out of camera range, to encourage any passing animal to take the path of least resistance; i.e., along the trail in the zone of sharp focus. Electric traps use a battery and solenoid, which is more gear to lug around, costs more, and may quit in wet weather. Corrosion or electrolysis may prove to be a problem. Elec-

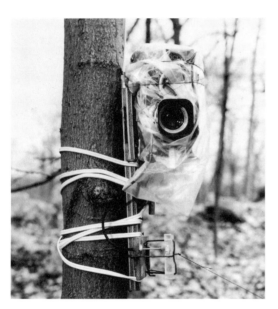

A mousetrap, before and after conversion to a mechanical camera-trap mechanism. This sort of trigger is foolproof and inexpensive, and will fire any camera having a cable-release socket. Left and above. Armed and ready. A "lowpod" is bound to a tree trunk with the flash-synch cord, and the mousetrap-trigger tacked to the lower part of it. The camera and flashgun are covered with plastic bags lashed down to prevent flapping. A sunshade protects the lens from rain, snow, or stray light.

tric traps are faster in response and a great deal more flexibility is possible in triggering mechanisms. So—take your choice.

I would recommend mechanical traps as a starter. A small mousetrap makes a fine one.

Following the illustration, remove the bait-holder and discard it; remove the straight wire that holds down the bail or striker, and mount it with its own staple in the opposite end of the board. Make a zig-zag bend in this with pliers so it will hold up the bail; adjust the angle of this zig-zag according to the sensitivity desired. You may prefer hair-trigger sensitivity for quickest response, or a little stiffer operation so that the trap won't be set off by wind or a falling leaf. Glue a small flat board to the wire bail to push the cable-release plunger. Glue a wooden block to the bottom of the trap and drill a hole through it from the top to take the cable release—and there you are! With 15 or 20 cents worth of materials you have a fine little camera-trap.

Try the trap out on your camera. You may need to bend the spring a little for more "push." It's also a good idea to add a small wooden block so that the trap won't push the cable too far and damage the shutter mechanism. Another wooden block, triangular and about a quarter-inch wide, may be needed to make the bail strike the cable-release plunger at right angles, for smooth operation. To avoid vibration, don't mount the trap mechanism directly on the camera if you can avoid it.

To set a trap, choose a spot along a well-used trail; deer trails are well marked and usually easy to find, especially in winter. Find a spot where you can back off ten feet or so, and use a tree as a camera support if possible. Mount the camera with a clampod, using the screw device supplied with it or securing it to a branch. Make sure the camera is *solidly* mounted! If no tree is in the right spot, try a tripod; but animals are more likely to shy away from it, more so if it is bright metal. Painting it black or wrapping with tire tape will help. Mount the flashgun in the same manner, preferably in the same tree above the camera, or in another, a bit to one side. A homemade "lowpod," discussed in the flower photography chapter, makes a good camera support, and if you can use a long extension cord between camera and flashgun, lash the lowpod to the tree trunk with this wire. Make the whole rig as inconspicuous as possible. Sometimes the flashgun or camera can be set up in or behind a small bush, with just enough branches tied back to give a clear shot at the trail.

For a permanent setup, make two wooden boxes, with a hole in one for the camera lens and a hole in the other big enough for the flashgun reflector. Paint them black and nail them to trees in a suitable location. When the passing animals are used to seeing them, put the camera and flashgun inside and make a set. This way nothing new is visible; the boxes appear as usual and should arouse little suspicion. On the far side of the trail tie one end of a thin black nylon thread to a tree, bush, or stake driven into the ground, and lead it toward the camera. On the near side of the trail pass this thread through a loop of wire twisted around a stake or twig to act as a fairlead and reduce friction. If the thread is led from here directly to the camera, it will show up in the picture. Lead it to another wire loop under the camera, or around the leg of the tripod, if you use one. Tie it to the mousetrap trigger and you're all set. A bit of slack to allow for shrinkage is a good idea unless you are working with shy animals that may back off when they feel the thread. Shrinkage doesn't seem to affect nylon thread very much, but if it proves to be a problem try fisherman's nylon monofilament of three or four pounds strength, or fine enameled fishing line.

The height of the "trip-wire" will depend on what animals you are after. I think about three and a half feet is the best for deer. One will hit it with his neck and there's less chance he can back off before tripping the camera. Raccoons, skunks, and woodchucks will hit a thread six inches or so off the ground, and mice or chipmunks will miss it.

95

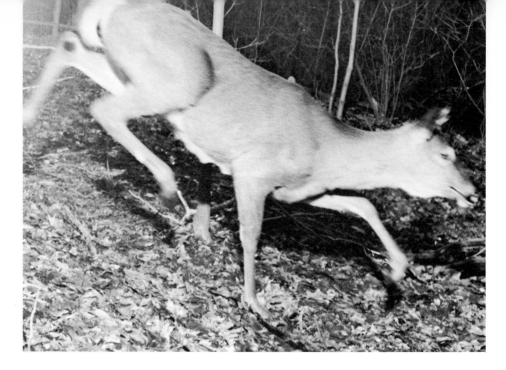

A doe does a one-legged "handstand" for the camera as she runs through a camera trap. The exposure of 1/500 sec. failed to stop her motion; strobe would have done so. Minolta Autocord camera, Verichrome Pan film, #22 flashbulb at about 15 feet, f/6.3.

An elk carcass in the snow made a good bait for a camera-trap setup. A thread was tied to a piece of meat, led under the spine of the dead animal, and attached to the camera on a tripod. The coyote grabbed the bait so fast that even a shutter speed of 1/500 sec. didn't stop his motion. Flash was used in case he came at night.

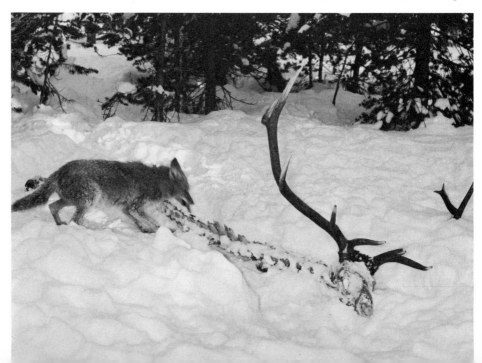

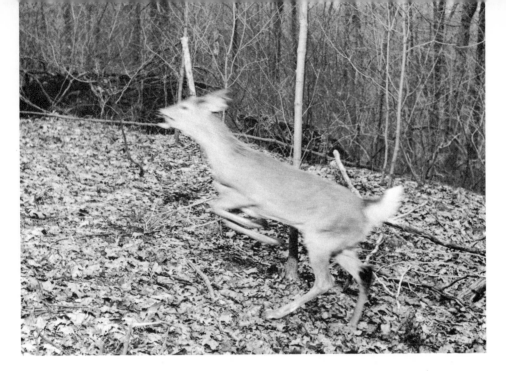

A young buck in a hurry! Even 1/500 sec. failed to stop this deer, alarmed by something and running through the camera-trap during daylight hours. Minolta Autocord, Verichrome Pan film, #22 flashbulb at about 15 feet, exposure 1/500 sec. at f/6.3.

A fine six-point buck trips the camera by hitting the thread with his antlers. Minolta Autocord camera, Verichrome Pan film, #22 flashbulb at about 15 feet, exposure 1/250 sec. at f/8.

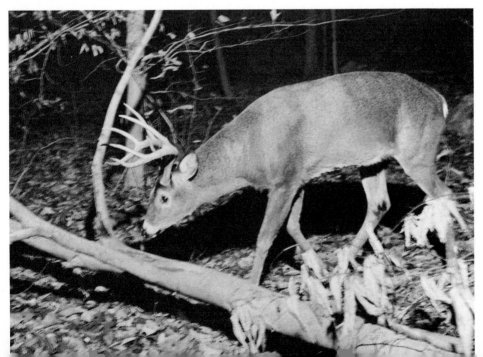

For rain protection, get some thin plastic bags such as those vegetables are packed in. Make sure they have not been perforated for ventilation! Put one over the flashgun and another over the camera. Put a sunshade or filter-holder on the camera, right over the bag, and cut out the circle of plastic over the lens. If the bag is too big, wrap it with thread so there are no loose ends to flap in the breeze; this will alarm most wild creatures.

Now check: film in camera? flashbulb? shutter cocked? focus set? thread clear of branches that might sway in the wind? any dead branches above the thread that may fall? nothing in front of the lens or flashgun? When everything is set, walk down the trail and deliberately trip the camera to be sure everything is going to work. *Don't skip this part of the preparations.* It is well worth a bulb and one exposure to guarantee all your work won't be futile for some small, easily-prevented reason.

Bait may be set on one or both sides of the trip-wire, out of camera range, or it can be set in the center of the field and rigged to trip the camera when it is picked up or moved. To accomplish this, twist a wire fairlead around the top of a small stake and drive it into the ground until only the loop shows. Tie the thread to the bait, lead it through this loop, and pull it up snug. When the bait is lifted an inch or two, or dragged aside, you've got your picture.

If you have a camera on which the shutter is released by pushing down a lever, you can use a mousetrap with no modifications. Tack it to a board and drive the board into the ground under the camera or mount it on the tripod. Tie a thin, easily-broken thread on the striker of the trap so it will pull down the shutter lever when it goes off, and tie the trip-wire to the bait-holder of the mousetrap. This rig can be made more sensitive and is the best way to use a mechanical trap for mice, shrews, small birds, and so on. If your camera has a built-in or accessory self-timer you can gamble for some interesting shots. Theoretically, the subject will trip the trap and turn to face the source of the sound, looking straight at the camera until it goes off. The gamble is that he may ignore the buzzing or that wind or other noises will drown it out. Then you would have a picture of fresh tracks or, at best, the animal's tail moving out of the frame! One advantage is that any vibration caused by the trap going off would die out before the shutter is released.

Electric traps use a battery as a power source, and a small solenoid or magnet to release the shutter. Trigger mechanisms can be made very sensitive in response, and more important, there is no chance of an animal, bird, falling twig, or leaf hitting the thread between the trail or the bait and the camera.

When a raccoon's den was located, a thin thread was stretched across the entrance and tied to an electric switch hooked to the camera. As a young raccoon stuck his head out, he tripped the switch and took his own picture. One electronic flash unit provided light.

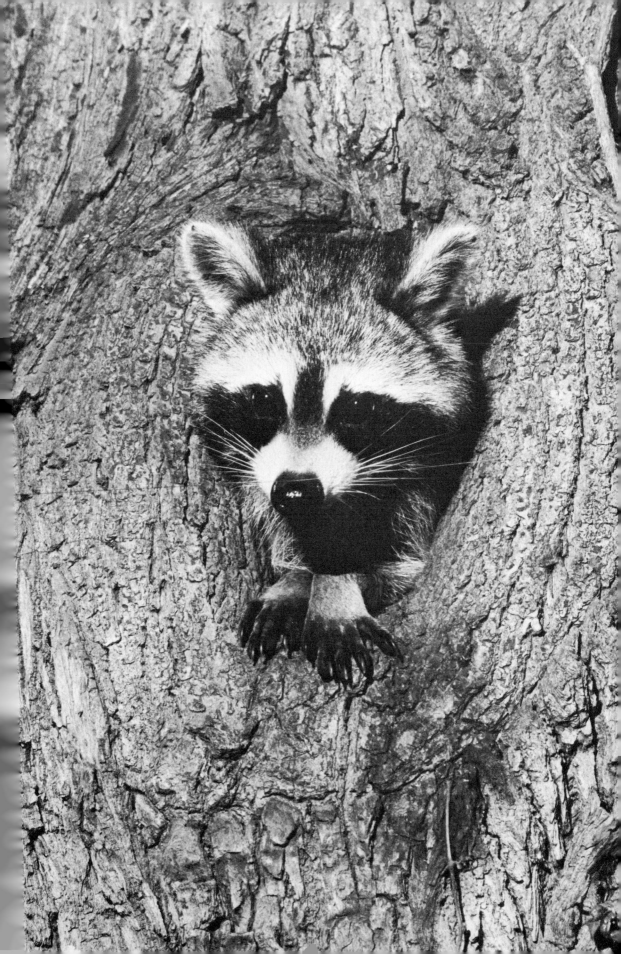

In the dim light just before dawn, deer were photographed by a combination of natural and artificial light. The flash unit caused their eyes to shine; the camera was panned and blurred the background.

Whatever sets it off must be exactly where the trigger-switch is. A thread can be used across the trail as before, but it will be only as long as the trail is wide; the subject must be in focus or the trap won't fire. Simple bent-wire switches can be used, or microswitches from electronic apparatus. By far the best idea was submitted to me by Mr. Joe Hall of San Mateo, Calif. He suggests using mercury switches. These are completely enclosed in glass tubes so there's no chance for corrosion to cause trouble or a stray leaf to jam the switch. Tipping the tube causes a blob of mercury to run to one end and short out two electrodes. It's a simple matter to mount the switch so the trip-thread will rotate it enough to fire; it will then swing back to its original position and not burn out a solenoid by staying closed too long.

Simple bent-wire switches can be made from brass wire, strips of sheet brass or copper, or in a pinch, paper clips. For trip-wire setups the thread pulls one wire or flat strip against the other to make contact. Taping both to a wood dowel a half-inch in diameter allows flexibility in mounting; it can be lashed to a tree or simply driven into the ground. Tape will also protect the soldered connections from moisture. Wire switches of a loop-and-straight wire type will

A simple remote-control device is excellent for photographing many small mammals. A Minolta Autocord, with fan-flashgun attached, was mounted on the Rowi universal camera stand. Peanuts baited in the red squirrel, and a Kagra air release was used to set off the shutter. Below. The end result. The camera is accurately focused on the bait used, the flash dictates a small *f*/stop, and a high shutter speed stops subject motion; sharp pictures are almost guaranteed.

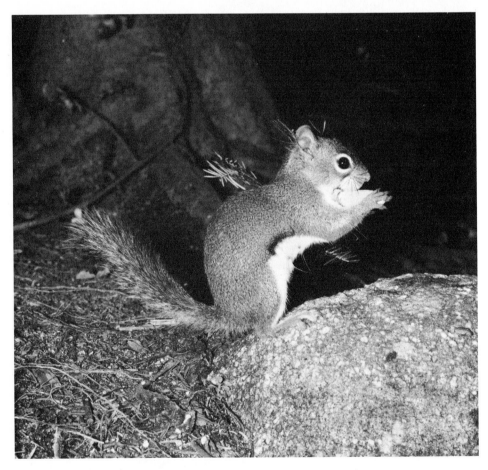

be set off by a pull or push from any direction. They can be made so sensitive that moving the center wire one-sixteenth of an inch will trip them, and bait can be set on top of a switch or hung from it with equal ease. Again, mounting on a short wooden dowel is the handiest. Bait can be anything from a gram of peanut butter to a ten-pound fish; it makes no difference. As soon as it is moved a hair either way the switch is actuated. Driving the dowel into the ground, with only the center wire protruding, hides it from the camera's eye. Slipping a small disk of celluloid, or even cardboard, over the wire will avoid the possibility of its filling with dirt and failing to fire. Microswitches used in electronic apparatus can also be used. They can be set off by a thread or the weight of an animal on a treadle arrangement. These are the most sensitive commercially-made switches; the weight of a shrew is enough to trip them.

A "tread" type of trigger switch may be made from a piece of plywood and a piece of sheet metal, both about a foot square. They are held apart by small pieces of sponge rubber; brass tacks driven into the plywood will make contact when an animal steps on the metal plate. Several may be set around the bait or in the trail, but there is still the chance an uncooperative animal will step over and around them without setting off the camera. They should be camouflaged with leaves or other natural cover, including sand. A well-nigh invisible set can be made with a little work. Enclosing the entire tread in a plastic bag will keep dirt and stones from jamming the switch open. There is a commercially made affair called an "Announcemat" made by the Recora Company, Summit, Ill., that is excellent for some situations. It measures 18" x 30" and is a rubber doormat with the switching apparatus built inside. There is little chance a walking animal would miss a tread of this size.

When used with a self-resetting camera and strobe unit, a tread-trap setup like this will record all the wild creatures that pass along a path during an entire night. Putting a pocket watch or small clock in one corner of the camera's view will also tell you at what hour they appeared. This watch should be well muffled; placed in a bottle or clear plastic container. The scientific value of such a setup is considerable; complete records of the habits of all species using that area can be made, as well as fairly accurate size measurements and hours of greatest activity. The various SLR and rangefinder models that are motorized are good cameras for this work. They will reset themselves in a second or two, will accept wide-angle or tele lenses, and are compact and rugged. The whole rig can be supported by a clampod on a tree trunk, and magazine backs are available. Any high-voltage dry-cell strobe unit will do fine. It is silent, and leaving it on for hours won't run batteries down too much.

The only potential source of trouble is the possibility that an animal will stand on the tread switch for a considerable length of time and this might burn out the solenoid. Including a time-delay relay in the circuit will avoid this. These relays are widely used for flashing display signs and are available in a wide range of voltages. If an animal stands on the tread, the camera will imme-

Above. A pod of sleeping sea lions off the Mexican coast were approached very slowly in a rowboat. By turning the motor of the boat off, we were able to get within 20 feet of the sea lions without waking them up. A 105mm telephoto lens on a 35mm SLR gave a full-frame image. Below. When an animal is moving rapidly, you may not have time to focus. Set the lens on the estimated distance, follow the animal in the viewfinder, and shoot when it looks good. With a little luck, you will get an acceptably sharp picture. The sea lion was photographed with a Nikon F, 105mm lens, 1/250 sec. at f/8.

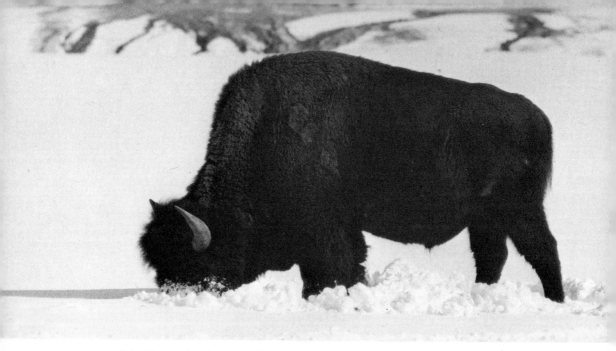

A feeding animal may be less wary than at other times, especially if he has his head buried in the snow. With a creature this big, it's wise not to get too close. A Hasselblad with a telephoto lens was used from about 80 feet away.

diately fire; after two seconds the relay will open the circuit and let the camera rewind itself; if he keep standing on the switch the relay will close again in about four seconds, and the cycle will repeat every six seconds or so until he moves off. You might end up with a bunch of near-identical pictures but at least the solenoid will not burn out. If there is any possibility that a home-made electric-camera rig might jam and burn itself out, another relay could be put into the main power-supply circuit.

Baits will vary widely for different creatures. Rabbits and woodchucks like lettuce and some other vegetables, deer will come to salt, apples, piles of acorns, corn, and sometimes even tobacco. Mink and weasels should appreciate a dead fish, though a skunk, gull, eagle, or crow may get to it first. A chicken or fish may entice a bobcat within range, and practically anything will draw skunks. Skunks, incidentally, may return to a trap as long as you keep baiting it; you may have to move the entire operation to catch anything else. Small mammals will come to peanut butter readily. Some photographers mix it with rolled oats. It's a good bet for chipmunks, ground squirrels, mice, skunks *(of course);* and possibly deer, dogs, cats, songbirds, and beetles. Bears will investigate anything in the "garbage" line like a beef bone, ham bone, or anything spread with honey or molasses. Bear-trapping should be tried only with a *very* inexpensive rig. Bears are unpredictable, and one is known to have demolished two cameras on two successive nights, even though they were enclosed in steel boxes.

The shyer mammals call for a good deal of effort in making a successful set. You may have to bury gloves and shoes in dry cow-manure for several days and wear them to avoid leaving human scent when you make the set. You stand a fair chance with the young of foxes, wolves, and coyotes in areas where they

104

are not persecuted regularly. A dead mouse or larger animal should draw some attention, and commercial scent solutions made for trappers are available. In arid regions a waterhole will draw all sorts of things—birds, mammals, reptiles, and amphibians. A trickle of water will make an audible and smellable attraction that will be well worth the effort to build and maintain. Learning the habits and natural foods of the creatures you are after is rewarding and fascinating in itself, let alone in its value in photography. The more you know about your quarry the better your chances are. Happily there are reams of material available in popular and scientific publications, covering every animal you are likely to see and many you'll probably never run into.

Don't expect success every time in baiting animals. With a plentiful supply of natural food they have little reason to change their feeding habits; unless you hit on a delicacy, they may avoid the best of traps. On the other hand they will flock to a food supply when times are hard. An otter that turns up his nose at dead fish in the warm months may trade portraits for sardines all winter.

This sort of situation makes a photographer wonder why he didn't take up something a little safer! Adult black bear, hibernating in cave, was photographed at ten feet with Canonflex, 50mm lens, and strobe unit. After every shot, bear growled loudly; photographer was panting heavily. Warm breath, condensing in cold air, caused foggy effect. After four shots, further photography was hopeless. (Conversion from Kodachrome.)

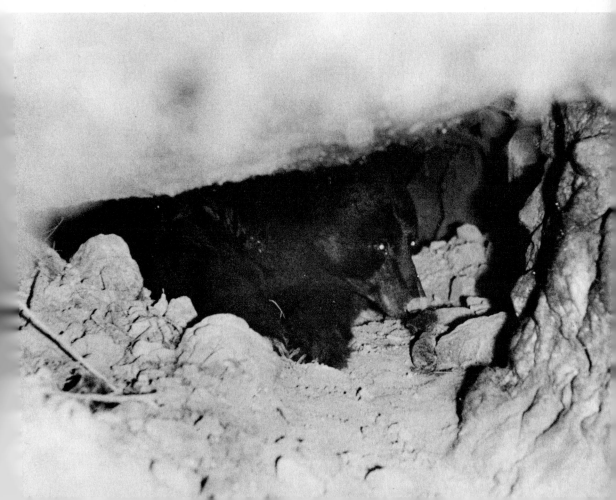

7

Reptiles and Amphibians

REPTILES, snakes especially, appear in the records as far back as history goes. They have been worshipped occasionally, respected generally, and persecuted entirely too often. "Herptiles," or reptiles and amphibians, deserve better treatment than they get.

Many persons, on moving to a country dwelling, industriously eliminate all lizards, frogs, and snakes from their immediate locality; then they wonder why they seem to be overrun with mosquitoes, insects, mice, and rats! Naturally, you don't want frogs under your bed; but letting them keep the grounds and gardens clear of unwanted insects is another matter. Learning a bit about these creatures almost always commands respect for their usefulness, and a desire to know more.

They are excellent subjects for photography for one major reason: they are controllable. Most quality work is done either with captives in a studio, or with specimens captured in the field and released at a time and place where conditions are good for photography. Active subjects can be slowed down a bit by chilling in a refrigerator. Shooting early in the morning after a cool night can also be productive. The excitement of the hunt and chase is enough by itself to draw many amateur herpetologists, even if they don't experience the satisfaction of producing artistic, accurate photographs of their specimens. Often a trained herpetologist will welcome the chance to go out collecting or just looking, and the photographer will complete a two-man team that can benefit both parties. The herpetologist will also know what creatures are likely to be found where, and when. Being in the wrong place at the wrong time is of no help.

Snakes are best found by walking softly and searching good habitat areas. A snake-stick with an iron hook on the end is useful in searching, and the only safe way to handle an unidentified snake. It can be used to turn over rocks and logs

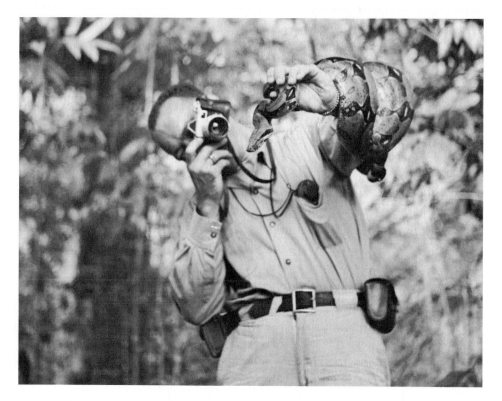

It is difficult to photograph an active snake if you do not have an assistant to control him. Sometimes head portraits are the only pictures possible when working single-handed. Preset the camera for distance and hold the snake (here a 7-foot boa) at arm's length; shoot when his head is in profile and held away from your own hand.

without exposing the fingers to the bite of whatever may be underneath.

Snakes can be attracted to some degree by creating a desirable habitat. One of the best methods is to get some boards two or three feet square and nail small wooden cleats underneath to raise them a few inches off the ground. Leaving these in a promising area and checking them every few days will give you a good chance to catch, or at least see, whatever reptiles are in the area.

In the summertime, little-traveled blacktop roads are an excellent place to go collecting; the snakes are attracted by the heat held by the road after the ground itself has cooled. Driving along slowly will turn up all sorts of interesting sights and should reveal a fair sampling of the terrestrial snakes common to the region.

Transporting your catch is best done in cloth bags with tightly-sewn seams, commonly called snake-sacks. Tying a knot in the neck of the sack should definitely prevent escapes. The bag can be wet down to keep snakes cool and amphibians moist. A few damp leaves in the bottom help. Snakes can stay in the sack for a few days if necessary, but frogs should be transferred to a can or glass jar half filled with damp paper towels at the earliest opportunity. Punch

some air holes in the lid, *from the inside out to avoid sharp projections on the inside.* Frogs of different species should not be put together as skin secretions may poison some of them. These secretions are irritating to human tissues, too. Keep your hands away from eyes and mouth until you can wash up.

Salamanders may be transported in the damp-paper-towel jar which will keep them unsquashed and safe. This procedure is recommended when live specimens are to be shipped to museums; done properly it affords safe conduct for several days or even weeks. Turtles are tough creatures and will do nicely in cardboard boxes; the only real danger is letting them crawl into inaccessible spots. Naturally, they should be put into aquaria as soon as possible. All bags and containers should be well washed after a specimen is removed. No creature should be kept any longer than necessary unless you are prepared to build a suitable habitat and care for it. Temporary storage for photographic subjects is not adequate for any extended period of time.

Unless the photographer has ample experience with poisonous snakes, he would do well to let them alone after identifying them. No matter how experienced, a photographer should not attempt to catch or photograph poisonous snakes by himself. Another person should always be on hand to handle the snake and shout if he heads for the photographer when the latter's attention is focused on the camera. An assistant is a great help in any case. Working alone with an active subject may yield only some head portraits of a specimen held at arm's length.

Quite good photographs can be made in the field if the weather is favorable and you are dealing with any but the fastest snakes. Catch a snake and take him to a good spot for photography. When he is released, he will try to get away, but can be stopped and "herded" with snake-sticks until he stays put for a few minutes. A good trick is to drop a cloth of some kind over the snake as soon as he coils—he may even crawl under the cloth of his own accord if given a chance. Get all set up and focused on the cloth, and snatch it away *with a string or stick* when you are ready.

Use a telephoto lens for snakes. A 135mm or longer will let you work at five feet from a medium-sized snake and still fill the frame. Remember, a snake can strike about a third of his length; measure this with your eye and allow a good safety margin. *Just because he hasn't struck since you caught him doesn't mean he won't.* Bites from nonpoisonous snakes are unpleasant and unnecessary even though not dangerous.

Use a fairly small aperture to get some depth of field—working close you will need it. I often shoot at 1/50 or 1/100 sec. and stop down as far as this shutter speed will let me. With rattlesnakes, this speed will cause the vibrating rattles to blur but will stop the tongue successfully—the blur adds a great deal of atmosphere to the picture, and shooting when the snake sticks out his tongue adds another bit of realistic behavior to the shot. This can be overdone—naturally you don't want your snake photographs to be a row of protruding

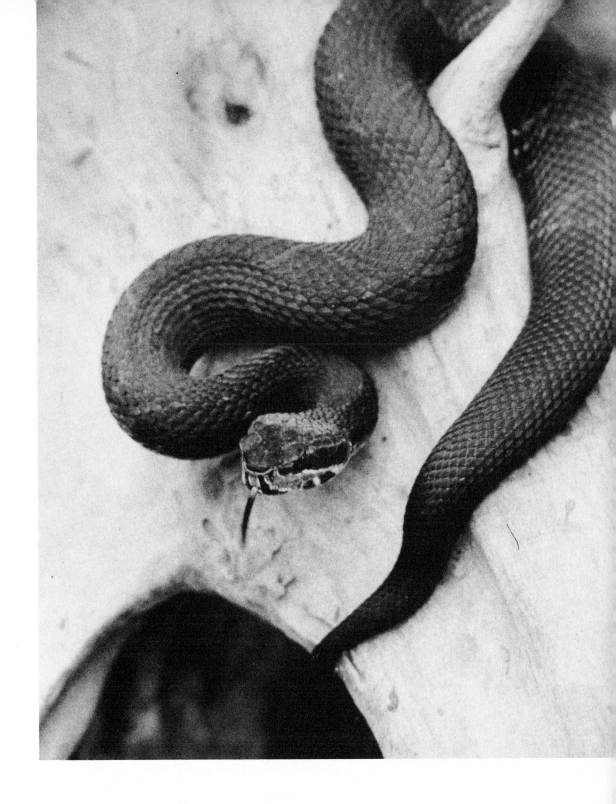

Using a medium-telephoto lens is the only safe way to get quality close-ups of poisonous snakes. This cotton-mouth moccasin was set on a piece of driftwood, using snakesticks, and photographed from about four feet, using a 150mm Kilfitt lens on a Praktina with bellows attachment. Panatomic-X film, exposure 1/50 sec. at *f*/8 on a cloudy day.

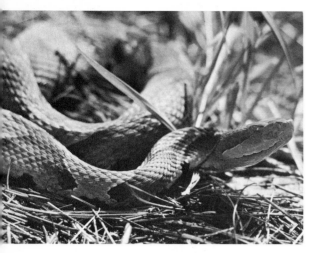 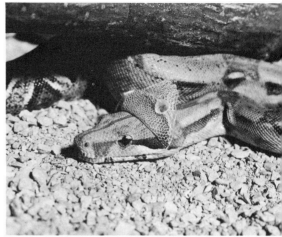

Above, left. As a rule, it's better to shoot a snake in its natural habitat rather than risk transporting poisonous species to your home. This copperhead was shot from ground level on a bed of pine needles and blades of grass. Right. But when you keep an animal in captivity for some time, you will learn, roughly, when he is going to do what, and can catch it on film. This boa constrictor has just begun to shed his skin—right on schedule! Below. Crosslighting brings out the skin texture of this Mexican beaded lizard, a close relative of the Gila monster. He was shot from above, rather than at his own level, to show the rounded nose characteristic of the family. Canonflex, 100mm lens, 1/125 sec. at f/8 on Adox KB-14 film.

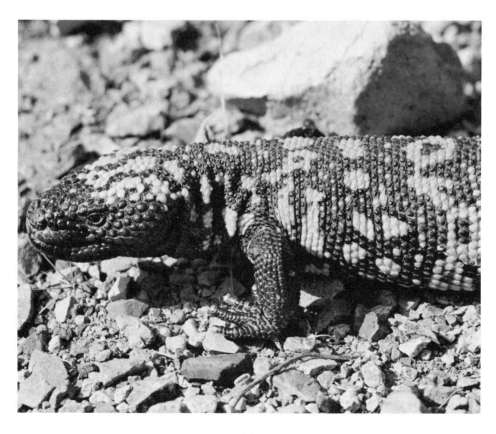

tongues. Careful choice of a setting for field photographs adds to their artistic, scientific and commercial value. Knowing a little about herpetology lets you choose a suitable location for the specimen at hand. Generally, where you find him will give you a good clue; but what if you catch him on a blacktop road?

Lizards are the hardest of reptiles to catch. Some are as fast as greased lightning. Others may stay motionless until you can clap your hand over them or slip a noose of grass, thread, or nylon monofilament over their heads. If you are good with a slingshot or rubber band, you may be able to stun one long enough to pick it up. Chasing the faster lizards with a butterfly net is a lot of fun and once in a while successful. Sinking a large glass jar until the mouth is level with the ground may net you some of the smaller lizards; when they tumble in they can't climb out. Wire box traps can be set at the end of a funnel formed by screen wire and a fence or two logs. These can be productive if you can set them and walk noisily through a field toward them. If the fences are long enough you may catch nearly all the ground lizards in that area. In handling lizards, *never* grab or hold one by the tail. It will invariably break off; your specimen is useless for photography, and the lizard will be a bit off balance until the new tail grows in.

Shooting through the glass side of a terrarium is almost a necessity. If there's an avenue of escape, an active lizard will take it. The anoles in the south and some other species will let you get within telephoto lens range in broad daylight if you move slowly. Some geckos will live on or in houses and come out at night to catch mosquitoes and insects on screened windows or near lights. They are generally tame but won't stand for a bright light being shone on them. If you can focus on their silhouettes and shoot with strobe your activity shouldn't disturb them very much. If you keep lizards in captivity for any length of time, remember many of them will not drink water from a dish. Sprinkle small potted plants or the sides of the terrarium with water; they will lick off the drops.

Studio shots of reptiles and amphibians are quite satisfactory if care is taken in constructing the set. Some work is involved, but there are strobe and studio lights at your disposal, and an icebox nearby in which to chill active subjects until they become more cooperative. Also, many dark snakes register best when shot inside a translucent tent of paper and plastic—hardly a practical field technique.

When selecting a branch or rock for a particular specimen, be careful to get one of a tone that will photograph nicely. A light background with a dark snake on it will be burned out if you use enough light to make the snake itself reproduce well. However, if the match is too close there may be too little tone separation and the two will merge. A selection of branches of various shades can be piled in the corner of the studio or outdoors, space permitting, and used in any number of setups. Branches should be changed from time to time to give variety to your pictures.

111

For nocturnal snakes I often use a black cloth background, which makes a realistic setting. Backgrounds can be paper or wrinkle-free cloth in various shades. You may want to add some blotches of spray-on paint to break up a wide expanse of solid color. For black-and-white work a medium grey background is especially good, since a fairly strong background light can then be used to eliminate shadows cast by the main lights.

Careful studio work may prove kinder to the subject than field work. Good sunlight for photography means heat, and snakes will be killed by temperatures we can easily stand. Even desert-dwelling snakes will be killed by any considerable exposure to direct sunlight. Better to do your collecting, for several days if advantageous, keeping specimens until you can put in a long shooting session. There is ample information published on keeping reptiles safely, and it's easy.

An icebox is fine for small salamanders and amphibians. Anywhere from 40° to 60° F. will keep them healthy for a few days. As long as they don't dry out or get loose they'll come to no harm.

Frogs and toads are great fun to photograph in the field. The season is long and fruitful, starting with below-freezing evenings in the spring. Tree toads and spring peepers will be the first to sound off. When the temperature rises to the 40's and 50's everyone is tuned up and playing.

Arm yourself with a good spotlight, a tripod, flashgun or strobe unit, and a telephoto lens with extension tubes or a bellows attachment. A little dry-land practice in daylight is advisable. Pick a frog-sized stone and see what tubes your lens needs to get an image large enough to fill the frame nicely. Also, take a few "dry-runs" in changing lenses and loading film, and make sure you do it without dropping anything or setting things down. Dry working areas just don't exist in the swamp and a dropped lens will be hard to find underwater. A sportsman's headlight is excellent for frog-hunting and photographing, especially in the cool spring evenings. Later on, insects will swarm in front of your eyes when you use one. Hip boots or trout waders are standard equipment, but an old pair of sneakers will do when things warm up a bit. Watch your footing! It's no joke to lose your balance and dunk a mound of equipment, perhaps including a strobe unit with several hundred volts inside, looking for a way out. Locating a calling frog or toad can be quite a challenge, but is much easier if you have a companion. By separating you can get cross bearings on a calling frog and find him— sometimes. Once in a while one will resist all efforts to locate him, calling when you move away and becoming silent when you draw near. If he proves too difficult to find, forget him and pick an easier subject. The hidden one will probably be so covered with grasses that photographing him may prove impractical anyway. You can ease up on a frog at night until you are only a few feet away, and set up your tripod *carefully*. Make sure it's reasonably stable and on fairly firm bottom. Focus, ready the flashgun or switch on the strobe unit, and stand by. The safest procedure to assure some good results is to take at least one picture before you move in really close or change things in any way. After this

A black cloth background was used here to indicate that this snake *(pseustes poecilonotus)* is nocturnal in its habits. It was photographed in a studio setting with a Hasselblad and strobe lights on Panatomic-X film.

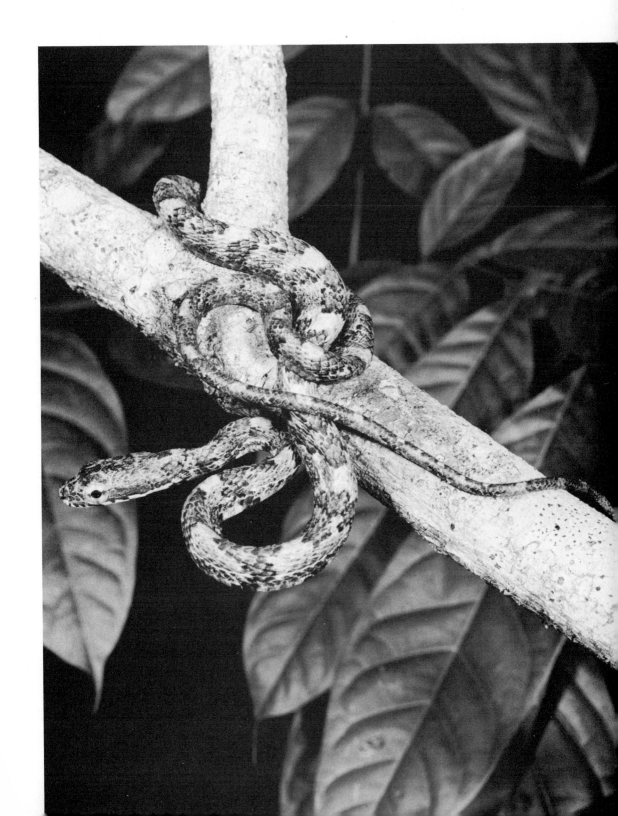

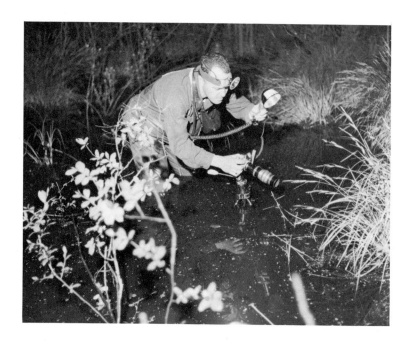

Above. The well-equipped swamp photographer in action! Clad in trout waders, fanny pouch around the neck, and using a sportsman's headlight, the author waits for a bullfrog to start calling. The strobe unit's power-pack is slipped inside the waders to shield it from splashed water, and the lamp-head is held above the camera for better modelling. The camera is used on a tripod to assure steadiness if the wait becomes a long one. Right. The spring peeper *(Hyla crucifer)* is heard a thousand times for each time he is seen. This specimen was located on a branch about a foot above water in a swamp. A Hasselblad camera was set on a tripod nearby, and the normal lens used with extension tubes. When all was ready, a whistled imitation of his call started him calling, and several strobe exposures were made before he stopped.

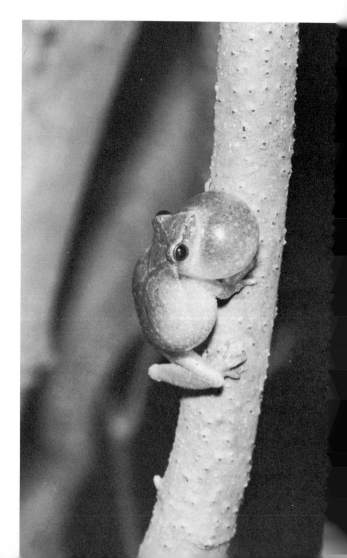

you can try to remove any twig or blade of grass that detracts from the picture; but you will have to move very slowly. Even so, the frog may well decide that "enough is enough" and leap away.

Hand-holding the camera and trying not to move is all right for plain "sitting" shots, but if you want a "singing" shot of the frog with his throat pouch swelled out, I think a tripod is definitely indicated. It may be a few minutes' wait and it will seem like a long few minutes if you are bent over, hand-holding a camera and straining to hold still. Imitating the call of a frog or toad may start him calling again. A small tape recorder is a great thing to use here. Record the calls, get your camera set up, and then play back the frog's own voice to him. It works beautifully!

Flash-on-the-camera is the most commonly used lighting arrangement and certainly the easiest. Using a tripod, you can detach the light and hold it above the camera for better modeling. It is possible to have an assistant hold a second light unit for backlighting. A backlight would have to be shielded so the light would not hit the camera lens directly, and reflections in the water might cause trouble. It probably should be saved for the studio or backyard work. If you have access to a small fishpond you can collect specimens in the field and work with them there, assuming the background can be made to look natural. Electric current is available for strobe units and a work light, and the footing is steadier; but the thrill of swamp-prowling is missing and there is no chance of spotting owl, raccoon or bobcat. I, for one, will take the swamp.

Salamanders are perhaps harder to find than other "herptiles," but wet weather in the spring may bring them out in droves. Caves are good at any time of year. The constant temperature and humidity make an ideal habitat for many moisture-loving animals, and they may forego their normal hibernation if they live in a cave.

Left. Since bamboo clumps are the natural habitat of this tree frog *(Hyla maxima)*, bamboo was used to construct a studio set. A removable glass front kept the frog confined in a terrarium until everything was ready; the glass was then dropped and the shutter released. Three strobe lights were used for illumination. Right. The diminutive size of this tree frog *(Hyla rubra)* was illustrated by perching him on a length of bamboo in a studio. Hasselblad, normal lens with extension tubes, three strobe lights. Exposure was *f*/22 on Panatomic-X film.

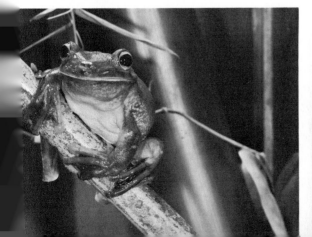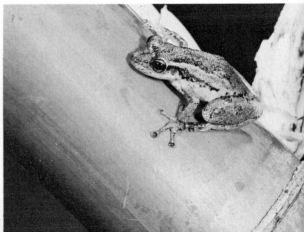

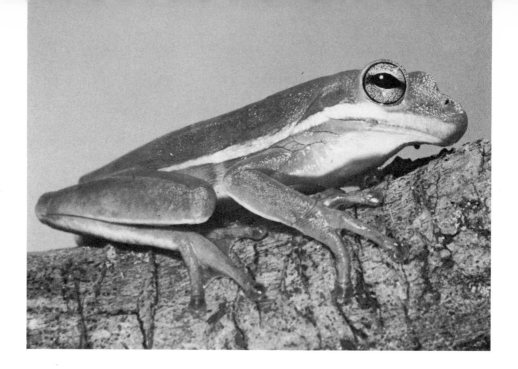

Above. A realistic studio setting shows details of this green tree frog *(Hyla cinerea)*. Medium-grey paper forms a background, and the specimen was placed (repeatedly) on a branch and kept moist by spraying with an atomizer of cold water. Three strobe units were used. Praktina, 58mm Biotar lens in bellows attachment, hand-held camera. Below. A common toad sits in a very simple studio setting; a small terrarium with a glass front that can be dropped just before the exposure is made. Hasselblad, normal lens with extension tubes, two strobe units. Strong backlight brings out the rough texture of the toad's skin.

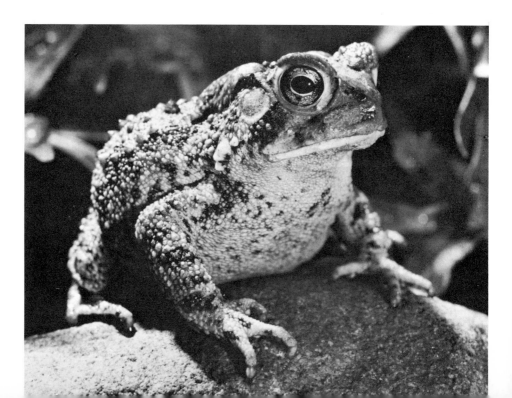

Above, left. The suction-cup pads on the feet of this tree frog (Hyla maxima) are displayed by photographing him from underneath as he clings to the glass front of a terrarium. Hasselblad, 150mm Kilfitt lens with extension tube, strobe lights; f/16 on Panatomic-X film. Right. An entirely different way of holding onto a glass surface is displayed in the close-up of a gecko lizard's foot, shot about half life-size. One electronic flash unit was used, positioned to show detail and texture in the toe plates. Below. Salamanders are handled easily in small indoor sets, or terraria, but must be kept moist. A bare flash unit often gives too many highlights; bouncing it from a small white umbrella is much better. Bark and leaves make a good natural background.

Woodland salamanders are found under rocks and in rotting logs. If you locate one, be sure to leave the spot just the way you found it, whether you take the salamander away for photography or not. Some salamanders guard their eggs for as much as two months and this allows good photographs to be made all through the summer, if you are lucky enough to locate a nest.

Portraits of frogs, toads, and salamanders can be made indoors with a little effort. Studio shots may be more valuable than any you can take in the wild. If you are trying to show color or size variation within a certain species, for example, this is practically the only way. Studio controls allow the most artistic settings you can devise, keeping within the range of accurate surroundings for the particular animal.

Mr. Charles Mohr suggests using a lazy susan as a stage to support the subjects. It can be rotated to get a profile or head-on shot without trying to re-pose the creature. Anything to make the work go more smoothly and rapidly, and to increase the comfort and peace of mind of a captured subject, is worth using and will result in better pictures and healthier specimens.

A small terrarium or aquarium can be used, and it will help to tip it on its side. Using a pane of glass to cover the open side will keep the specimens under control, and the glass can be dropped or lifted away just before the exposure. A few rocks and some natural vegetation will make a good setting for frogs and toads, and a rotted log for woodland salamanders. Dripping or spraying cold water on salamanders will keep them healthy and happy during shooting sessions. A few minutes of drying out may be fatal. If you turn your back on an active salamander and he disappears he may be dessicated by the time you find him again. Frogs and toads are often very cooperative for studio work. You may want to keep a fairly strong work light on them to make the diaphragm of the eye close down to show iris colors.

For "flight" shots you can induce them to jump through the same sort of electric-eye camera rig designed for bird work, or have an assistant induce the leap and try to catch it, setting off the camera by hand. The path of the jump can be controlled to some degree by allowing only one direction of take-off. Hold the frog in both cupped hands with only one opening available for his escape, or put him in a box with the end cut out. A well-defined and noticeable landing area, such as a white cardboard with nothing else nearby, may help. But often the contrary subject will leap helter-skelter. Interesting shots of a frog or toad catching an insect with his tongue are few in number and quite difficult to produce. Hand-timing is so seldom successful you should not expect a good result in less than a hundred shots; the electric-eye tripper is excellent if the light beam is kept narrow and the unit's response is fast enough. Dangling a moth or artificial trout fly, with the hook removed, on the thinnest thread available will let you try for some jump shots. These are a bit easier to anticipate and a hand-tripped camera will generally catch the jump at one point or another.

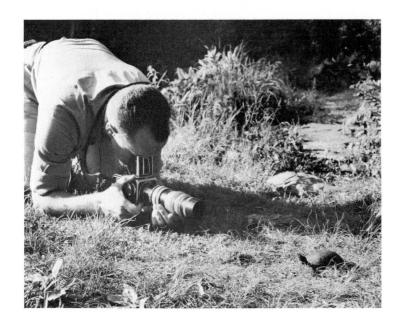

Above. Close-up pictures suffer from magnified vibrations nearly as much as tele-photo pictures do. Whenever possible, brace the camera firmly. Here a low camera angle was desirable, so both hands and forearms were planted solidly on the ground, and the camera gripped firmly in two places. This permitted a slow shutter speed and some depth of field. Below. Turtles can be faster than you think! A hundredth of a second failed to stop the leg action of this box turtle hustling across a sand flat. Praktina, 150mm Kilfitt lens, 1/100 sec. at f/11 on Panatomic-X film.

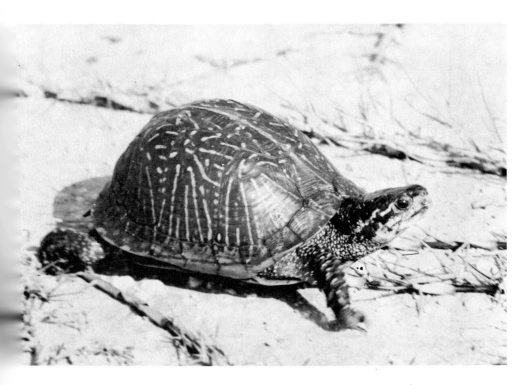

Spotted turtle was photographed from his own level to show details of head posture and profile of shell. Depth of field is quite shallow; fading light required an exposure of 1/50 sec. at f/5.6 on Panatomic-X film. Greater depth of field would improve this picture.

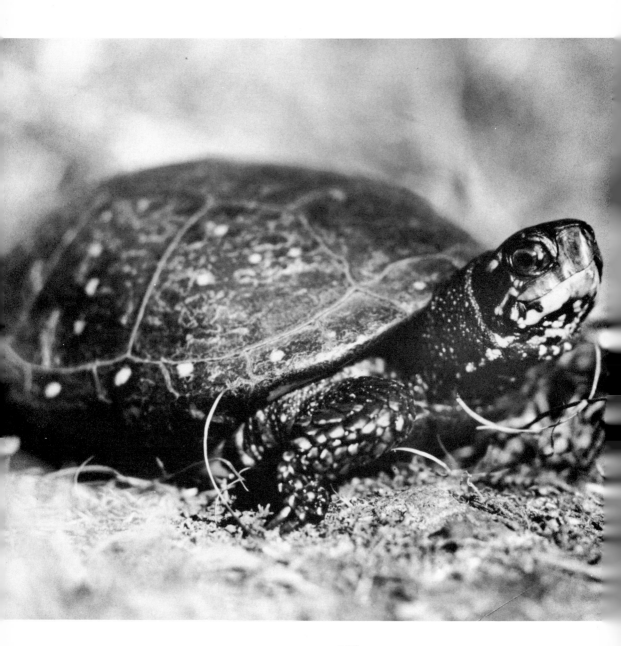

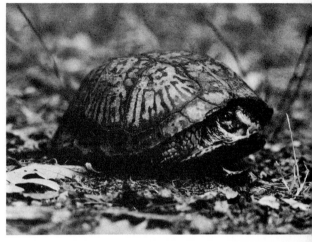

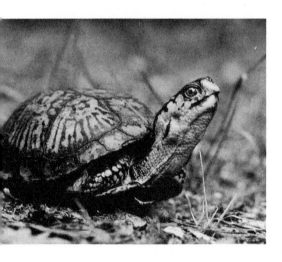

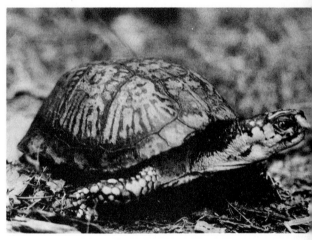

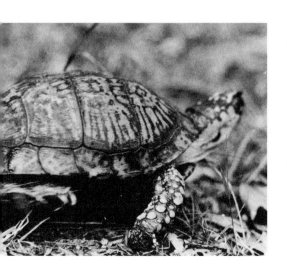

Turtles often hide when closely approached, and pull in their heads when picked up. From then on it's just a case of out-waiting them. When they do start to move, take a series of shots—peering out to see if all is safe, inspecting the surrounding territory, and finally moving off. Turtles can be surprisingly fast—use high shutter speeds if light levels permit.

Strobe units are much, much better than flashbulbs for work with amphibians. The heat of a flashbulb's blast at close range can do considerable damage to the health and peace of mind of a cool, moist salamander or frog, and the speed of a strobe unit is of obvious value in any kind of action work. Also, the mechanics of changing bulbs may alarm your subject so that you will have to re-pose him, and maybe chase him after each shot. Floodlights will generally be unsatisfactory, though they can be used for turtle pictures in a studio, and may even be of considerable help. Turtles who refuse to stick their heads out (until you've given up hope and aren't ready) will come alive and move if a moderate amount of heat is applied by floodlights. Don't be deceived by the apparent slowness of a turtle's movement. Try to shoot at 1/100 sec. or faster.

In the field, turtles are generally seen when they are basking on a log or rock near the water. When you approach, "ploop!" and they are gone. You can get a little closer by a slow approach in a canoe, but seldom can you get close enough to get a good image, even with telephoto equipment. A remote-control rig can be used to advantage, especially if there is one well-defined and popular sunning log. Using a blind will also allow some productive hours, and aside from the photographic value, will give you an interesting view of some seldom-seen behavior. With a bit of effort you can stretch a minnow seine below a well-used basking spot. On their way to the perch, the turtles will probably be at or near the surface and should cross over the edge of the seine easily. When they scramble into the water and head for the bottom, they will be caught and can be photographed elsewhere. To a person who is already acquainted with reptiles and amphibians, photographic studies will reveal details of anatomy and behavior that are difficult or impossible to see any other way. To the photographer who is new to this field of work, much new knowledge and enjoyment can be forthcoming.

Good pictures of reptiles and amphibians are not only valuable in scientific studies; they help the uninformed public learn how beneficial these creatures are, and thus help overcome deep-seated prejudices.

8
Insects

THERE are more insects than any other living things on earth, and they have been with us over 200 million years. Possibly three-quarters of all living things are insects! Over 900,000 species have been classified, and this may be only ten per cent of the total number! Insects play a vital part in the lives of birds, fish, amphibians and man. About one per cent of the known insects are considered harmful to man, but this small proportion attracts the greatest amount of interest and study. Knowledge about any part of this vast insect world is valuable.

One of the nicest things about photographing insects is that there are very few occasions when a photographer is completely balked. A bird or mammal stalker may return from a day's work weary and empty-handed, but there is almost never a shortage of insect subjects. Another nice facet of this field is that half a day's time and one bus fare are enough to get a photographer into some excellent hunting territory. At times his subjects may come to him without being asked; and if too many of them don't come at once, how convenient! Anyone who has never closely examined the common beetles, caterpillars, flies or moths has some surprises in store. Photography of these small creatures is an entrancing pastime, and not as hard as it might seem.

The larger insects, moths, butterflies, large beetles, dragonflies, and the like, can be photographed successfully with rangefinder cameras or twin-lens reflexes fitted with close-up lenses. By far the best camera for insect work is the single-lens reflex, with extension tubes or a good macro lens. A medium telephoto lens helps greatly in getting a large image without crawling on top of a specimen. For any work involving life-size film images or larger, there is no camera to consider but a single-lens reflex, or a rangefinder camera converted into one by a reflex attachment.

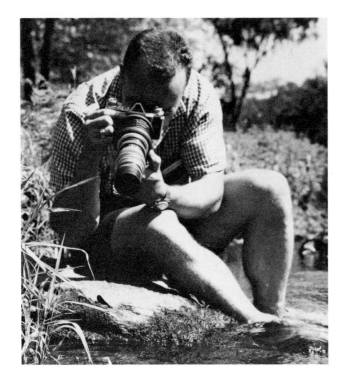

Stalking a damsel fly out-doors. After a slow approach pictures can be made at a range of two feet or less. A steady camera is very important; notice the two-handed camera support, and the wrist braced against the knee.

An outdoor study of a damsel fly. Praktina, 150mm Kilfitt lens, bellows attachment, image size on film about half life-size. Camera was positioned so that film plane was roughly parallel to the insect's body, so most of the insect would be within the zone of sharp focus. Plus-X film, exposed 1/200 sec. at f/11.

Head-on view of a damsel fly. The camera was aimed down at the fly, rather than horizontally, to make the zone of sharp focus more nearly coincide with the head and wings of the insect. Praktina, 150mm Kilfitt lens, bellows attachment, Plus-X film exposed 1/200 sec. at *f*/11 in bright sunlight.

A resting butterfly, with tongue tightly coiled, was photographed on a leaf. The soft light of a cloudy day produced this effect. Praktina, 150mm Kilfitt lens with bellows attachment, Plus-X film exposed 1/100 sec. at *f*/8.

Field work can be profitable, although a great deal of insect work is done in studios under controlled conditions. The field man generally concerns himself with the larger specimens since extreme close-up equipment is difficult to make comfortably portable.

A field laboratory can be set up at the car or any other convenient place. All photographic gear can be left here, and collecting done within a 100-yard radius. This will produce a whole line-up of subjects for a shooting session, and the bulk and weight of the equipment is no hindrance.

Field work includes some techniques used in bird and mammal photography. Insects that have "favorite perches," such as dragonflies, call for the birder's remote-controlled camera, or long telephoto lenses. The idea of a blind to conceal the cameraman is a good one, but it shouldn't be necessary. A bit of natural cover used as camouflage should do the job. The extremely long lenses are excellent for this work. Even with a 300mm lens, the camera should be no more than five or six feet away, and the dragonfly may not tolerate this close an approach. With an extreme-tele lens, lens-mirror optical system, or prism-telescope objective, the camera can be 20 or 30 feet away. Few such long-focal length systems will focus this close. The Questar telescope is superb; at close

126

ranges it is more a long-distance microscope than a telescope. It will focus on objects less than ten feet away; but at this range you couldn't get a whole dragonfly onto the negative! From 20 feet or thereabouts he will be nicely framed and will pay little or no attention to the photographer.

Prowling with the camera ready is profitable photographically. With any flying or leaping insect a photographer's approach should be slow and cautious. Pre-set the camera for the distance that particular size of insect requires, place your eye to the finder, and move in slowly. As soon as the image is sharp, fire away. A strobe unit will provide plenty of light on the subject and eliminate motion problems.

Generally, it's better to photograph an insect from his own level, rather than to shoot down on him. Legs, antennae, and other parts will show up better and the background is relatively so far away it's not distracting.

Flowers are good attractors for beetles, bees, and some other insects. Check them if you're collecting, or train the camera on one to catch flight shots of insects entering and leaving. Immobilize the flower with a wire or wooden brace outside camera range. You may have to cover other flowers in the vicinity with cloth or netting to herd insect visitors to the proper place.

Hungry katydid was caught by hand and moved indoors, where he started chewing on a leaf. Even the flash didn't bother him much; he didn't even try to fly away, and was finally released unharmed.

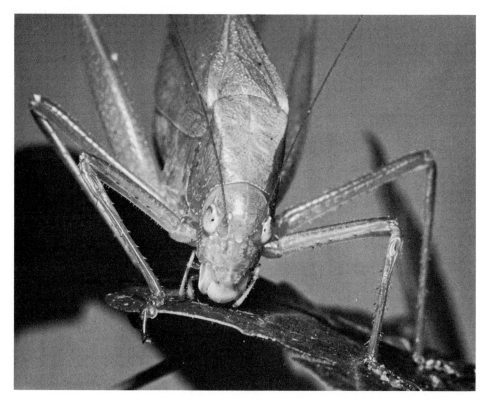

Though you don't know just what size subject you're likely to run into, a few basic lens-tube combinations can be worked out beforehand to handle, for instance, insects 2½ to 3 inches long; insects to be filmed life-size on the negative; and even subjects to be twice or three times life-size. You may find that using a medium-size extension tube and the normal lens lets you shoot the average-sized moth at about 12 inches, and using a full set of extension tubes gives a life-size image. Going a step further, using a full set of tubes with a 135mm lens should be good for three-inch subjects at a range of about 2½ feet. It's much easier to photograph butterflies and wary insects at this distance than at the very close ranges a normal lens requires.

Different makes of cameras and tubes vary enough so there's no general rule for which combination gives what magnification, or for how much exposure increase there must be when using various tubes or amounts of bellows extensions. The *exact* amount of exposure increase needed in any individual case can be easily worked out by using the formula discussed in Chapter 4; however, a fairly close guesstimate can simply be stored in your memory and will be adequate for most purposes. For instance, if the subject is more than 1½ feet away, you need no corrections. If the subject is about one foot away, open up one-half stop. If the subject is *half life-size*—a three-inch object fills a 35mm viewfinder frame—open up a trifle more than one stop. If the subject is *life-size*—a 1½ inch subject fills the frame—open up two stops.

These four simple *rules of thumb* can be written on a small peel-off label, or a piece of paper tape, and stuck to the back or bottom of the camera, in the lid of your gadget bag, or any other convenient place, and within a week or two you will have them memorized.

Most of the time, though, when shooting close-ups of anything that moves, you will want to use electronic flash to stop motion. Now exposures are simplified. The light will be constant for every exposure, and if you use the same electronic flash unit and the same film, you will always use the same *f*/stop at any given distance. With this as a constant, you can mark the *f*/stops right on the focusing mount of the lens; then it will read distance and *f*/stop simultaneously. Use stick-on paper dots, or to make a neater and more permanent job, take a Dymo Tapewriter and print out nice neat little numbers on black or clear self-sticky plastic tape. With an electronic flash having a Kodachrome II guide number of 28 and a compensating-diaphragm macro lens, the distances and *f*/stop markings will be: 4 feet, *f*/8; 2½ feet, *f*/11; 20 inches, *f*/16; 14 inches, *f*/22; 9½ inches, *f*/32.

Most macro lenses and extension tube sets will let you shoot up to life-size on the film. To get a larger image, you must add more tubes or a bellows; compute exposures by formula, or take a guess, shoot tests, and *keep notes.* Examine the processed tests, and put *f*/stop labels on the bellows track. Whenever the subject image is larger than life-size on the film, the lens should be reversed so that the front element faces the film instead of the scene. This will produce

Canonflex rigged for extreme close-up photography of mosquito on girl's hand. A 100mm lens was used, since insect wouldn't tolerate a close approach. Strobe is mounted on camera, and lens used in reverse position on bellows attachment. Index finger of left hand trips automatic-diaphragm button just before right hand sets off shutter.

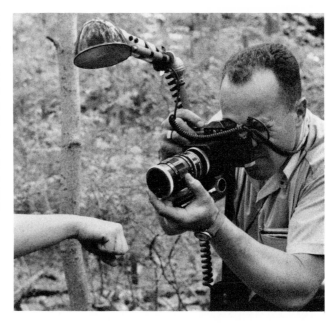

A close view of a familiar insect. This mosquito was photographed on a painted wall, with the strobe unit held at about right angles to the surface. The shadow produced separates insect and background better than frontlighting would have. Praktina with extension tube producing twice life-size image, 58mm Biotar lens at $f/16$ (effectively $f/45$), Multiblitz strobe unit, Plus-X film.

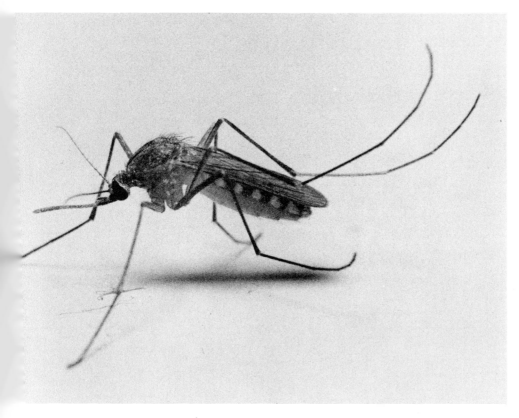

sharper images. The difference is slight, but worth taking advantage of. A few cameras have extension tubes that mount a lens this way. Several cameras have a tube that produces an image about twice life-size, with the normal lens reversed.

Automatic lenses are a joy to use and tremendously valuable in these extreme-magnification pictures, especially in the field or when photographing a moving specimen. Viewing and focusing are done with the lens wide open, the image at its brightest, and the depth of field at its shallowest. A sharp viewfinder-image when the shutter is pressed practically guarantees a sharp negative, with the subject centered in the area of sharp focus. When an automatic lens is used with extension tubes or bellows some means must be devised to trip the automatic diaphragm a split-second before the shutter is released. Some lenses can be tripped by a cable release, and a double release lets the diaphragm and shutter be set off by pushing a single button. Internally-coupled diaphragms can be actuated by adding a lever or push-rod to the inside of the extension tubes. The length can be determined by a little experimentation. When the lens is reversed, the automatic diaphragm button that stops down the lens is facing away from the camera, and is usually out in the open where it can be tripped by hand. With a little practice it's quite easy to trip the automatic diaphragm with the left hand just before the shutter is set off with the right. Using strobe eliminates the problem of camera-movement, and results are excellent with a minimum of effort.

An ox beetle, after chilling in a refrigerator, warms up on a twig in the studio. Praktina, 58mm Biotar in bellows attachment, three strobe units: one side of camera, one for backlighting, and one on the grey paper background. Panatomic-X, f/8.

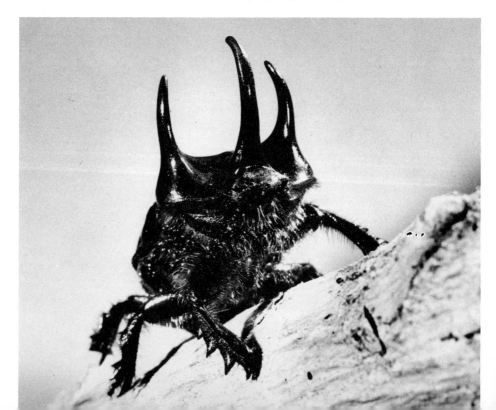

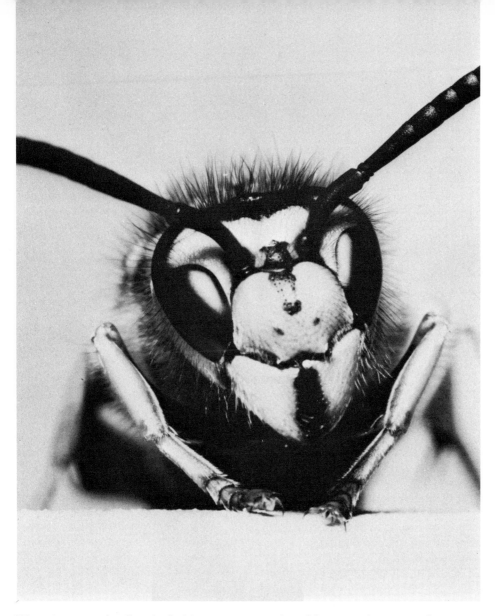

Ultra-close-up of yellow jacket hornet was produced by mounting macro lens on a bellows to give an image five times life-size. Insect was doped with carbon dioxide gas and lighted by one electronic flash held above him. Exposures were determined by prior tests.

Most modern lenses are fine for the extreme close-ups some insect photography requires. Special lenses are made for this type of work: the Micro-Tessars, Micro-Summars, Luminars. These lenses are symmetrical, and generally slower than normal lenses. They are supposed to be sharper at the higher magnifications, and probably are, but the difference is hard to detect in practice. Certainly all lenses you now have should be given a good trial before you purchase any new ones. One-inch lenses from motion-picture cameras can be excellent, giving twice as big an image as the normal 50mm lenses. They are also lightweight and quite fast.

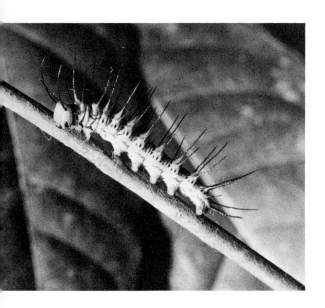

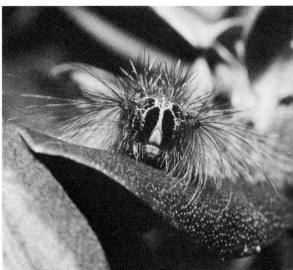

Above, left. A twig and green leaves for a background made an effective set for this caterpillar, photographed with a Hasselblad and one strobe unit on Panatomic-X film at *f*/11. The twig was mounted parallel to the film plane to make the best use of the fairly shallow depth of field. Above, right. This gypsy-moth caterpillar, with distinctive face-pattern, was found crawling on a rhododendron bush. Camera with macro lens was placed to have a leaf behind the caterpillar, which was photographed half life-size with a small electronic flash unit. Below, left. Wood tick, crawling on photographer's arm, was shot at twice life-size by using macro lens on a special homemade extension tube. An assistant held a small electronic flash unit to give modelling reflections from tick's back. Below, right. A slow, careful approach may let you get close enough to photograph insects at a range of two or three inches. The eye colors of this horsefly show up well as she rests on a window sill in a kitchen. Macro lens, life-size image, small electronic flash unit.

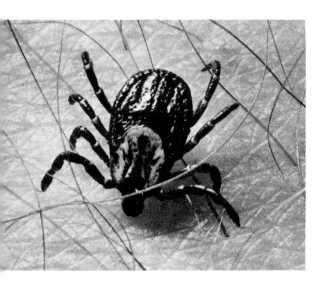

The various macro lenses are very valuable and convenient to use in photographing insects. Most types have a double-helical mount that extends enough to give a half life-size image, and will focus back to infinity. A special extension tube is supplied that will focus from the half life-size image distance (about 4½ inches from front of lens to subject) to full life-size. Most macro lenses are well recessed to eliminate the need for attaching a sunshade. This is a good feature but may cause trouble when you work close; it will block off light unless you use side- or rimlight. A flatter construction or a longer focal length would avoid this. There are a few 100mm and 135mm macro lenses available now, and more coming.

Studios for insect photography can be a corner of a shed or garage, a table in any room in the house, or whatever area is handy; not much space is needed. Strobe units are by far the best lighting equipment and props are simple: just a branch, green leaf, twig or cigar-box of sand or earth. Insects can be controlled quite well by chilling them in the refrigerator for a short time. The active ones will be slowed down or stopped temporarily.

Several shots should be possible before they warm up and become too active. Another chilling makes them tractable again—temporarily!

Carbon dioxide can be used as a chilling agent. Small steel "bottles" sold for emergency inflation of automobile tires hold it under pressure, and the valve can be barely opened to produce a stream of very cold gas. It is altogether too easy to kill a specimen this way; the icebox method of subduing insects is preferable.

The chilling should be done carefully, and watched closely. Put your specimen into a glass bottle, with air holes in the lid, and pop him into the refrigerator's freezing compartment. Check him often; five or ten minutes should be enough—and don't go off and forget him! A jar of forgotten specimens, like *Pentatomidae,* is seldom considered proper company for the family's food supply and is universally looked upon with disfavor by wives, mothers, and cooks. Also, you'd have to go out and round up some more specimens for photography.

Crawling insects can be placed on a twig parallel to the film plane of the camera, and shot as they crawl into the frame. When they get to the end of the twig, they will turn around and come back again, giving another picture opportunity before they have to be "herded" or relocated. Beetles will often fly when they get to the end of the twig, and with luck you'll get a fine take-off picture. Head-on shots can be made just as insects reach the end of the twig. Watch them in the finder and shoot just when they come into focus. For scientific work, or where a size-reference is desired, use a length of plastic-insulated wire instead of a twig. If this is of known diameter (say 2mm) measurements can be made quite accurately from the finished photograph. A whole caterpillar study, from the first instar, 5mm long, to the 60mm adult, can be made on the same wire.

Backgrounds can be plain paper of a neutral shade, blue paper to simulate sky, or a few green leaves arranged so the specimen will show up nicely in profile.

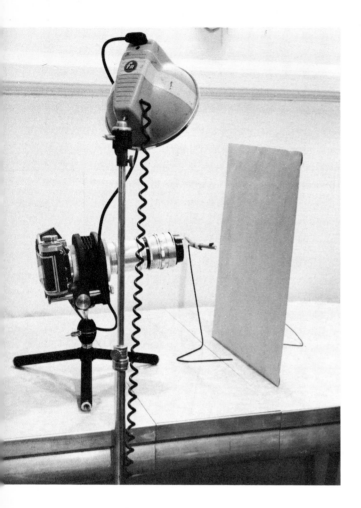

A simple stand for small subjects like the salticid spider, opposite, is easily made from coat-hangers. A background card is supported in the same manner. The camera is on a Rowi tripod; bellows and extension tubes produce an image about three times lifesize. The spider, about a quarter-inch across, was quieted by chilling in the refrigerator before being set upon a twig and photographed. A single strobe unit was held above the camera to throw shadows under the spider and separate him from the twig. Notice the shallow depth of field produced, even at $f/16$, when working with an image almost three times life-size on the film.

If shadows become a problem, use a fairly dark background paper and beam one light directly at it.

Extreme close-ups of insects are seldom done with live specimens, as any slight movement would be photographically disastrous. Of course, it is possible to lash a live insect down, but few people have the patience or dexterity to do it, and a well-chilled or dead specimen is much easier to work with. Photographs of dead specimens should never be passed off as photographs of live insects. This is unethical and fakes are easily detected by experts.

Details of antennae, mouthparts, or eyes make fascinating studies, and the degree of enlargement can be carried as far as you wish. Adding more and more lens-extensions increases the possibility of movement, but using strobe lights virtually eliminates troubles from this quarter. The depth of field gets shallower and shallower, and we must decide what part of the subject at hand we most want in sharp focus. An enlarger baseboard and upright makes a very good camera stand. A single-lens reflex with a waist-level finder is easiest to use, and can be raised or lowered at will. The insect can be laid on paper, or to eliminate shadows, on a sheet of clear glass with a paper background a few inches below it.

134

In extreme-enlargement work the lighting should be more contrasty than normal. Using one light generally yields the best results. It can be placed to throw a shadow underneath the insect, separating him nicely from the background.

Though spiders are not insects, the photographic techniques are the same. They are fine subjects since they tolerate a close approach and allow the photographer to move around. The webs are a study in themselves, and need only a modicum of time and equipment to be photographed. An atomizer or spray gun will add water droplets to make a web stand out. A dark background cloth adds contrasts and separation. Lighting can be sunlight, strobe or diffused daylight. The dew-covered web will look unnatural if lighted by direct sunlight or strobe; save these for dry-web pictures.

Opposite, upper left. You may not be the only hunter on the scene! This small spider captured a housefly as I was getting ready. Such bits of unexpected action are often the best shots. Upper right. A dead-leaf mantid with her egg case, covered with newly-hatched young, was photographed in a studio with a banana leaf for a background. Hasselblad, normal lens with extension tubes, two strobe units. Panatomic-X film, exposed at f/16. Opposite, below. Close-up of a dead-leaf mantid's head, as she hangs upside down from a twig, shows pointed compounded eyes, antennae, mouth parts, and front legs ready to grasp prey. Praktina, normal lens reversed and mounted to give life-size image, one strobe unit, f/16 on Panatomic-X film. Below. A spider built a web in the author's window, and was duly photographed after sunset so the dark background would provide contrast. One strobe unit was used on the side of the camera and another backlighted the web from the outside. Hasselblad with normal lens, strobe exposure at f/16 on Panatomic-X film.

There are few days and hours in the day when good insect photography can't be undertaken. Rainy and windy days are no hindrance to any sort of studio work, and outdoor work can start before dawn and run late into night. In the early morning, many specimens are sluggish and easy to control, though the light level may require flash or strobe. It's a great time to be afield for any reason, and especially for photographing or collecting. Darkness brings forth a host of insects seldom seen in daylight, and they will usually come to a bright light. Shine a floodlight on a white sheet, building or board, with a paper funnel and bottle below it to catch the insects. Shining a light at a screened window or door is almost as productive. Moths and beetles will flock to it and can be photographed on the screen itself or collected for later work.

A clean window with a strong light behind it lets you photograph the underside of the specimens attracted. With a bit of care to avoid reflections the glass will scarcely be noticeable and certainly not objectionable.

Aquatic insects are caught in dip nets and transferred to a small aquarium set up at the water's edge. Paper or cloth behind it makes a uniform background. Aquaria can be made from microscope slides, cover glasses, or squares of window glass cut to size. The aquaria should be thin so the subjects will stay in focus. If the surface of the water shows in the picture, try filling the aquarium to the brim, adding water with an eye-dropper. The meniscus will disappear and the surface becomes a straight line that shows all possible detail and doesn't conceal any part of the insect.

While I wouldn't recommend everyone's attempting to photograph a series of 890 caterpillars as I once did in Trinidad for the New York Zoological Society, I certainly think insect photography deserves a place in your picture-taking schedule. The results can be amusing, colorful, and full of variety.

9

Picture-Making in Zoos and Aquariums

ANY photographer who passes up the opportunities a good zoo offers is missing more than he may realize. Especially in the field of nature photography, worthwhile training and practice can be undertaken there, and many excellent pictures of rare and unusual specimens can be made nowhere else. A zoo offers a concentrated, continuously-varying workshop where a photographer can (and must!) use many of the techniques he should perfect for field work. Zoo animals come in sizes from two-inch, one-ounce mice to ten-foot-high elephants weighing several tons. For some you will need wide-angle lenses; for others the longest telephotos you can lay your hands upon. The only safe procedure is to carry all the lenses you have.

Lighting situations will be daylight in one instance, dim shade in another, or tungsten, fluorescent or diffused skylight illumination. You may shoot with strobe at 1/5000 sec., or make a 20-second time exposure. The color specialist will have a field day. Differences in form and contour are almost as varied as are the colors. Zoo photography can be for practice, artistic value, science, humor, record purposes, information, or just plain fun.

The local birds and animals are generally well represented and offer a chance for close-range study that will be of value when working with the same species in the wild. Admittedly, the zoo animals are living under artificial conditions and their behavior is not always as it would be under natural conditions; but the basic patterns remain the same. The behavior associated with curiosity or alarm will be close to that of their wild counterparts. You can get to know them to some extent, at least, and this is well worth the effort. Certain postures and actions can easily be learned and may indicate what the animal is getting ready to do. Tail-flicking, head positions, and general "expressions" may well tell you that your subject is alarmed and about ready to run or fly—recognizing this attitude in the field will

caution you not to approach closer until the animal calms down a bit. I can think of no better, more convenient or more enjoyable place to field-test a new lens or camera in a limited amount of time. You can run the gamut from extreme close-ups through medium shots to quite long range work, and will be using f/stops from 2 to 22.

Many situations require only the normal lens, and a rangefinder camera or twin-lens reflex will do fine. A fast shutter is helpful, and synchronized flash or strobe improves the quality of the finished picture. Seldom can you move around zoo animals to improve the lighting angle, but fill-in flash will save the day. Even in good light, harsh shadows are modified nicely, and there is a sparkle to properly done synchro-sunlight shots that lifts them out of the ordinary. Strobe units are far kinder to human and animal eyes than flashbulbs.

Some zoos have forbidden the use of flashbulbs; one reason is that many people throw them anywhere after use. The bulbs also put out considerable heat, which could crack glass enclosures, and the blast of light and heat is much more disturbing to birds and animals than the cool, quick blink of a strobe. After the first shot or two, a hummingbird may continue feeding while the strobe goes off, whereas one flashbulb exposure may agitate him seriously and even dangerously. Light from an electronic-flash unit is practically the same as daylight in color; daylight-type film will do fine whether you shoot indoors or out. I feel the color quality of pictures made by strobe is better than those made with blue flashbulbs.

For stopping motion there is nothing that comes close to a strobe unit. Most portable units have an effective duration of 1/800 to 1/1200 sec.; ample for most uses. The higher-speed units designed for scientific use are heavy and costly, and films begin to show serious speed loss and color shifts when exposures run 1/10,000 sec. and less. Strobe units are very handy for fill-in flash in daylight using blade-type shutters. The same amount of strobe light reaches the film, regardless of the shutter speed selected. Therefore, the strobe-to-subject distance determines the f/stop; an exposure meter shows what shutter speed at this f/stop is correct; and there you are. However, using the regular strobe guide number will kill daylight shadows completely and may overexpose the subject.

For a three-to-one lighting ratio, multiply the regular guide number by 1.7 and use that to compute the strobe fill-in exposure. If we use a strobe unit having a guide number of 60 with Ektachrome film, and want to shoot a kangaroo 15 feet away in good sunlight, we would multiply the guide number of 60 by 1.7, getting a new number of about 100. Divide it by 15 (feet) and get (approximately) 7. Set the diaphragm at f/7 and check the exposure meter. It will indicate 1/100 sec. at f/7 as the right daytime exposure. This will give a properly-exposed background and highlights, and the strobe will throw enough light into the shadows to render

Finding a really rare creature in a zoo is always a treat, especially if it's in a photographable situation. Happily, the London zoo's giant panda, "Chi-Chi," is in an open-moat enclosure. A 200mm lens and a little patience can produce informative and appealing pictures.

detail without ruining the modeling effect of the direct sunlight. At ten feet, under the same conditions, we would set the diaphragm at $f/10$, and, from the meter, our shutter speed at 1/50 sec. If the calculated shutter speed falls between the settings on your camera, choose the closest one and adjust the diaphragm to give the correct *daytime* exposure.

The $f/$stop may be higher or lower than it should be, but the daylight exposure is the more important, and a slight variance in the amount of strobe fill won't be noticeable. The same procedures can be used with a focal-plane shutter and flash-bulbs. The difference is that changing the shutter speed also changes the amount of flash-illumination, and the calculations can get a bit complicated. Try to work

When animals are motionless, slow exposures are possible. These fennecs were photographed at a half-second; the camera was pressed firmly against the glass of their cage to prevent motion.

with one or two speeds for which you know the proper flash exposure, and multiply the guide numbers by the same factor of 1.7—or close down about ⅔ of a stop.

The bird house will probably occupy as much of your time as any other single location. Most birds are kept in wire-mesh enclosures and may at first glance seem to be a waste of time photographically. Not so! Try shooting with the lens wide open and held close against the wire. You'll discover that the wire magically disappears. There's your subject, pretty as a picture and with no cage front evident. Using a single-lens reflex, you can watch the image as you stop down and can see just how far you can go; it may be a stop or two less than the maximum aperture before wires begin to appear. After framing and focusing, keep your eye at the viewfinder and move the camera left and right, up and down, to see if the bars show at all. If there are greyish bands evident, open the diaphragm a bit and center the subject in the clearest area.

With twin-lens reflexes and rangefinder cameras, you will be shooting blind, but it's still worth trying. Open the lens wide and center it in an opening. "Cyclone" fencing, with a mesh of about two inches, shouldn't cause any trouble at all. Even heavily-painted turkey wire with a mesh of ½" x 1½" can be "eliminated" by this method. Indoors or out, shade the wire directly in front of the lens as much as possible, especially when using a flash or strobe. If the wire is painted a light color, or is shiny, there may be no way to shoot through it successfully; but generally this simple trick will work like a charm. Remove the lens shade if necessary to get the front element of the lens right up close to the wire. Wide-angle lenses, especially retrofocus types, may show wires at all apertures, but most normal and telephoto lenses will cut right through. The faster the lens, the better.

The wire will cut down on the intensity of the light entering the lens, sometimes as much as one full stop. Take a reflected-light meter reading through the wire and it should be correct. When using flash, the light will be cut down first when it goes from flash-tube through the wire to the subject, and again when it is reflected back through the wire and into the lens. This may be as much as two full stops in the case of heavily-painted turkey wire. In any sort of unusual work like this, *take notes* and take them carefully! Whenever you're experimenting it's a good idea to take two or three test exposures first, writing down the type of light, meter reading, filter if any, flash-to-subject distance, f/stop and shutter speed, and anything else pertinent. When you see the results of these test exposures you're well prepared to do some extensive work—much better than a whole roll of duds on the first go-round.

Telephoto lenses are necessary at close ranges of five feet or so to get close-ups of small birds. Also, framing in close will avoid getting a half-dozen different species in one picture. A 100mm or a 135mm is a good all-around lens for a 35mm camera and occasionally you will need a 200mm. In fact, if you carry a 300mm or even a 400mm telephoto, you may be very much surprised at how often you will use it!

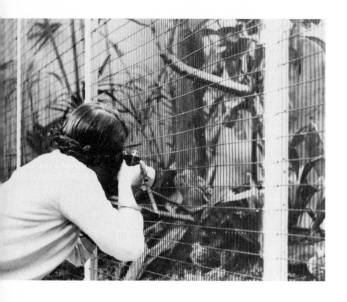

Shooting through wires is successful only if you hold the lens right against the wire and shoot at a wide aperture; generally f/4 or wider. With a single-lens reflex, you can see exactly how much effect the wire has, if any.

A common jacana, photographed through black-painted turkey wire. A shallow depth of field is unavoidable when photographing through wire-mesh cages. Praktina, 58mm Biotar, exposure 1/50 sec. at f/2.8 on Panatomic-X film.

Color Plate 1. Winter is a good time to pursue the larger mammals, since vegetation no longer conceals them and they seem less wary. But anything as big as a bison should be approached most carefully!

Color Plates 2 and 3. (2) Showing both adult and young Emperor penguins in one picture makes it that much more meaningful and informative. Incident-light meters give best results; bright snow will overwhelm the reflected type. (3) Electronic flash is a lifesaver in insect work. You usually need the action-stopping and depth of field to successfully catch short-lived and unexpected action, such as this spider trapping a yellow jacket.

Color Plates 4–6. (4) Looking at a subject from many different angles often reveals one type of lighting to be better than another for that particular subject. Backlighting brings out the most detail and beauty in these Pulsatilla blossoms. (5) Small mammals raiding a bird feeder offer many good opportunities for photography. They will often stay long enough for a whole series of exposures, and electronic flash will stop any motion. (6) Sunsets are common, available, and free, but you must get into an obstruction-free vantage point well beforehand to produce good photographs. Underexpose for saturated colors and occasionally use telephoto and wide-angle lenses.

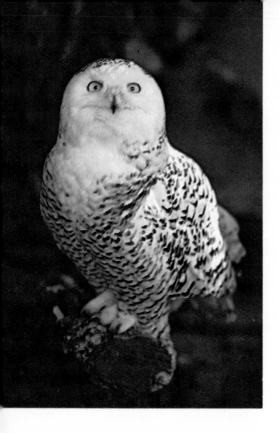

Color Plates 7 and 8. (7) Most bars and wires in a zoo situation will disappear if the lens is brought close to them. Use a moderate telephoto lens to achieve a large image and eliminate much distracting background. (8) For any close-ups underwater, flash is almost mandatory to produce enough light for good exposure and depth of field. Electronic flash stopped the waving fins of this yellow-headed jawfish.

Zoo animals behind large-mesh wire fences are no problem at all; just center the lens in an opening and shoot. Eagle was behind "Cyclone" fencing and was photographed with a Hasselblad and normal lens, 1/100 sec. at f/5.6 on Panatomic-X film; cloudy weather.

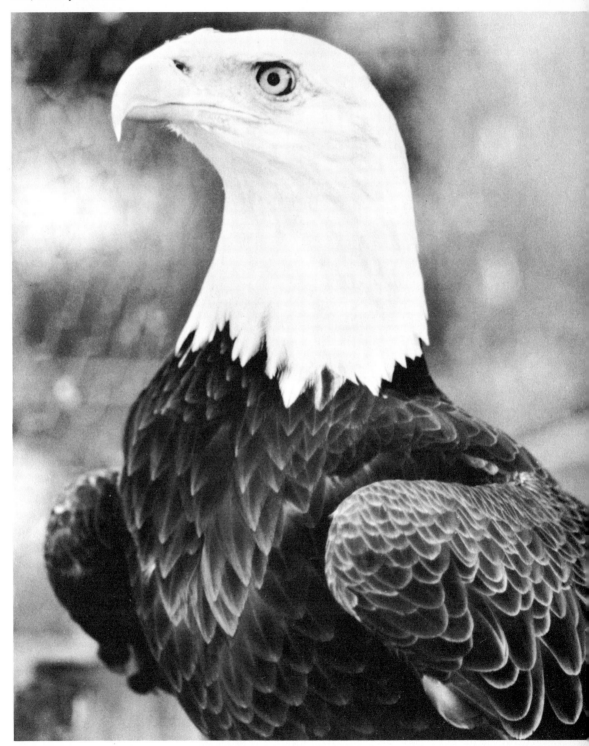

Every picture need not show the whole animal; it can emphasize the face, or any particularly important feature. A 105mm lens was pressed against the wires to record this proboscis monkey. Nikon F at *f*/4.

Extension tubes or a bellows are needed to focus close with a telephoto lens. Most 100mm and 135mm lenses will focus down to four feet or so without tubes, but you'll often be working at two, three, and four feet. Also, pushing a camera with a normal lens up to within a few inches of a small bird may panic him into hiding in the corner of the cage. Using a tele lens from a little further away will yield much better results. With wire cages you can't back up and not have the wires show, but at a glass-fronted enclosure this is quite practical. *If the glass is scrupulously clean* there's no problem, but this happens altogether too seldom. The keeper will generally clean the glass for you and may even be able to remove smudges from the inside surface. For the best results, move the camera about as you sight through the finder, looking carefully at the subject all the while. There may be normally-unnoticeable smudges of dirt or oil, or even a defect in the glass, that you can spot this way, and avoid. Even clean glass will produce a "fog" effect on film if the flash or strobe light hits it directly. Sometimes you can shield the glass immediately in front of the lens from the light, but more often you must shoot away and hope for the best.

Camera reflections may show up in the glass and appear as out-of-focus rings and blotches on the film. A simple device will lick this problem in short order. For a single-lens reflex, take a piece of black cardboard and cut a hole in the center, just big enough to fit over the lens or be clamped to it by a filter ring. The ring should be painted black, and a cardboard a foot square will be big enough for most work. You can still frame and focus in the normal manner, but the only reflections that enter the lens are those of the black cardboard—practically nil. Rangefinder cameras can be equipped likewise, with holes for the lens and both rangefinder windows. For twin-lens reflexes cut two holes for the two lens. There is some chance that light entering the viewfinder of a twin-lens reflex will produce reflections. Wear a hat or drape a focusing cloth over your head if it seems necessary.

Reflection-eliminator made from a rectangle of black cardboard. This one is simply pressed onto the lens of a single-lens reflex camera; a filter-ring could also have been used to hold it in place, but would have to be painted black.

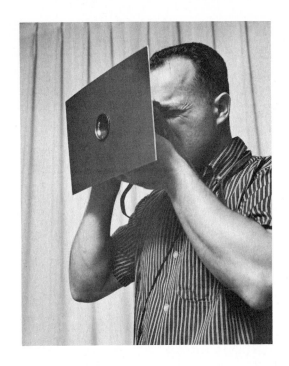

Photographing an animal with its children or mate is always more interesting than an individual portrait. Swans commonly carry their young on their backs but they are not often distinguishable. You may have to wait a bit until the cygnet sticks his head out to look around.

Left. By shooting through the side of this emu's cage, and not the front, all evidence of fences was eliminated. He was recorded as he came to investigate the photographer. Hasselblad, normal lens, 1/250 sec. at f/5.6 on Panatomic-X film. Right. The delicate neck-pleatings of a nene, or Hawaiian goose, are one of its most noticeable characteristics. Shooting head-portraits with the lens nearly wide open shows this feature nicely while keeping the background way out of focus.

There will be times, especially at the aquarium, when you will need a reflection-killer bigger than cardboards will conveniently make. A sheet of black cloth, with a hole cut in the middle, can be set up on lightstands or held by assistants for these occasions. As long as no shiny parts protrude and the glass is clean you should have no problems—from reflections at least.

Large flightless birds such as rheas, emus, ostriches, and cassowaries are generally kept outdoors in pens and can be photographed with tele equipment. You may be tempted to use a normal lens and lean over the fence but it's a risky operation. These birds peck at shiny objects like eyeglasses and can do a lot of damage. Aside from the danger involved, equipment may not be safe from disaster or ingestion. There is at least one emu in the world with a perfectly good exposure meter in its stomach.

Pinioned cranes, flamingos, geese, and ducks are all prime subjects and are often found in attractive settings. The medium telephoto lenses cut out extraneous background objects and concentrate attention on the bird itself; long tele lenses allow head portraits and close-ups. Flash or strobe fill will lighten the shadow areas and put a catch-light in the eye.

The more modern zoos keep large animals in moated enclosures without bars—a wonderful idea, visually and photographically. Telephoto lenses pro-

duce full-frame close-ups in quite natural surroundings, and the open area of the moat allows some flexibility in the angle of approach. Notice where the sun will be at different hours of the day, and plan your work accordingly. If the animal is quiet, use a tripod to guarantee sharpness. To catch a particular posture or bit of action, set the camera on the tripod and wait with a cable release in hand. Trying to handhold a camera for more than 30 seconds or a minute will produce a fine set of wobbles; with a tripod your entire attention can be focused on the timing involved.

Small mammals and reptiles kept in glass-fronted cages are some of the few subjects for which you'll need a wide-angle lens. The cages may only be a foot deep and the normal lens close to the glass won't include the whole animal. With the wide-angle you can shoot successfully with either available or artificial light.

Even in fairly strong daylight, you may be well advised to use flash. When an animal's eyes are deep-set, the flash will add a lot of sparkle to the picture. The orangutan was photographed with a 400mm lens at a range of about 80 feet. Even at that distance, the flash helped considerably.

149

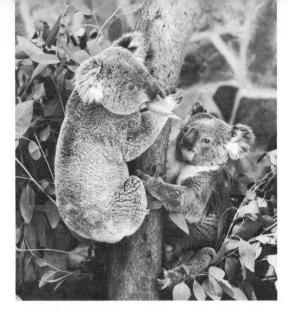

Opposite, above. A cold morning brought a frosty yawn from this zoo lion, photographed with a 500mm lens across a moat. The Hasselblad was mounted on a tripod, and a short wait was necessary to catch yawn at its peak. Opposite, below. The low light of early morning produced this profile of the lion, photographed at about 100 feet. The stone wall background is still in shadow, providing plane separation and contrast. Both shots, Panatomic-X film; exposure 1/100 sec. at f/9. Above. If one appealing animal "doing its thing" is good, two are better. These koalas, eating eucalyptus leaves, are engaged in their favorite activity. The soft light of a cloudy day is much better than bright sun, which would have shown harsh shadows. Below. Despite the fact that zoo animals continually hear every sort of noise humans produce, it still pays to try and attract their attention by making a peculiar sound. Koalas always look quizzical, but don't always look toward the camera!

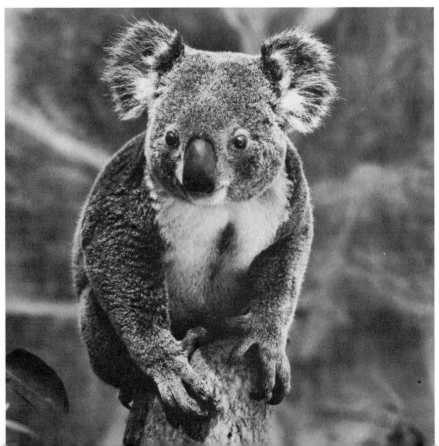

Many aquarium specimens call for wide-angle lenses, too, especially if they cruise back and forth close to the front of the tank. The depth of field produced by a wide-angle lens is a big help with a moving subject.

Behaviorism studies must be made with a hand-held camera since you'll have to follow a fish around with your eye glued to the finder and wait for him to perform. Automatic lenses that stop themselves down a split-second before the actual exposure are a tremendous help here. Focusing on a moving subject with the lens wide open allows some margin for error when an automatic lens is used; the depth of field is always greater on the film-image than you see in the finder.

Most aquarium tanks are well-lighted and excellent black-and-whites can be made by available light. Several high-speed color emulsions let you capture many zoo and aquarium specimens in color with a minimum of fuss and equipment.

A few years ago I photographed the penguins indoors at the New York Zoological Park. To do it I lugged in a camera, telephoto lenses, tripod, two strobe units, two light stands, 40 feet of wire, and a large black cardboard reflection-eliminator. It took a couple of hours to set up and get the coverage I was after. Recently, I re-shot the same birds on High-Speed Ektachrome, using available light and shooting at 1/50 sec. at $f/2.5$. The only equipment involved was a 35mm camera and lenses. Results were good enough to be published in *Popular Photography* and required perhaps a tenth of the previous effort to produce.

Under extremely unfavorable lighting conditions, where even High-Speed Ektachrome is too slow, there is another trick to consider. Independent processing laboratories can push the speed of most color films to double their normal ratings with a very slight loss in color saturation and gain in contrast. If you plan to use an entire roll under poor light conditions, it's not a bad idea at all. Active fish can drive a photographer to distraction, when he needs fairly high shutter speeds and would love to have a little depth of field too. Using High-Speed Ektachrome at an exposure index of 320 can be his salvation.

Above all, *don't* stint on film when shooting a moving subject or trying to catch a particular bit of activity. Of a series of shots, one will always be better than the others; if you stop shooting after the first one or two you are gambling on getting good results and almost certainly will not come back with the best it's possible to get. Your own reaction time may be too slow to catch the peak of the action the first time or two, and there are other things that can go wrong —it's best to shoot enough to guarantee one outstanding exposure.

The outdoor pools and tanks at a public aquarium call for the same techniques and equipment as zoo work does. In addition, modern aquaria often have indoor windows where you can watch fish, seals, turtles, and porpoises swimming underwater. If the windows are large, and the subject comes close to them, try backing away and using fill-in flash. The sunlight in the pool will be coming from almost straight above and the shadow areas go quite dark without addi-

Above. A friendly, playful porpoise makes a fine subject, but also moves pretty fast. The camera was pre-focused where he was expected and tripped at the peak of his motion. Foam-flecked water forms a pleasing natural background. Below. Until recently, killer whales were unknown in captivity and only a handful of people had seen them. Now they are readily accessible. A 105mm telephoto produced this close-up view of a toothy smile.

tional light. It's seldom possible to shoo everyone away and rig anti-reflection screens in a large situation like this; try flash-on-camera, shooting at an angle of *at least 45 degrees* to the glass and you should have no flash-bounce to trouble you.

To see where flash reflections will be, hold a flashlight at the camera and point it toward the glass. Shooting straight at the glass window or tank with a flash on the camera guarantees poor results—but how often we see someone trying to do just that! If you want to shoot head-on, move the flash well to one side of the camera; generally as far as you can get it and still have it hit the subject. You may have to close doors or black out opposing windows if their reflections are evident.

Left. Since electronic flash shooting often produces a dark background, a dark subject, like this batfish, may be "lost" against it. Shooting by available light is preferable, even if slow shutter speeds cause a slight loss of sharpness. Right. Always try to visualize the effect of the flash. It was held above the camera here; holding it to one side would have left the other side of the triggerfish in deep shadow.

Above. Light subjects photographed by flash, like the filefish, will stand out sharply against a dark background. Electronic-flash is excellent for aquarium specimens in both black-and-white and color, stopping action and yielding good depth of field. Below. Two salient features of the fresh-water porpoise are its cylindrical snout and the whiskers growing on it. Flash was used from above to give modelling; black cardboard around the lens eliminated reflections.

If using color film, always check to see what type of light is falling on the subject. Sunlight is of course evident, but four small tanks may have four different sources of illumination and all look pretty much the same. Tungsten bulbs and spotlights, of course, call for tungsten-type film, but fluorescent tubes are a problem to figure out. They may be "Daylight" types. They may also be "Cool White," "Warm White," "Deluxe Warm White," or "Soft White." Furthermore, "Daylight" tubes from two different manufacturers will give light of slightly different colors. Some tubes will give best results with daylight films; others with type "A" or "B" films. You can seldom see the tubes themselves. If you can find out what type they are, try the daylight films with the daylight-type

Starfish climbing on glass front of aquarium was photographed with Canonflex and 50mm lens with supplementary close-up lens. Subject was about 14 inches from camera. Plus-X film, exposure 1/30 sec. at f/8. This was a lucky shot.

fluorescents, and for critical work use color-correcting gelatine filters. Surprisingly, some daylight tubes may require a CC10R (red) filter, and others a CC10B (blue). For the "Soft White" and "Warm White" types, try type F films with a CC10M (magenta); type B films with a CC10 or CC20R, or type A films with no filter. The General Electric Co. has published an excellent, comprehensive table of films and filters for fluorescent illumination.

They all should be considered bases for your own testing; differences in film, processing, and exposures make it unwise to set any hard-and-fast rules. Also, I suspect the manufacturers change the phosphor formulae from time to time without notice. Unless critical work is needed, you can do quite well with

Tungsten spotlights above a large tank furnished illumination for this spiny lobster, pictured as he walked across the sandy bottom. Praktina, 58mm f/2 Biotar lens, exposure on Plus-X film, 1/50 sec. at f/2.2.

157

two cameras, one loaded with daylight film and one with artificial-light film. Switch back and forth as conditions dictate, *keep notes,* and shoot a picture on each roll if in doubt. Mark the rolls when they are processed and make a list of which tanks register best on each type of film. After one trip most of the experimenting should be over and you can get good pictures of whatever specimens they put into the individual tanks.

There's a great deal more bona fide wildlife in a zoo than people realize. Wild creatures that discover a place where they are safe and can get free food indefinitely aren't prone to desert this place until they have to. Migrating songbirds and waterfowl stop in twice a year and some may spend the whole winter. Often there are more "freeloading" wild birds than captive ones on a duckpond in winter. The visiting wildlife in a zoo is considerably tamer than it is in the field, and tends to stay a little apart from the zoo specimens. This is very helpful if you want to photograph black ducks, for example, without having other species of ducks, geese, and swans in the same frame. Mammals and other wildlife are not so noticeable in a zoo, but they may still be there in force. Muskrats, raccoons, foxes, and deer are not unknown, and squirrels, chipmunks, mice, and a few snakes are fairly common.

To do a good job photographically, allow *plenty* of time for a zoo trip. I would consider four days the absolute minimum to do justice to the New York Zoological Park, and a week would not be too much. Most zoos are cooperative toward photographers and will help them out whenever it's practical to do so. What few restrictions they have imposed are necessary and should be observed always. Breaking the rules, even if not dangerous, isn't conducive to well-planned pictures, good public relations, the granting of any special favors or a welcome when you come back the next time. Zoo keepers and attendants are there because they love the animals and working with them. When you show any sincere interest in their charges they will usually go out of their way to help you get the good pictures you are after. If you support the zoological society by becoming a member, you'll not only be showing your appreciation and helping your own cause, but will also be kept informed of new arrivals, special displays and interesting events as they occur. The staff members will appreciate a print if you catch some unusual behavior; many are photographers themselves. They may have some special techniques to share with you.

The rules and restrictions are for the good of the photographer, the zoo specimens, or both. Remember that *these animals are not tame,* no matter how nice and friendly they look. Their keepers know them and you don't; believe what the keepers tell you and follow their instructions *to the letter.* It seems ridiculous to warn people not to push their cameras between cage bars at bears and big cats; but I know of two one-armed skeptics who had to learn this the hard way. The staff and personnel of a zoo want you to enjoy yourself; and with an inquisitive eye and a good supply of film and common sense you are bound to.

10
Underwater and Marine Photography

To ME, the sea is the most fascinating classroom on earth. There is a staggering amount of work still to be done there, and any serious photographic efforts are bound to be valuable. It has been estimated that some 90,000 species of marine invertebrates have been classified to date, and at least another 90,000 are yet to be classified! Twenty thousand species of backboned fishes swim the seas that cover three-quarters of our planet, and man has barely scratched (or splashed) the surface in exploring the vastest "continent"—Oceania.

No one needs to be convinced of the popularity of skin-diving, but putting the sport's attractions into words is a bit difficult. Fascination, exploration, variety, freedom, entering new areas, gaining new knowledge, and appreciation of natural beauty should all be included in a description. I have never met anyone who did considerable diving and then gave it up voluntarily. I even met one *non-swimmer* who spends hours floating around a hundred yards from the shore, utterly enthralled by what she sees and meets! The eyes and nose are kept dry and protected by the mask; the snorkel provides more air than one can possibly use; fins let any kind of clumsy kick supply propulsion; and there you are. A five-year-old can do it. Normal water-safety procedures and common sense are all you need to start what many consider the most captivating sport of all.

Herman Kitchen, undersea cinematographer, says, "The first Aqualung dive is an indelible experience." I know of no better way to phrase it. To fly, free of gravity, completely and gloriously free, is like nothing else on earth. Soaring above the bottom, banking along the side of an underwater cliff, being a fish in action and fact, doing loops, rolls and Immelman turns—incomparable!

Unfortunately, skin divers have earned a bad reputation through stupid and destructive practices—like holding contests to see how many pounds of fish each man can kill in a given time. There are still some who dive only to strut

159

and say, "See how much slaughter I can produce." But thinking divers are turning more and more to photography and other useful activities, and taking one or two fish for the table. It's a swing in the right direction, and makes the future look brighter.

Photography underwater has its own special problems. The camera must, of course, be protected by a waterproof case of some sort, and at least one control, the shutter release, operable underwater. Any camera can be used under water. The 35mm size is excellent for most jobs, and has advantages over other types that far outweigh its faults. The greater depth of field of short lenses, lens interchangeability, film capacity of 36–400 shots per load, rapid-wind levers, and spring-motor attachments are features seldom found in larger cameras.

Twin-lens reflexes are good but will load only 12 or 24 exposures. If you have plenty of time to get a lesser number of pictures, they can be excellent. The Hasselblad and other 2¼" x 2¼" SLR's permit foolproof through-the-lens viewing and focusing and will take wide-angle lenses. Also, the magazine loading will speed things up, especially if a case is built with a reloading hatch so you can change magazines without removing the camera. If you must have a larger negative or transparency, the SLR is the way to go. Just as in dry-land work, all the advantage is with the 35mm cameras.

View and press cameras are sometimes used underwater, but must be hauled back aboard a boat to be reloaded after every shot. It is the slowest, clumsiest imaginable way to shoot, and should be avoided if possible!

Motion-picture cameras ideally should have electric drives, interchangeable lenses, reflex viewing, and magazines holding 200 feet or more of film; however, problems of cost and bulk may dictate the use of less versatile models. Some very good films have been made with simple Super 8mm automatic cameras.

Whatever camera you use, it must be protected from the water by being enclosed in a waterproof case. In the past, flexible cases have been used, sort of a rubber balloon with a glass window. They weren't very satisfactory! Now most cases are made of clear plastic. Models are made for most popular brands of cameras, even the cheaper ones; the cases cost from $50 to $100. It is not very difficult to make a plastic case to fit your own camera, and you would have a custom-made housing just the way you want it. However, this job absorbs an enormous amount of time, and if your time is valuable, it may be cheaper to buy a ready-made case. Of course, there is always the problem of not finding a housing to fit your camera, in which case, you would be forced to build a housing yourself or have one built. If you are not a tinkerer, stay with the ready-made cases.

The only camera that does not require an underwater housing is the *Nikonos*. This is a compact focal-plane 35mm model that is completely waterproof by itself. All controls are sealed with "O" rings, and you can change shutter speeds and diaphragm settings, focus, wind, and shoot underwater. Its main disadvantage is that there is no way to focus accurately; distances must be guessed and

the lens set accordingly. But with the wide-angle lenses standard on the Nikonos, and at distances of four or five feet and further, this is not really a problem. The "normal" lens is a 35mm $f/2.5$ that focuses to 2.75 feet. It has a flat lens-port and can be used above water for shots of sailboats with lots of spray flying about, in rainstorms, blizzards, and so on. There is also a 28mm lens available; this gives better results underwater but cannot be used above water, shooting through air. There is also an 80mm lens made that is designed for photographing unapproachable fish; however, because of the need for guess-focusing a lot of out-of-focus pictures are taken with this lens! One more factory-supplied item is a special extension tube for the normal lens that will give a life-sized image of small creatures underwater. There is no other range available; it is a fixed life-size-image rig, but it is very good for this specialized work. This has to be used with flash.

Where the Nikonos really shines is in its use with very wide-angle lenses. These are not offered by the manufacturer, but are supplied—at a price—by several independent gadgeteers. The 20mm and 21mm lenses will give a full-frame, rectangular image and include a 90-degree angle of view. The Fisheye lenses take in nearly 180 degrees but give a round image. The depth of field of the 20mm and 21mm lenses is very good, and with the Fisheye it is unbelievable. Even things that are *touching* the lens-port are in reasonably good focus!

The Nikonos camera offers a simple, fairly inexpensive way to take pictures underwater. Accessories help a great deal; pictured are the UPSI flashcube-gun and a small exposure meter in its own case.

For photographing people, scenes, large corals, wrecks, and other big objects these very wide-angle lenses are superb. The only disadvantage is the high price involved. It is possible to adapt a lens to a Nikonos in a home workshop, but this takes a vast amount of tinkering and is enormously time-consuming. It's largely trial-and-error work, and you must shoot through a dome, not a flat port, which complicates things; but it can be done.

At most every meeting of divers, someone is sure to ask, "How can I take underwater pictures without spending a lot of money?" My answer to this question would be in two parts, "Instamatic" and "Sea Case." Instamatic by now is a household word, known the world over. This Kodak camera, now made in a dozen models, is very good for underwater use. Several models have built-in spring motors for rapid-sequence shooting. All have drop-in loading that is very convenient when working with wet hands in a small boat. Most models have automatic exposure, and some have close-up focusing. All in all, the Instamatic is an excellent camera for the money and its results rival those made with much more expensive gear. Choose a model with at least an *f*/8 lens, or for deep diving and dim light, an *f*/2.8.

Though wide-angle lenses aren't recommended for fish photography, it's worth a try if you can get close. This queen triggerfish was photographed with a Nikonos and a 35mm lens on fast black-and-white film.

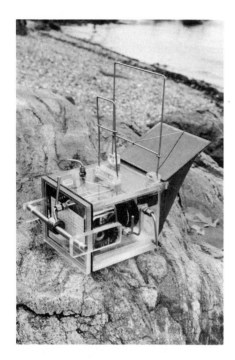

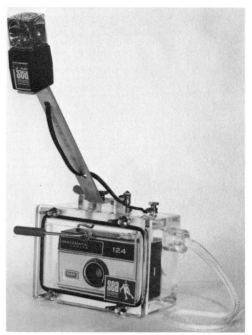

Above, left. Rigid plastic case for Superwide Hasselblad. Sunshade of black plastic folds down to protect face of case when not in use. All controls except shutter speed may be changed underwater. Above, right. Instamatic cameras have proven their worth by the millions, so it should be no surprise that they work very well underwater too. The snug-fitting case is made by Sea Research & Development, and sports a flashcube-gun attachment. Below, left. The author's homemade underwater case for Nikon F camera also accommodates the electric motor and the Photomic finder. A small electronic flash unit attaches to the top. Though bulky, this rig is very good for photographing fish and small creatures. Below, right. The Sea Glove case for the Nikon F camera is of modern, compact, snug-fitting design. Various front pieces accommodate any lens from the Fisheye to the 500mm, and all controls are available. This is the best underwater case I've ever seen and is an excellent tool for the scientist or sport diver.

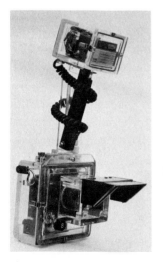

The Sea Case is made by the Sea Research & Development Co., Bartow, Fla. It is a very well-made Plexiglass case for the various Instamatic models and costs about $50. This price, incidentally, includes a flashgun for using flashcubes underwater. When you consider that the Nikonos flashgun *alone* costs $90—and has a reputation for breakdowns—you can see that the Sea Case is a bargain. There is also a Sea Case for the Instamatic movie cameras, and the same comments apply to both camera and case—an excellent value received for the amount of money expended!

Most photographers already own one or several cameras they are happy with, and want to use these underwater as well as above. For them the ready-made case is the answer *if* one is available and has the features desired. If not, it will be necessary to have one built. Anyone tackling this activity should read *Camera Below* by Hank Frey and Paul Tzimoulis, published by Association Press, New York, before starting to draw plans or begin construction. In fact, this excellent volume should be required reading for *all* underwater photographers, professionals and beginners alike. As an added bonus, this book lists all the ready-made cases available at the time it was written (1968). At least two dozen cameras have ready-made cases for them.

Building an underwater case is probably something everyone should do at least once, and at least the monetary investment is lower compared with the cost of a manufactured housing. If you decide to build your own housing, bear in mind the following suggestions.

Keep the design compact; too much bulk means too much buoyancy and makes for clumsy handling both under water and above. Take a ruler and measure your camera; try to visualize what sort of gears and levers you will use to operate its various knobs and gadgets, allow an extra quarter inch or so, and round off to the next bigger half-inch measurement. Then go to a plastics dealer (see the *Yellow Pages,* "Plastics—Sheets, Rods, Tubes, or Fabricating") and have him make up a box with these *inside* measurements out of half-inch plastic. Three-eighths of an inch will do for pressure, but half-inch is much better for resisting knocks and bumps, and the seams are much stronger. Make sure the dealer gives you clear seams. Usually, the back side is the one that comes off for reloading, and there are several ways of sealing this. A simple retained "O" ring is almost universally used, and is cheap and easy to replace if it gets scratched or deteriorates. These closures get tighter the deeper you go and the greater the water-pressure. As an alternative, mill grooves in the lid where the box touches, leaving a narrow ridge. Glue a flat rubber gasket to the box edge; with pressure the ridge will impress itself into the rubber and make a tight seal. Or to avoid milling, glue a very narrow rubber gasket, a sixteenth-inch wide, to the lid; it will cut into the flat rubber gasket the same way. But "O" rings are hard to beat.

For closures, I prefer stainless-steel spring-loaded clamps. I have also used eccentric cams on bars that press only on the center of the lid (not worth the trouble) and the standard method of four, six, or eight wing-nuts on brass or

stainless studs. These are good and quite foolproof; your measuring can be quite a bit off and there is still room to take up the slack with this system. For the shafts I suggest buying control-shaft glands that contain an "O" ring in the proper size groove. They only cost a dollar apiece and will withstand pressures much higher than your body will! If you're not sure of the precise positioning, mount a gland in a disk of half-inch thick plastic, drill an oversized hole in the case—about half-inch—and place the disk against the case wall with the control shaft through the oversized hole. Then slide the shaft around until it is in place and cement the disk to the case wall. (Easier done than said!)

Usually, one-eighth-inch thick brass or stainless-steel rod is adequate for control shafts, and can be bent into shape easily. Keep the section going through the gland *absolutely straight,* and smooth or chamfer the end so it won't gouge the "O" ring. Winding levers are worked by a crank-shaped control rod. Knobs can be operated by a snug cap soldered to the control rod; or you can put a pin in the knob and use an "L" shaped control rod; or cut a groove and use a "T" shaped rod. Looking over several ready-made cases will give you a lot of ideas on construction. It is not difficult, but sometimes a bit tricky! *Don't* let the shutter-release control hold the button down while you wind the shutter; this jams things up in great style. You can buy knobs for one-eighth-inch and one-quarter-inch shafts from the various electronics supply houses; check their catalogues. Small rods and tubes are found in hobby shops and well-equipped machine shops. Any oddball bits of linkage can often be cast from epoxy cement or carved from Plexiglass.

Often you will see a standard tire-inflation valve mounted in a case wall. This is *not* meant for pressurizing the case to resist water pressure; cases aren't designed to withstand pressure from the inside, and you will blow the seals. What it is meant to do is to make any leaks detectable without wetting the camera. Just before entering the water, put a little pressure into the case—a half-dozen strokes of a hand pump—and submerge it; then look carefully for any bubbles. It is better to have air coming out than water going in.

A sunshade is a very good idea underwater, because any particles floating immediately in front of the lens-port will be very noticeable if they are well lighted. Shading the first few inches of water helps a great deal. I like to make this sunshade of one-quarter-inch black plastic, and hinge it so it lies flat and protects the lens-port when you are not actually taking pictures. It shouldn't touch the port, though, or grains of sand will be trapped and cause scratches. Cement some one-sixteenth thick strips or blocks along the edges, to hold the sunshade away. If you don't choose to use a sunshade, cement some blocks around the edges of the case front for the same reason. Sooner or later someone will set it face-down on a table or shelf.

Occasionally you will see fuzzy rounded light marks on your pictures. This is often due to bright parts of the camera being reflected by the inside of the lens-port and affecting the film. Either paint the parts black, or cut a piece of black

Above. Since a lens' angle of view decreases underwater, a normal lens acts as a slight telephoto. This can be helpful in photographing shy fish like this yellowtail snapper, caught as he headed for a safe refuge under a head of antler coral. Rolleimarin camera, Verichrome Pan film, 1/125 sec. at f/6.3. (Kitchen-Kinne photo.) Below. Even with good light in shallow water, flash may improve a picture greatly. The markings of these blue-striped grunts would have been lost without the flash-fill of a small electronic flash unit just above the camera. Nikon F, Micro-Nikkor lens.

paper or cardboard to fit around the lens. It may also help to glue a black paper sunshade inside the case, on the top front, to keep sunlight off the camera itself.

Exposure meters are sometimes mounted inside a camera housing, tucked into a corner somewhere, but are more often carried separately in their own housings. The old standby is a wide-mouth glass jar, with a meter wedged inside. This works fine to 25 or 30 feet, and it costs nothing. It's more convenient, though, to have a compact meter and housing attached to the camera case itself, or on a wrist strap. Any of the inexpensive direct-reading meters will be fine; even those using a calculator-dial will do. Just print a card listing the camera settings for each number on the meter-dial and enclose it in the jar or housing. You will need a different card for each different ASA rating. A sample might read:

KODACHROME-X

Meter reading	Shutter	f/stop
19	1/125	8
18	1/60	8
17	1/60	5.6
16	1/60	4
15	1/60	2.8
14	1/30	2.8

The ultimate in convenience is to use one of the cameras with through-the-lens metering. This spoils you for anything else! If you carry two cameras, consider using two films whose speeds are in an exact ratio: that is, one is two, three, or four times as fast as the other. This simplifies underwater mental calculations and avoids mistakes.

In looking over ready-made housings you will have noticed that some shoot through a curved dome and cost a lot more than those shooting through a flat port. And you wonder if it is worth the extra money. Sorry to say, the answer is "yes"— if we are talking about any wide-angle shooting. Using a 50mm or longer lens, you will not need a domed port; with a 35mm, 28mm, or 21mm lens you will. For fish, no; for people, yes. The domes must be precisely positioned in relation to the lens, since they become part of the optical system and this is critical. The ready-made domed-port cases are expensive—a few hundred dollars at least—and the home-made ones require an unbelievable amount of trial-and-error tinkering. If you decide to build your own, make sure the lens can protrude well forward, even into the dome itself, and use a dome with a large enough radius. For testing, it is convenient to have a swimming pool handy; but if not, try making a trough four feet long, with a mirror set at a 45-degree angle at one end. Fill it with water, float the dome in it, and you can at least check close focus in the center of the field.

Put a clear-glass flashlight bulb in the far end as a focusing target. You can buy war surplus glass domes in small sizes, and for larger ones contact someone who sells or repairs marine compasses. These have thick cast-plastic hemispherical domes that work very well on an underwater camera. They start at three inches or so, and go up to a foot or more in width. As size increases, so does cost! But the smaller ones are fairly reasonable.

You may also wonder whether or not flash is worth the expense involved. For many, many shallow-water pictures it just isn't needed; but once you start to use it you don't want to be without it. Every serious underwater photographer wants to have a flash at hand, whether or not he uses it. But since electricity and salt water don't like each other *at all,* using flash in the sea is often an aggravating battle of man against machine, trying to make the fool things work and keep them working. The secret lies in using *well-designed, high-quality* cables, connectors, and guns. Then you have at least got a fighting chance. After buying, trying, and building all sorts of gear, I've standardized on a flashcube gun, an adapter to use M-series bulbs in this gun, and a small electronic flash unit in a homemade case. The flashcube gun is made by UPSI, Box 26, Marathon, Fla. 33050, and is an absolute dream. You can carry nine cubes—for a full 36 shots—tucked into your swim-suit, and change them underwater. They give just the right amount of light for any shooting up to six feet or so; you won't overpower the available light or have black backgrounds. Also, the gun is on a coil-cord and can be positioned correctly for any situation. For more light, two stops more, I plug in a homemade adapter and shoot M-5 bulbs in this same gun. If I'm shooting small fishes and want to stop motion, I use a Spiratone Monopak strobe in a homemade case. All these lighting units have "Sea-Link" connectors (made by Sea Research & Development) and are interchangeable. Flash or strobe will fit my Nikonos, Nikkormat in Sea Glove case, motorized Nikon F, or Hasselblad Superwide. Having everything interchangeable is the greatest; you can put flash or strobe on any camera, and switch from camera to camera even in mid-roll.

I think the best underwater camera now available would be the Nikkormat in a Sea Glove housing. For fish and other marine creatures you would use the Micro-Nikkor, giving up to half-life-size magnification, or for shy subjects the 105mm telephoto, with a plus-1 or plus-2 close-up lens. For underwater scenics, large fish, or photographing people, put on a domed port and use the 20mm, 28mm, or 35mm lens. (The Sea Glove has interchangeable ports for lenses from the Fisheye through the 500mm.) The through-the-lens metering system is very good, there is flash at hand for immediate use, and the entire rig is compact and easy to use. I find myself carrying two cameras on most dives—a Nikonos with the 21mm lens, and the Nikkormat/Sea Glove with the Micro-Nikkor lens—with flashcubes on the Nikonos and the electronic flash on the Nikkormat. You can do just about anything with these two cameras.

There is not much in the way of photo accessories to take underwater with you. Viewfinders aren't really necessary underwater, and most experienced diver-

Above. In dirty water, ultra-wide-angle lenses are worth their weight in diamonds. With visibility about seven feet, a 21mm lens on a Nikonos, covering 90 degrees, caught this entire porpoise. Longer lenses would have taken in just the head, if that. Below. Adult green turtle, resting on the bottom, was shot with a 21mm lens on a Nikonos. This was necessary because of dirty water conditions; but ultra-wide-angle lenses cause considerable distortion in objects projecting toward the camera. Notice the front flipper.

photographers end up not using or even carrying them. At first, it's a good idea to know roughly what angle you are taking in, and a simple frame finder will accomplish this. With a reflex camera, you will be focusing on the groundglass screen, and can see half of it, or a little more. You know from dry-land experience how big the field is in relation to the center spot; when you see the center spot underwater, it is easy to judge how much else you will get. Don't let anyone tell you reflexes can't be focused underwater: they say this because the mask and the case wall keep your eye 2½ or 3 inches away from the viewfinder. But a reflex works beautifully underwater. Try it.

You can even use a rangefinder camera in an underwater housing, though here you can only see a tiny part of the viewfinder image. If you line up your eye carefully, you will be able to see the superimposed-image rangefinder spot and can tell if the image is in focus. The best idea is to preset the camera for a certain distance, hold the camera to your eye, swim in slowly until the rangefinder shows sharp focus, and then shoot. It is clumsy, but it does work.

The reason wide-angle lenses are so popular for underwater work is because optics do funny things underwater. A wide-angle lens acts like a normal, and a normal lens like a telephoto when shooting through a *flat port*. (With a dome, the angle of view is the same above and below water.) So a wide-angle lens lets you work closer, and this is most important in doing quality work—the less water you have to shoot through, the sharper the image and the brighter the colors.

Another thing that happens to optics underwater is the shift in focus—this is what makes everything look so *big* when you first put on a mask and dunk your head underwater. Your brain eventually gets used to this effect, but the camera doesn't. What looks like *three* feet underwater is actually *four;* but your eye and the camera lens both see things the same way, and if you set the footage scale to three feet you'll be in focus. If for critical focus you want to measure the distance underwater, you will have to use a four-foot yardstick (each foot is sixteen inches underwater). With close-up rigs on nonreflex, nonrangefinder cameras like the Nikonos, a simple wire frame will indicate the plane of sharp focus. Set this around your subject, and it will be in focus.

If you want to start a lively discussion, just mention the word "filters" in a group of diver-photographers. Some swear by them, some swear at them, but no one seems to be neutral. There are points to be made on both sides. One big disadvantage of any filter is that it requires additional exposure, anywhere from a half-stop to three or four, and this can be a serious hindrance. But beyond this the situation gets complicated. In black-and-white work, a yellow filter will increase contrast nicely, and a red more so. But they will also make blue objects dark, which may not be desirable: blue markings on fish, for example, shouldn't look black in photographs. And if you shoot toward the open sea, the blue water and distant fish will come out near-black. Things near the camera are well-exposed, and it looks as though you had a floodlight at the camera, whose light

didn't carry into the distance. In color, red or magenta filters *will* correct for the blueness or greenness of sea water, there's no doubt about it, but it's a mixed blessing at best. The nonfilter group will say that in clear shallow water, you don't need a filter; that at depth no amount of filtering will correct the light anyhow, and you *expect* things to look blue anyway; that with flash you don't want a filter; and that whenever you need strong correction filters, that's exactly the time you can't afford to increase exposure to compensate for them. All these statements are true—but it's also true that adding the right filters can raise the quality of many underwater pictures, and it is usually worth a try. A little testing is the only way to decide if you want to use filters or not.

Buy two 2-inch square Kodak color-compensating (CC) gelatine filters: a CC30R (red) and a CC30M (magenta). These should cost around a dollar or so. Cut them carefully—no fingerprints, please—with scissors, then tape a small piece of one filter on the back of your lens. Shoot some underwater pictures, switch to the other filter and shoot them again, then shoot a third set with no filter. Remember to open up one stop for the filters and to close down again for no filter, and keep a record of which came first—alphabetically, this would be *M*agenta, *N*o filter, then *R*ed. You can run these tests all on one roll of film, and it shouldn't take more than a half-hour. You only have to do it once, assuming you have fairly typical water conditions. It's worth doing.

Incidentally, when using flashcubes, look closely and see if they are made with clear bulbs and a blue plastic cube—if so, take the cube off underwater. This gives a slightly reddish light, and at five or six feet the blue water will "correct" it just the right amount. At close distances leave the plastic cube on. With individual flashbulbs, you can scrape off the blue-plastic coating or dissolve it in lye or acid, though this is a lot of bother. With an electronic flash, if the light is too blue, tape a pink gelatine filter—a CC or even a piece of stage gelatine—over the reflector, and leave it there for all underwater work.

As for film choice, Kodak's Plus-X is popular as a black-and-white emulsion, and the faster Tri-X for deep waters and dim light. Plus-X has good contrast, which helps. Usually I use Panatomic-X rated at ASA 100 and develop it in Diafine, and Tri-X if I need more speed. For color photography, Ektachrome-X is far and away the favorite. It has zappy, zingy colors, good speed (ASA 64), and can be pushed in processing to ASA 125 with excellent results, and ASA 250 with some quality loss. Those who primarily want color prints use Kodacolor-X, an ASA 64 color-negative film; this is not as sharp as the other films. For the ultimate in sharpness, you can't beat Kodachrome. Kodachrome-X, at ASA 64, is fast enough for most situations, and Kodak will boost its speed to ASA 200 in an emergency situation at extra cost. Kodachrome-X is my standard color film, as my clients want the sharpest possible slides for reproduction. When you need more speed, there is always High-Speed Ektachrome at ASA 160, which can be pushed to ASA 320 or ASA 640 by private labs, or to ASA 400 by Kodak. This is a good emulsion, though a little lower in contrast than the others. It is sometimes the *only*

way to take color pictures underwater. High-Speed Ektachrome seems to be a bit more heat-sensitive than other emulsions; be careful.

A rigid case, big enough to hold all camera gear, is handy to have aboard a diving boat. It should be fiber or plywood, and perhaps 1' x 1' x 2'. Line it with foam plastic to soften the hard knocks, and make the lid fairly waterproof; everything in a diving boat seems to get splashed or dripped on. Keep a bunch of plastic bags handy, and keep raw stock in one and exposed film in another. It is heartbreaking to shoot a whole roll of film, and then have someone splash water all over it. Plastic bags will prevent this.

If you possibly can, use a diving boat with a top of some sort to keep sun from beating down on your gear, *especially* the film bag. A canvas top is enough to keep your gear 50 degrees cooler than in direct sunlight. If you must dive from a skiff, take along some big white towels and a sombrero-type wide-brimmed hat. This will give you at least a spot of shade in which to change film. To avoid having your hair drip water into the camera, wrap a towel around your head. Put film in plastic bags, wrap in a white towel, and stow it under the seat, or under the hat. It's too easy to cook film and ruin it, and you won't even know it until it's too late to reshoot. In some places you can dive from the shore, and there it is easier to find some shade. But watch out for blowing sand! Sand will stick to a lubricated "O" ring and cause the case to leak. Wipe the seals off with a tissue just before closing the case.

"O" ring seals should always be lubricated. It is best to use "Sea-Lube," sold by UPSI, but a Chap-Stick will do in a pinch. When storing a case for any length of time, remove the "O" ring, put it in a plastic bag, and store it inside the case. Never leave a case tightly clamped shut; the seals will lose their elasticity and may leak later. It's a good idea to carry a few spare "O" rings; buy three or four when you get the original one. They are cheap, and it's awfully hard to find one if you are far from an airport or industrial supply house. Check the *Yellow Pages* under "Seals."

Picking subjects underwater isn't a matter of hunting for them; it's a case of being surrounded by good ones and not knowing where to turn first. In a strange spot, stick your head in and look around a bit to see what it's like. You may want to make a black-and-white dive, a wide-angle scenic shooting session, or put on the close-up lens and shoot the tiny subjects. Fish will often come to investigate the anchor line and the new arrivals, especially if they haven't been pestered by spear fishermen. Look into any interesting holes and peer under rocks and coral heads; you never know what you'll find, and it's often very photogenic. When using a flash, don't hold it close to the camera; you'll get "backscatter" from floating particles—like snowflakes in a car's headlights. Hold the flash to one side, so the light will fall on the subject at an angle of 30 or 45 degrees. This also gives good modelling, much better than flat, head-on lighting. It's entirely feasible to use extension flash underwater, and multiple flash as well. Simply plug one of the small slave-trippers into a flashgun or

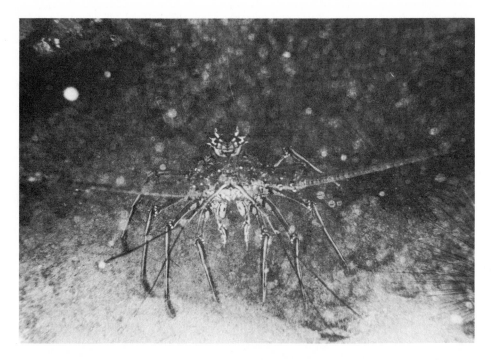

Above. When a subject crawls under a rock ledge, you must bring the flash near the camera to have it light him at all. If there's much suspended matter in the water, we get a "backscatter" of reflected light; this is a good example of backscatter. Below. If a diver moves slowly and is patient, he may be accepted as a strange but harmless member of an underwater community, and find himself in the midst of schooling fish that pay him little attention. Then he can take pictures until his film runs out.

A school of curious jacks circles the author on a reef 25 feet below the surface in the Bahamas. Dim light on a cloudy day required a fairly slow exposure, even with a fast black-and-white film. Hasselblad, super wide-angle lens, 1/50 sec. at *f*/5.6 on Plus-X film with a CC30Y gelatin filter.

electronic flash unit, and have an assistant hold and aim it. For this work it's good to carry a slate and pencil; telling your assistant just what to do is hard to accomplish with gestures.

With natural light, *avoid* shooting straight down from the surface. The light source, the sky, is directly behind you, and this flat lighting coupled with diffusion caused by the water makes for the lowest contrast imaginable. Pictures will be dull and flat, with no modelling or depth. Dive down and shoot horizontally. Some very interesting effects are possible by shooting up from the bottom toward the surface, such as silhouetting fish, another diver, or the boat against the sky. Just a breaking wave or surface-chop can make a striking picture if the light is right.

To attract fish, try chumming. You can carry a bucket of oily fish the way sports fishermen do, but this is pretty messy. Try taking some cans of sardines or cheap, oily fish into the water with you, and stab some holes in them when you get to the bottom. The trickle of fish flavor will attract a lot of attention. You can also break open sea urchins with your knife or snorkel, and if you've collected some crayfish, save the bodies and chum with them.

The scent of fish may bring an inquisitive shark to the scene. In shallow waters near the shore, you are most unlikely to meet any dangerous species, except at night. But remember sharks are unpredictable at best, and none too bright either. It's wise not to antagonize them. Remember their normal food is found either on the surface or on the bottom, so midwater is the safest place to be. And don't get so engrossed that you forget to take any pictures—this has happened more than once. Sharks are beautiful, graceful swimmers and well worth some film.

Barracuda are among the most curious of all marine fishes, and most always come to look you over. They may hang back, facing you end-on, and are then very hard to spot. Swimming toward them will make them turn broadside and then swim away. If you're close enough, this is a good time for pictures. I don't feel that during daylight and in clear water there's anything to fear from barracuda. They look fierce (they can't help that), and they are curious. They are also most efficient predators and don't go around biting people by mistake, or for that matter by intent either. Their aim is good; they have plucked a fish off a spear being held in both hands by a diver. And when they have been speared, they have been known to bite. (I think I would too.) But barracuda are not something to be feared, unless you do something foolish—like rinsing fishy fingers overboard from a skiff, diving at night with speared fish on a stringer, and so on. It's probably accurate to say that when you see a barracuda, he's already decided not to bite you. With their speed, fifty mph or better, you couldn't get away from one underwater if he *did* attack. So relax.

After or between dives, if the water's rough or you're boatless, take your camera along the shore and check the tidepools. They are great little mini-worlds where creatures are concentrated and can't get away. With a close-up

rig, you can submerge the lens of an underwater camera and shoot small creatures to your heart's content. Shooting with a dry camera is profitable too, but you may need a polarizing filter to cut down reflections. You can also hold a black cloth or cardboard to block the sky reflections. If tripod legs sink into sand or mud, put each into a tin can. On kelp and seaweeds, rubber feet will slip; use a tripod with sharp metal spikes on the legs.

Another good technique is to take a small aquarium to the shore. Fill it with clear, even filtered, water, collect marine creatures from the sea or the tidepools with a net, rinse them well, and pop them into the aquarium. You can control them very well, they will be fresh and healthy, and you can release them afterwards—or make bouillabaise! You will need a black cardboard reflection-dodger and some gray or colored cards to use behind the tank as backgrounds. Active subjects can be "herded" into the plane of sharp focus with a pane of glass that confines them to the front inch or so of the aquarium. Shooting at life-size or higher magnifications is much easier this way, and results will show it.

The capture-shoot-release system also gives your nonphotographing buddies or the kids something very useful to do while you are photographing. With just sneakers and a net the tidepools can be hunted, and with a mask and snorkel all sorts of denizens of the shallows can be caught. If you must transport them any distance, put them into glass jars filled to the brim and tightly capped. Any air space will allow sloshing, which will damage delicate specimens, and, believe it or not, make fish seasick!

Manatees prefer muddy waters, but with luck may be found on clear water. With more luck and considerable patience—this dive took three hours—one may let you approach closely and photograph him breathing at a range of a few feet. Nikonos, 35mm lens, Panatomic-X rated at ASA 100.

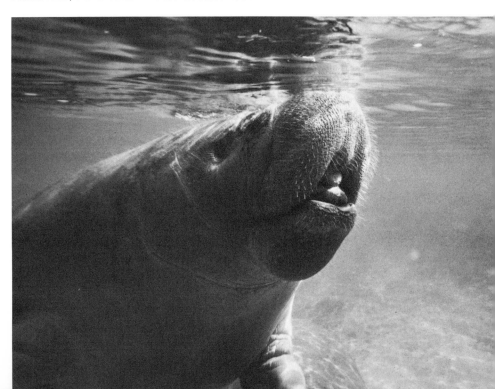

11
Photographing Rocks, Gems, and Minerals

IT WOULD be hard to overemphasize the importance of rocks, gems, and minerals in our modern world. Practically everything made by man started with the mother earth, and our present technology would be impossible without the tremendous warehouse of building materials our planet offers. Gems have been prized since history began, and mineral deposits are so important to a nation that wars have been fought over them. Studying these basic materials is an intriguing hobby, as is evidenced by the activities of tens of thousands of "rockhounds" with their own magazines, clubs, and societies.

Finding and collecting specimens is half the fun. There is no shortage of just plain rocks, but finding an unusual or specific specimen will take a little work. Roadcuts, cliffs, mountains, quarries, mine dumps, and excavations are excellent hunting grounds. Little equipment is necessary; just a pair of gloves, a geologist's pick or hammer, cold chisel, notebook, and some newspaper for wrapping will do fine. It will all fit into a small pack, along with a field guide for making positive identification. Small specimens are generally as good or better than large ones, and are a lot easier to lug around. Settle for one or two specimens of each rock or mineral; there's no sense being greedy about it. For photographing objects *in situ,* carry a ruler or small metric rule to place against it for a size-reference. Specimens should be washed in water or alcohol to see what they're really like.

The terms rocks, stones, minerals, and gems may confuse a beginner. Rocks are simply solid mineral material making up the crust of the earth. Stones to the average man are the same as rocks, but strictly speaking, stones are consolidated or solid, whereas rocks include clay, loose material like sand, or molten lava. Minerals are chemical elements or compounds found naturally in the earth's crust, generally with a definite form or crystal structure. They are practically

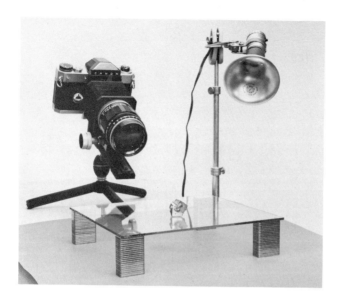

Equipment set up to photograph pyrite crystal, placed on a sheet of glass to avoid background shadows. Canonflex with bellows and 100mm $f/2$ lens is supported on Rowi camera stand. Sheet of construction paper provides a uniform background.

A most unusual pyrite crystal from the collection of Louis Zara. Supporting specimens on glass avoids shadows, but produces some reflections; these may be spotted or airbrushed out of finished prints if desired.

always solids; water and mercury are the only common exceptions. Rocks are made up of one mineral and some impurities, or several minerals together. The individual minerals are stable and can often be seen in the composition of a rock; quartz in granite, for instance. Gems are generally precious or semi-precious "stones" cut for ornament. Some mineral ores and one variety of soft coal are gems only when used as such. An unusual gem-mineral is the pearl, built up of layers of aragonite inside living oysters. Practically all gems are minerals; but most minerals are not gems. Some two thousand minerals are known, and one mineral may take several forms. Rubies, sapphires, oriental amethyst, oriental emerald, and oriental topaz are all *corundum;* commonly used in sandpaper and grinding wheels.

It would be hard to find better or more cooperative subjects for photography than rocks, gems, and minerals. They don't sway in the wind like flowers, flit around like birds, jump and wiggle like insects, or hide behind the bars in a zoo. A photographer needn't go underwater for them, or wait for the right weather, except in special cases. They are not as wild as game animals nor as hard to find as many other subjects are. Specimens range from a gram or two to several hundred tons; most can be photographed well with a minimum of equipment (though sometimes a maximum of effort!). Most small specimens are quite easy to shoot, and though the "thumbnails" and "micro-mounts" require more time and equipment, photographs will show details of color, form, and structure that may be invisible except under a good microscope.

Here again the 35mm single-lens reflex is the best camera to use. Larger cameras will have less depth of field at any given aperture, film cost is higher, and the entire process more complicated. There's seldom any advantage to a larger film size. You can take advantage of the wide variety of film types available in 35mm size, both black-and-white and color. Photographs of rocks in the field or geological formations require a camera with a few refinements; but for most indoor work the simplest camera having a good lens is as effective as the more complicated ones. In many cases a shutter is even unnecessary; the "bulb" setting is the one most often used. Waist-level finders are best for indoor work. You'll need as many extension tubes or the longest bellows attachment you can find, or both. The ideal camera is a single-lens reflex having interchangeable eye-level and waist-level finders, fitted with a macro lens or a good close-up lens on a bellows. Two identical camera bodies let you photograph the same specimen in both color and monochrome during one shooting session. Automatic lenses are convenient but not really necessary. For high-magnification work a rigid camera support is essential, and it should be as vibration-free as you can make it.

As for lights, reflector photofloods are inexpensive and suitable for fairly large specimens. Microscope lamps, preferably of the focusing type, do better for smaller ones. Some focusing automobile spotlights are good, but must be run from a 6- or 12-volt transformer. The small doorbell transformers will not

be satisfactory; a heavy-duty one must be used. Ultra-violet lights will bring out fluorescent colors and yield the sharpest results in black-and-white photography at high magnifications.

Most macro lenses and sets of extension tubes for 35mm SLR's allow one-to-one magnification, or life-size on the film. Any rock specimen an inch in length or larger will require nothing else in the way of camera equipment. For this less-than-life-size magnification, I prefer working on a good steady table with the camera on a small tripod. For a background, lay a sheet of colored paper flat on the table and prop the far end up with a couple books or a paperweight. Small pieces of cellulose tape will anchor it in place. If you want a completely shadowless background, support a pane of glass a few inches above the paper, and set the specimen on it. In either case, decide which face of the rock looks best and prop it into position. Small pieces of balsa wood or pillars of modelling clay behind it will hold it in place and won't show in the picture. Occasionally small specimens look best when balanced on a common pin or

Left. An enlarger upright and baseboard used as a camera support for shooting straight down on specimens. A waist-level viewfinder is much more convenient than a prism for this work. Small reflector-floods provide plenty of light and keep exposures conveniently short. Right. For extreme enlargements, a long bellows extension is necessary. Here the camera (with waist-level finder) is at top, mounted on the camera bellows attachment. Next is a homemade adapter, the enlarger bellows, a regular extension tube set, and a tube set that mounts the lens in reverse position. The scale described in the text is mounted on the camera; a pointer on the lens indicates lens-film distance, exposure-increase factor, and magnification.

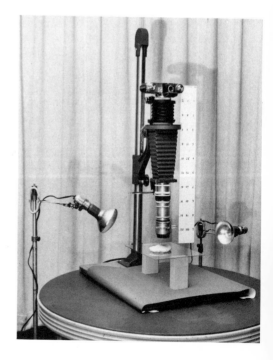

short piece of balsa wood. These can be painted black if desired. Any model-airplane hobby shop will have a good selection of lengths and thicknesses of balsa.

Use photoflood lamps in clamp-on sockets for illumination; mount them on light stands or any other convenient support. Experiment with the lighting to bring out the best texture, detail, or translucence; whatever you want most to show. Even with a sunshade, check to be sure stray light doesn't hit the front surface of the lens directly. Watch the image in the viewfinder as you stop down the diaphragm, to see the effect of increasing depth of field. At low magnifications the smallest f/stop may produce too much depth of field, putting the background sharply in focus and drawing attention from the subject itself.

When everything is ready, dust off the specimen and setting with a camel's hair brush, or by blowing gently with a drinking straw or ear syringe. Sometimes wetting the rock will bring out colors and details. Water evaporates too quickly; try mineral oil and wipe the rock almost dry before setting it in place. Either a reflected-light or incident-type exposure meter will do for large specimens, but incident-light meters are best for small ones.

The size of the specimen will determine how many tubes or how much bellows-extension is needed, and of course we must increase exposure, as in any other close-up work. The tables and discussions in the flower and insect chapters apply here as well.

At the higher magnifications there are so many variables that tests are the only practical way to determine exposures critically, but a table is fairly accurate. It may be lettered onto a cardboard, mounted on the camera stand, and a cardboard pointer on the lens will indicate at a glance the pertinent information.

For a two-inch lens, the table would be as follows:

Lens-film distance in inches:	Multiply exposure time by:	Magnification:
2	1	—
4	4	1
6	9	2
8	16	3
10	25	4
12	36	5
14	49	6
16	64	7
18	81	8
20	100	9
22	121	10
24	144	11

Draw this scale full size on white cardboard and attach it to the camera support so that the "zero" mark is at the film plane of the camera. Tape the cardboard pointer to the lens so it will indicate the distance from the film plane to the optical center of the lens. (At infinity focus this will be two inches.)

Reciprocity-law failure must also be taken into account, as discussed in the chapter on flower photography. With extreme magnifications, exposure may run longer than the 70-second maximum covered by the table. Again, tests are the only course of action. For color balance, try three shots of each setup, using the CC10Y (yellow), CC10R (red), and CC05G (green) filters. One should indicate the general direction to take; you'll have to estimate the filter density to use.

Close-up of oölitic limestone, or "beach rock," made with extreme-close-up equipment producing a magnification of about 8½ : 1. One spotlight was used to provide contrast. Panatomic-X film, *f*/2 Biotar lens used at *f*/11, exposure eight seconds.

Use strong lights at high magnifications to keep exposures fairly short and lessen vibration problems. Make the exposure by turning the lights on for the required amount of time. Turn out the room lights and open the camera shutter on "B" or "T," wait for vibrations to die down, then make the exposure. A "Time-O-Lite" darkroom timer can be set to keep the lights on for any time period from one second to one minute. For longer exposures you could set the timer for half the time needed and trip it twice. Whenever making photographs larger than life-size, reverse the lens for optimum definition and flatness of field.

Twelve-diameter enlargements are about the limit of satisfactory photomacrography with this sort of equipment. For higher magnification, use the microscope-camera methods. They are fully discussed in the Kodak Data Book, *Photography Through the Microscope*. Many results in photomicrography can be improved by using filters.

For high magnifications, an enlarger baseboard and upright make a very convenient camera stand. Some enlarger heads are attached with a standard tripod screw, and the camera can be mounted directly when the enlarger head is removed. Sometimes the enlarger bellows can also be used, with the camera mounted where the negative carrier and lamphead normally go. The camera can be raised and lowered at will, and focusing is easy with a waist-level finder on the camera. A stage can be built to hold specimens of any size; if it has a screw adjustment for height, so much the better. For extreme enlargements, a microscope stage is excellent; a specimen can be shifted a millimeter or two until it is in the center of the field. It's easier to focus by moving the specimen up or down instead of the camera or lens. A moving specimen stage can be built from the focusing rack of an old press or view camera, or slide projector. The adjustment should be as fine and delicate as possible.

There is another factor that enters into high-magnification photography and can cause no end of trouble. This is diffraction of the image. At small apertures and extreme enlargements, diffraction causes the image to become fuzzy and lose contrast. Stopping down the lens increases the depth of field, but also increases the effects of diffraction. There is a point where the advantage of more depth of field is more than offset by the fuzziness caused by diffraction. This point will vary for each lens and degree of enlargement. Run a series of tests on black-and-white film, using all f/stops from f/4 to f/16 or f/22, and make careful notes so you'll know which was which. These negatives should be fairly thin and as consistent as possible. Critical examination, or a set of prints, will indicate how far you can stop down to get the best possible compromise.

The shorter wavelengths of light cause less diffraction of the image than longer ones. Adding blue filters to the lights will help a little, but for critical work ultraviolet light should be used. This involves more work, but the results are considerably better at high magnification than when white light is used. It should always be considered when the image is about ten times life-size, and is valuable even at the 3x or 4x level. The same degree of sharpness can be ob-

tained at $f/32$ with ultraviolet light as at $f/22$ with white light, and of course the depth of field is greater at the smaller f/stop.

The light source can be inexpensive self-filtering fluorescent tubes that plug into standard fixtures, or special lamps made by Hanovia and General Electric. The fluorescent tubes are fairly weak, running from 4 to 15 watts in the small sizes. The light from such a linear source as a fluorescent tube is diffused, and no "spotlight effects" are possible. They will produce good photographs of fluorescing minerals and are satisfactory for black-and-white work as well. The larger 100-watt sealed-beam units are available in either spot or flood types, but weigh and cost more.

Ultraviolet light with a wavelength of about 3,650 Angstrom units is excellent for photography. Shorter wavelengths than this will require quartz lenses. Not all lenses will pass UV light well, even of the 3,650 wavelength. The newer "rare-earth" lenses are not good for this purpose. Experimenting is the only way to check your particular lens. The Leitz Elmar, Micro-Tessar, and Goerz Dagor pass ultraviolet very well. Lens coatings apparently make no difference, unless, of course, they are of the type designed to eliminate excess UV light in normal photography.

As in infrared photography, there is a focus difference with ultraviolet, when compared to visible light. The shift is in the opposite direction. After focusing under white light, we must *increase* the lens-subject distance, to get a sharp image with UV light.

Bob Adlington of the American Museum of Natural History has worked out a simple and foolproof method of determining the focus-shift necessary for close-up photography by ultraviolet light. I am greatly indebted to him for making it available to me. In practice, stand a 30-60-90 degree draftsman's triangle on edge on the specimen stage, so that the hypotenuse makes a 30-degree angle with the horizontal. Glue a metric rule with inscribed markings along the hypotenuse. Using white light, carefully focus on an index mark near the middle of the scale; the 40mm mark, for example. Lock the camera in place so it will not shift, turn out the white lights, and make an exposure by ultraviolet light *only*. On examining the processed film, you will find that a mark several millimeters below the index mark is sharp. If the zone of sharp focus is 4mm down the scale, for example, the lens-subject distance must be increased 2mm; just half the distance. The easiest way to accomplish this is to lower the specimen stage, but the camera assembly could be moved higher instead.

This change of focus will vary between individual lenses and at different degrees of magnification with the same lens. Shifting the specimen up or down, a millimeter or two, may be difficult to do accurately. If in doubt, bracket exposures by moving it a slight amount between shots. The amount of focus-shift between visible and UV light gets smaller with higher magnifications; it may drop to 0.5mm or so. At low magnifications it is considerable. Shooting at an object 10 feet away, the focus-difference might be 12–18 inches.

Specimen of Andersonite photographed under white lights. Canonflex, 50mm lens with supplementary close-up lens; subject 12 inches from lens. Ilford FP3 film rated at ASA 200 and developed in Acufine.

The same specimen photographed under ultraviolet light. Camera and lens same as above, but a 1-A filter was added to eliminate image cast by ultraviolet light; only the fluorescing material formed the image. A short white-light exposure shows contours of the entire specimen.

Exposure meters are extremely sensitive to ultraviolet light, and can be used quite successfully. ASA ratings must be assigned to each film used, and determined by a series of tests. Incident meters are best for small specimens. Simply place the meter in the subject position, facing toward the camera lens. Readings should be made under ultraviolet light only, with room lights turned off.

Many films can be used for photography by UV light. Kodak Fine-Grain Positive film (developed as a negative) is very cheap, extremely fine-grained film. Panatomic-X and Tri-X are good too, as are the thin-emulsion films designed for critical use. If a lot of UV work is planned, the Fine-Grain Positive film will probably prove the best. It is very sensitive to ultraviolet but fairly insensitive to light of other wavelengths. It can be processed under a yellow safelight. This developing by inspection is very convenient, and the film cost is so low that extensive testing and wide bracketing of exposures and focus settings are practical.

In this reflected-light type of ultraviolet photography, we try to keep all visible light from affecting the film, and must use lens systems that transmit UV light. For photographing fluorescent materials, we try to keep all *invisible* light from affecting the film, and must use lenses or filters that do *not* transmit UV light. The easiest method is to add a filter to the lens system that will pass all the visible fluorescent light but will stop all ultraviolet. In black-and-white work, use the K-2 (*not* K-1) or G filter. The Wratten 1-A and 2-A filters absorb all radiation below 380 mμ and 400 mμ, respectively. The 1-A will probably prove best for color work. The K-2, G, 1-A, and 2-A filters are available in glass, or gelatine squares. The inexpensive gelatine filters will do fine for testing and all but extremely critical uses.

Getting good results on color film is easy in some cases, and the most difficult thing imaginable at other times. Exposures of more than two minutes rarely yield good results in color. Try to increase the light intensity and use a shorter exposure. Regular Kodachrome is excellent in most cases. It is available in type A for use with photoflood bulbs or Daylight type for strobe light illumination. If a certain subject doesn't reproduce accurately on Kodachrome, try either Ektachrome or Anscochrome. It's hard to predict which will be best in any given case. If none of these produce the desired results, you'll have to use filters.

Take the transparency that comes closest to the true appearance of the specimen, and view it through various Kodak color-compensating gelatine filters. These are available in six colors (magenta, cyan, and yellow; red, green, and blue) and a wide range of densities. A set of CC10 or CC20 filters is usually "strong" enough. When the transparency looks good through a particular filter, set up equipment just as it was when that picture was made, add the filter to the lens or the light source, and make another exposure. The best results will usually come from filtering the light source, but this requires larger and more expensive filters; try a filter on the lens first. With a small specimen you may be able to prop up the small filters near the subject so the colored "shadow" of

the filter covers the specimen. There will be a little scattered white light but it shouldn't affect matters too much. With filters on the light source, an incident-type exposure meter should indicate correct exposure. With filters on the lens, the exposure must be increased a little. The Kodak Data Book, *Kodak Color Films,* lists filter factors for all the color-compensating gelatine filters. These filters, incidentally, may be bound into a mount with a slightly off-color transparency to correct the overall color balance for noncritical uses.

Ultraviolet light makes certain fossils stand out beautifully. Using only UV light for illumination, a fluorescing fossil creature will appear to be suspended against a black background. It is often preferable to show the matrix as well as the fossil itself. This can be done by adding a short white-light exposure to the UV exposure. Turn on the white lights for a few seconds after the UV exposure is completed and before closing the camera shutter.

To get closest to Mother Earth and the source of all mineral and rock specimens, go spelunking. Wandering (or crawling or sliding or splashing) through caves is an excellent way to get certain specimens and a thrilling hobby in itself. Photographing in a cave produces striking and beautiful pictures, but it is not always the easiest of things to do. Artificial light is necessary for almost every exposure, and many factors are present to make normally dependable equipment behave erratically. The high humidity affects electric and electronic gear and fogs up lenses and viewfinders. The heat of a carbide lamp—*carefully applied!*—will evaporate it, but a hard breath near the lens will fog it up again. None of the anti-fog preparations for eyeglasses are safe to use on a lens. They can do permanent damage. Only one cave in a hundred will let you work without giving your camera some hard knocks, and dripping water seems to be the rule rather than the exception.

The problem of protecting a camera and still having it ready for use has been neatly solved by John Spence and Russell Gurnee. They have built wooden and sheet-metal boxes for their cameras. The hinged front and back lock together to form a rigid handle, and hold a flashgun, spare lenses and accessories in clips. The flashgun can be used where it is or moved a few feet to one side for better modelling. These boxes provide protection against knocks and jars, water, mud, and dust. They're equally useful in rain and snow, or aboard small boats. They can be made completely waterproof.

The only alternative to using a cave-box is to wrap cameras in plastic and stow them in a canvas pack. Unwrapping and re-wrapping is a chore, and some good opportunities will be missed. Also, many passages are just wide enough for one person; packs will have to be taken off and passed ahead or dragged behind.

Strobe units are fine for cave photography as long as they work. Subject motion and slight camera motions will be stopped. The color balance is excellent for daylight-type color films, and the light has good carrying power. However!—humidity has made every unit I've ever tried quit after a certain time,

The author's cave box for two Canonflexes. Front and back of box lock together rigidly when open. Flash reflector is set as far from lens as possible, and can be removed and held several feet to one side for better modelling. Spare lenses, filters, close-up lens and flash circuit are in front cover; spare film, notebook, and pencil in rear. Box is waterproof when closed.

One of the most unusual of the cave-dwelling creatures, the guacharo, or oilbird. This specimen was caught as it flew from its nest in a Trinidad cave. Minolta Autocord camera, one strobe unit, f/5.6 on Verichrome Pan film. Even the 1/2000 sec. flash did not stop all wing motion. (Russ Kinne for New York Zoological Society.)

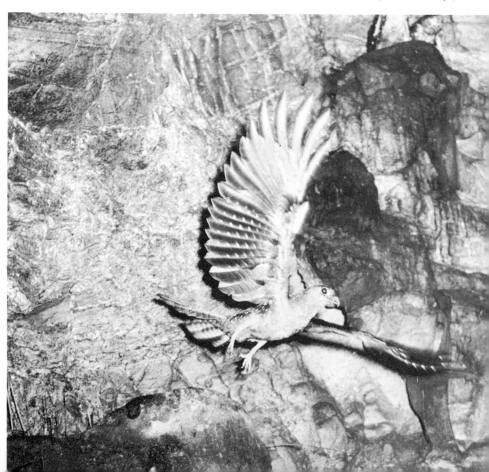

and weight and bulk are a disadvantage. On a long or important trip you should carry a flashgun and bulbs in case the strobes fail. When you reach this point the question arises, why carry a strobe at all?

Flashbulbs are small and light, dependable and highly satisfactory for cave work. The Sylvania M-5 and M-25 bulbs in proper reflectors give plenty of light for most purposes, even with the Kodachromes and slow black-and-white films. Larger bulbs are good for distant shots and large rooms.

As in most photography, a second light improves pictures immensely. Extension cords are inconvenient to use in a cave; slave-flash is the obvious answer. Lots of slave units are made for strobe units, most of which will work for flash. The Kodak Electric-Eye Remote Flash Unit is a dandy. Unlike some slaves, the Kodak unit will *not* go off in your face when your headlight strikes the photocell. It is, all in all, an excellent gun, and a joy to use. It even has a safety-button so a bulb won't go off in your fingers if someone else takes a shot while you're inserting a bulb.

Flashpowder is dangerous. Many oldtime photographers have blown off fingers and suffered serious burns from it. The charges are small bombs and you must take extreme care in transporting, storing and handling it; but—nothing else produces such a *glorious* blast of light or does such a grand job of lighting large rooms underground. Twenty or thirty cents' worth of flashpowder produces as much light as a thousand flashbulbs that need yards of wire, hundreds of light stands and a bevy of assistants to set up. There's just no comparison, price-wise or labor-wise, when you want to illuminate a large chamber. Lay the powder on one end of a strip of waxed paper, light the other end, and stand back.

Unfortunately, even "smokeless" powder makes smoke, and it takes a long time to clear away. Take your flashpowder pictures on the way out, and fire the furthest charge first. You can get powder from Newco Products, Inc., in Loveland, Ohio. Seal small charges in waxed paper and carry them in a waterproof can. For safety's sake, don't put more than three or four into a single container; *and don't let anyone become the least bit careless in handling flashpowder, above ground or below.*

If there are no people in the cave scene you wish to photograph, you can set up the camera on a tripod, open the shutter, and walk around with a flashgun or strobe unit, firing any number of flashes. A large room can be illuminated this way, using only one strobe unit or flashgun. Each flash should be aimed or shielded so that the light does not hit the lens directly. Make sure, also, that your headlamp is not visible from camera position as you move around; it will cause tracks on the film. An assistant can cap the lens or hold a black object in front of it between flashes. With this technique you can refocus between background exposures and any including close objects.

Wide-angle lenses are the most useful underground, but normal and medium telephotos have their place too. Any lens from 20mm to 100mm is good.

Opposite page. Cave picture taken with flash-on-camera and three Kodak Electric-Eye Remote Flash Units. Canonflex with 35mm f/2.5 lens; Sylvania M-25 bulbs, used in all units, have the shortest "reaction time" of all the small powerful flashbulbs available, and are best for cave and slave work. Slave units eliminate wires strung between flashguns, which are unsightly and often unreliable. Farthest flash about 60 feet from camera; end of passageway over 100 feet. Canonflex, Panatomic-X film, exposure 1/30 sec. at f/8.

The 100mm, especially with a close-up lens, is great for bats, bugs, and inaccessible formations. Many flash units aren't designed for wide-angles, and will cause dark corners with an extreme wide-angle. Frankly, I like this effect. The viewer realizes that all surroundings are in pitch-darkness, and the "spotlight" effect is dramatic. One of the most common faults is to over-light a cave. They are dark places and should look it. Lighting up every nook and cranny makes them look like rockpiles; preserving the overall impression of darkness maintains a cave's mystery and majesty.

Some caves hold a surprising amount of wildlife. Bats, salamanders, spiders, crayfish, beetles, moths, and pack rats are all good troglodytes. Many of them have evolved or developed certain characteristics as a result of their underground existence and are most unusual subjects. Some fish, salamanders, beetles, and spiders are blind. Other animals may be pure white; colors are of no use in the dark. Bats and one species of bird, the guacharo *(Steatornis caripensis)* navigate in total darkness by using "sonar" or echo-location.

If you're inclined to think of rocks, gems, and minerals as tame and uninteresting subjects, you may change your tune after grappling with some of the technical puzzlers in studio work, or after exploring the dark reaches of a good cave.

Nature photography is not a particularly new field. Pioneers like H. K. Job were turning out excellent photographs around the turn of the century, and many of Will Beebe's fish, fowl, and animal friends all over the world were recorded not many years later at his favorite exposure; f/64, 1/5 sec.

Today, teen-agers are winning wildlife-picture contests, and one boy had one of his bird photographs chosen for the dust jacket of a gift-edition book when he was only 17. On the other end of the scale, many people are taking to wildlife photography when they retire; some of *National Geographic's* most striking essays are produced by a man who never owned a camera until he was 55. There's room for everyone, regardless of age or training.

It is interesting to read the attendance figures for many of our federal wildlife refuges. Even where legal hunting and fishing are permitted, those who come to look and photograph outnumber the hunters or fishermen eight to one. With each new development in equipment or supplies, better and better work is produced in color and monochrome, stills, and motion pictures.

190

Wildlife photography is full of unexpected adventures. One famous bird photographer was arrested as a suspicious character while whippoorwill-listening, and another met his future wife on the opposite side of an owl's nest, high in a tree.

No one recorded what the owl thought of all this.

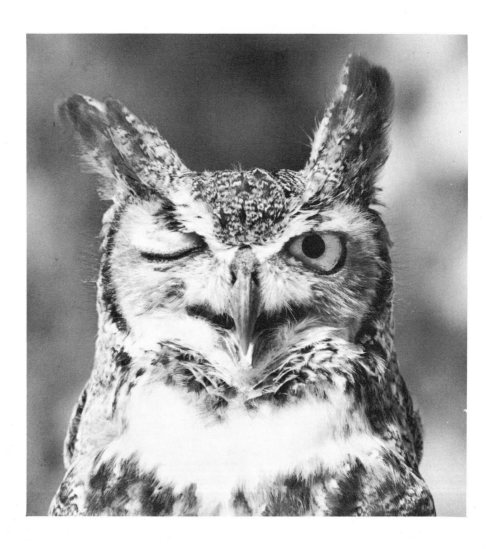